Packaging Prototypes 3: Thinking Green

EDWARD DENISON & GUANG YU REN

Photography by John Suett

RotoVision

DESIGN FUNDAMENTALS

Packaging Prototypes 3

Thinking Green

'We are in the midst of a basic paradigm shift in science, from the metaphor of the machine to the metaphor of the living organism'.

David Korten, *The Post Corporate World*

A RotoVision Book
Published and distributed by RotoVision SA

RotoVision SA, Sales, Editorial & Production Office
Sheridan House, 112/116A Western Road
Hove, East Sussex BN3 1DD, UK

Tel: +44 (0)1273 72 72 68
Fax: +44 (0)1273 72 72 69
Email: sales@rotovision.com
www.rotovision.com

10 9 8 7 6 5 4 3 2 1

ISBN 2-88046-560-5

Photography by John Suett

Systems diagrams by Edward Denison
Designs diagrams by Guang Yu Ren

Production and separations in Singapore by
ProVision Pte. Ltd.

Tel: +65 334 7720
Fax: +65 334 7721

CONTENTS

INTRODUCTION 7

 The Rise of Ecological Consumerism 9

 The Call for an Evolutionary Systems
 Perspective 12

 The Role of Design 15

 Packaging Systems 18

 Aluminium and Steel Recycling 18

 Glass Recycling 19

 Plastic Recycling 21

 Paper Recycling 22

 Returnable Packaging 23

 Refilling 25

 Composting 26

 Reconstitution 27

 Examples of Redesigning Packaging 28

 Case Studies 34

 Materials and Icon Keys 45

THE DESIGNS 47

 Green Checklist 149

 Bibliography 150

 Legislation 152

 Acknowledgements 153

 Useful Addresses 154

INDEX 158

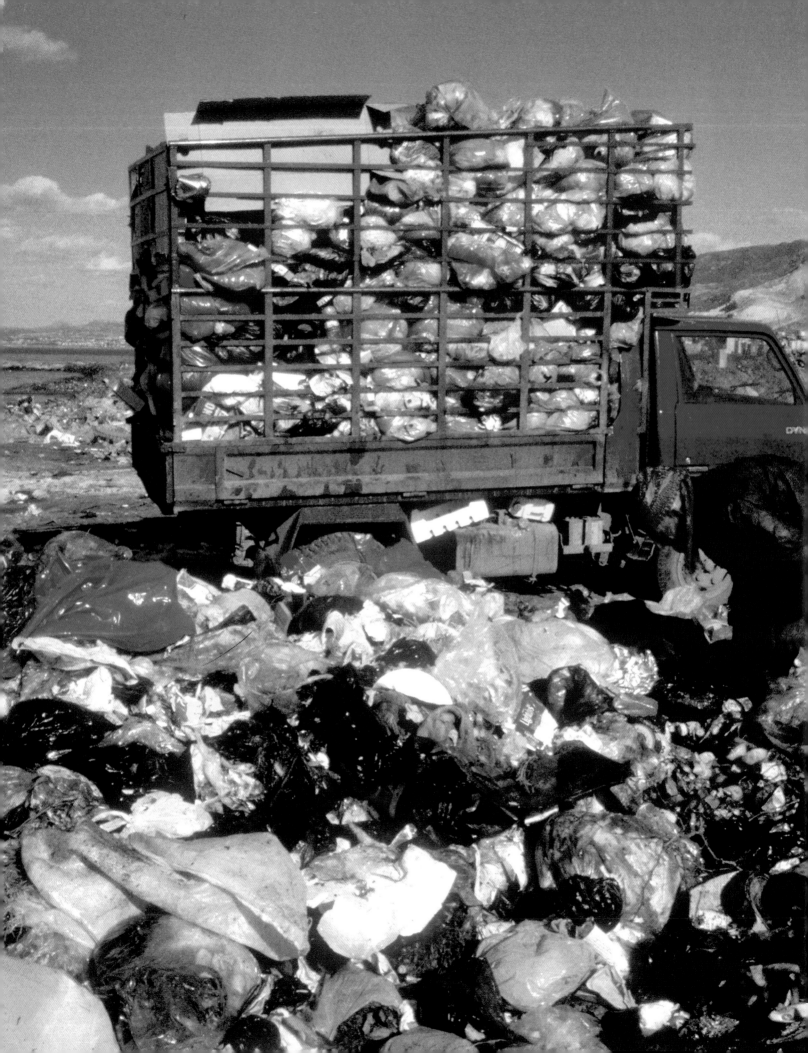

INTRODUCTION

Throughout our relatively short existence, human-kind has utilised a vast array of forms and devices to contain goods. Packaging fulfils a wide range of functions surrounding the products and produce we want and need, including safe transportation, preservation and portioning, as well as providing a platform for information about weight, content and nature of the product. Whether it is our ancestors' use of leaves to wrap wild berries or contemporary sophisticated methods of containing spent nuclear fuel, packaging is the means by which we aim to fulfil a wide range of needs centred on product protection. Such a diversity of needs outlines the importance and intricacy of packaging as an integral system in a complex web of systems that we employ to sustain the lifestyles that we choose to lead. The dilemma humankind presently faces is that our unsustainable lifestyles are so threatening the environment that has forever sustained us, that our very existence within this environment is now far from assured. Nature's experiment with humankind might not only prove to be unfit for our species, but unimaginably devastating for the other species sharing this planet.

One could argue that humankind has always been unsustainable and has always afforded the luxury of being able to choose the easiest evolutionary path by moving onto 'greener pastures'. Our predicament in the 21st century, however, is quite simple. There is nowhere left for us to go. We have, at last, reached the outer limits of our physical evolutionary development and thus are now just beginning to come to terms with the

physical confines of the planet on which we have been provided life for so long. Globalisation, in all its guises, is certainly not so threatening as simply to symbolise the limits of our physical growth, while opening up the boundless potential of the cooperative human spirit. A radical reorientation of emphasis is needed if we are to be assured of a sound future on this planet. To attain this new emphasis requires a paradigm shift in our current thinking. It is not a question of seeking to hinder what humankind can do or currently does, but rather rethinking the reason for and the way of doing almost everything. Instead of seeking the most for ourselves as individuals, we might do better by relearning the idea of the systems perspective. The paternalist paradigm that has supported domination and Newtonian reductionism must be replaced by a more cooperative, inclusive and sympathetic systems approach that applies to all things on earth if we are not to invite our own extinction. Above all else, this might be the greatest challenge facing humankind, as we prepare for the rapid and inevitable transformation that has the potential to destabilise our own species and perhaps that of all known life in the universe.

Such a change of thinking cannot be expected to arrive in an instant. Humankind's capacity for change is far from effective. Our instincts have taught us to resist change, fearing the loss of comfort and stability provided by existing practices, no matter how devastating these might be to our health and the health of the planet. This is why we find some industries resisting change, as they

persevere with practices that continue to bring harm. Literature from one industry representative body in the US still states that 'contrary to public opinion, there is plenty of inexpensive landfill space available, significantly reducing the cost of disposal in some areas'. Change, although always unavoidable, is always incremental.

This book was conceived at a time regarded by many as being a period of change in environmental perception among the general public. A period of time in which our environmental concerns have become less significant. The broader picture, however, might suggest something very different indeed. Understanding of environmental issues has reached a critical stage of development within the public realm. This period of environmental 'awakening' might now be seen as drawing to a close. It might be remembered as a period of consolidation for the myriad of issues and complex, often contradictory information that we received regarding the state of our environment during the 1960s through to the late '80s. We are now in a period of response whereby we should be implementing that which we have learnt in order to achieve a quality of life that is not in any way detrimental to the environment around us. It is therefore of great importance that those extolling the virtues of a 'greener' way of life do so with simplicity and guidance.

This is one aim of this book, which offers a wide range of samples in the field of packaging that have in some way helped reduce the environmental burden caused by our current unsustainable living. Each sample cannot possibly provide all the necessary solutions to all the inevitable problems, but rather each might be seen as a step in the right direction. They have been chosen for daring to change and for making a significant improvement on what came before them – daring to think differently and rethink the boundaries of design, manufacturing and distribution to produce better results for all parties, no matter what their goals.

Each design therefore must not be seen in isolation from its own context, but part of the process of refining and improving our capacity to reduce environmental impact. This book does not provide rigid, prescriptive solutions to individual packaging problems, but is one facilitator among many in a long and complex process of change that we need to encourage. The samples are not chosen on their own separate merit, but on their capacity to embrace a systemic approach to environmental problems. It would be wrong, therefore, to assume that the positive attributes of one sample could not be utilised in a completely different field of design, manufacturing or distribution. In the light of systems thinking it is precisely this wider, more open-minded approach that leads to more effective design innovations. This, indeed, must be the essence of design: problem solving at the highest level of systemic thinking. Without this view, our solutions too often only serve to create greater problems elsewhere. It is time to rethink our approach to design so that at no point in the life or death of any of the things we create do we permanently degrade, exploit or abuse the state, well-being or health of any other life form.

Though this might not be totally true of many designs featured in this book, all can be seen as a start. For many, this might be seen as one point from which to begin. Much ground has been covered before us and so there is plenty from which to draw inspiration and guidance. Although packaging is far from being that which will drive us to the brink, it is highly symbolic of the wasteful lifestyles that we lead and an integral piece of the system on which we currently rely for our living. Therefore in this light it could, along with so many other things, be regarded as the 'straw that broke the camel's back'. To ensure that this does not happen is vital for humankind, for without the environment all else is impossible. The genius we have acquired in areas as diverse as space technology, genetic engineering, medical science, microbiology, nanotechnology and information technology, along with all our financial and political institutions will all be lost if we do not first learn how to preserve the environment.

'The fight against pollution cannot be successful if the patterns of production and consumption continue to be of a scale, a complexity, and a degree of violence which, as is becoming more apparent, do not fit into the laws of the Universe, to which man is just as much a subject as the rest of creation.'

E.F. Schumacher, *Small is Beautiful*, p.247

THE RISE OF ECOLOGICAL CONSUMERISM

Though the principle of packaging has changed little over the centuries, in recent decades its role has greatly increased in scope and complexity, along with global trade and consumption. These developments have seen the role of packaging grow from being a largely functional product requirement to an intensely heterogeneous and sophisticated industry. This accelerating developmental trend is likely to have a significant impact both for society in general and for the design profession. For society, increasingly globalised production and manufacturing will necessitate further advances in transportation and logistics, while the nature of consumption processes are changing the way we carry out commerce – with the onset of e-trading, for example. The designer will experience an increasingly complex and also multidisciplinary field in which to practice, requiring greater flexibility and crossdisciplinary awareness and interaction with other professions.

These changes may be seen as a continuum of many evolutionary trends that, for the packaging industry, have forged major transformations to keep apace with contemporary consumer demands and legislative requirements. Few recent trends in the industry have had such a significant impact as those in the domain of environmental responsibility.

The discernible evidence of increasing environmental degradation due to industrial malpractice in our quest for development has intensified the need for greater accountability and responsibility from industry. Perhaps no other industry has faced such public scrutiny as that of packaging. The visual impact of discarded packaging and mounting piles of waste together with our daily interaction with over-packaged products, makes the packaging industry an easy target as a significant contributor to the increasing degradation of the environment. Packaging, as litter, imparts considerable guilt on the consumer, as it reminds us how much we discard, and, as a potent symbol of our 'throw away' culture, it should serve as a constant reminder that things could, and should, be a lot better. After a decade or so of emerging self-reflection, there are signs that suggest we may be on the cusp of significant change.

The consolidation of early consumer environmental awareness throughout the late 1960s and early 1970s bore some fruit by the 1980s. These decades were marked by a significant arousal of environmentalism in popular youth culture and academia. In addition to the horrors of war and famine being broadcast into our homes, there also

9

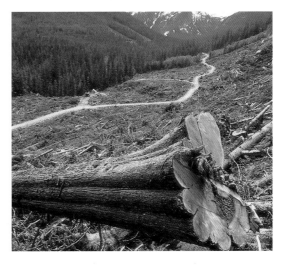

Clearcutting of Canada's temperate rainforest, Vancouver Island, 1997 (above). Image courtesy of Greenpeace.

Illegally exported German toxic waste dumped in an apple orchard in Sibiu, Romania, 1992 (left). Image courtesy of Greenpeace.

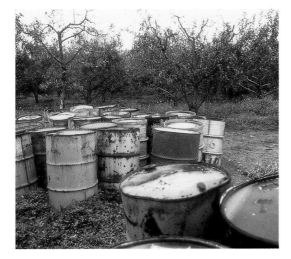

appeared something deeply wrong with the natural world that we had inherited. The very environment on which we depend was bearing the brunt of our failure to live peacefully and cooperatively. Despite these early flourishes of environmental consciousness, it was not until the late 1980s, following a period of significant global economic prosperity, that the general public finally awoke to the signs of widespread environmental destruction and a broad questioning of prevailing consumerist lifestyles. Our opulent lifestyles were being blamed for emerging ecological catastrophes such as deforestation, the greenhouse effect and ozone depletion. Such signals could no longer be ignored and the ecological agenda became firmly etched in economic, political and social ideology.

India; Exxon Valdez oil spilt off the coast of Canada; the creation of the ozone hole occurred; and reckless fishing techniques became widespread – these could all be seen as the inevitable consequence of humankind's unmitigated desire for development, whatever the cost.

The local consequences of economic demands were, at the same time, becoming apparent globally. Entirely new scientific diagnoses of catastrophic environmental problems were being brought to the public's attention and provided the public with identifiable consequences and prognoses of their irrepressible activities. Emerging media networks, that left no stone unturned, broadcast these disturbing scenes across the globe. Consumers were no longer able to turn their backs on the

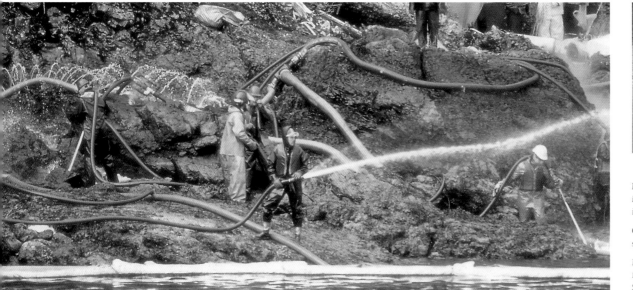

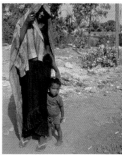

Family living on dye waste dump in Vapi, India, 1996 (above). All images courtesy of Greenpeace.

Clean-up after Exxon Valdez oil spill in Alaska, USA, 1989 (left).

Dead sperm whale trapped in an illegal Italian drift net in Mallorca, Spain, 1993 (facing page).

Western societies reeled in the fallout caused by their own avarice, as a string of major environmental catastrophes in the space of a decade underlined the severity of the world's environmental problems. Droughts occurred on a scale never previously experienced, as millions died in famines in the Horn of Africa; the fallout from the nuclear disaster at Chernobyl reinforced our naivety in dealing with this potentially catastrophic method of harnessing energy; logging of the world's rainforests together with continued burning of fossil fuels was threatening the balance of carbon dioxide in the atmosphere causing global warming; forests and waterways were being destroyed from acid in unregulated industrial emissions; chemical spills killed and injured thousands such as at Bhopal in

consequences of their consumption. The world finally woke to the calls from nature that something very serious was wrong.

Early forecasts suggested that these damaging activities needed to be significantly changed if we were not to alter irreversibly the systems through which the earth provides life. Such activities are fuelled by unrestrained development, founded on and promoted by economic rationalism, which remains the driving force of the capitalist system in place for over three centuries; three centuries in which our overriding perceptions have been moulded by a Newtonian, mechanistic, view of the world, a world in which all things operate as clockwork, where the whole is no more or no less than the sum of its parts.

By understanding the individual parts it was thought that humankind could gain dominion of the whole. By placing such a disproportionate significance on material wealth for the fulfilment of the individual, other equally important factors such as spiritual development, care for the environment and care for one another have been systematically ignored. Indeed, anything that cannot be deemed economically viable is deemed unsustainable or irrational.

The pace of change that occurred in the early 1990s was swift in accommodating the increasingly stringent demands of a new, 'eco-friendly' consumer. Companies began producing packaging made from recycled materials; entirely new product lines were conceived, based on this new environmental consciousness; individual products and materials were hounded if they did not conform to this new methodology. Chlorofluorocarbons (CFCs) were banned as a propellant in aerosol cans; PVC began to be dismissed for its leaching of chemicals; chlorine-bleached paper was overshadowed by the natural shades of new 'recycled' papers; rainforest hardwood timber for furniture or as a construction material was considered as distasteful as fur clothing; opposition to drift-net fishing forced tuna packaging to bear the seal of dolphin friendliness. Consumers were, for the first time, being exposed to the complexities and contradictions of the environmental agenda. The realisation was dawning that we were part of the problem as well as being empowered to provide the solutions. Although more a matter of perception, 'green' issues were no longer confined to the realm of the eccentric hippy. Environmental concerns were at last reaching the mainstream. People were not only buying green, they were voting green. Public opinion finally reached a critical mass that forced the environmental agenda onto the international political platform with unprecedented popularity.

These sentiments manifested themselves in the 1992 Rio Earth Summit – the first ever meeting of global heads of state to address the mounting global environmental crisis. The world's industrial nations were called upon to clean up their act or face the consequences of environmental collapse. Since then, subsequent gatherings have proven largely impotent and illustrate the power of industry over the democratic process.

Unfortunately these sentiments were brief; the products often failed to satisfy the environmental criteria they claimed to fulfil, and the political promises fell short further still. However, the seed was sown for greater developments in critical

environmental theory and for a greater underlying awareness of the implications of our lifestyles. 'Think globally, act locally' became the popular rallying call of this era.

The packaging industry made significant changes to the way in which it had operated previously. Entire product ranges were forced to change in very short spaces of time. For example, the abolition of CFCs necessitated entirely new methods of packaging and dispensation of liquid products. These early legislative requirements may be seen as both the cause and effect of technological improvements that have persistently provided greater efficiencies in packaging, such as light-weighting, the use of composite materials, more effective recycling and improved design. These efficiencies not only benefit

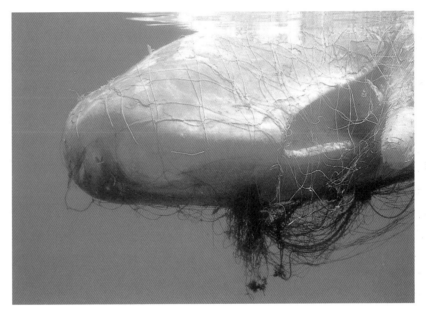

'To bring it down to the basic concept, we must build up areas liberated from the industrial system. That means, liberated from nuclear weapons and from supermarkets. What we are talking about is a new social formation and a new civilisation.'
J. A. Palmer, *Fifty Key Thinkers on the Environment*, p.269

the packaging waste stream and reduce its environmental impact, but they also pass on considerable economic benefits.

The mutual benefit to long-term environmental consequences plus long-term economic outcomes can be seen as a significant and ongoing success for the packaging industry. It is vital, therefore, that the momentum established by these early environmental successes are not lost to subsequent waves of economic and consumer rationalism. In the field of packaging, the designer, as creator and innovator of new concepts and environmentally responsible products, must remain diligent in ensuring that the footprint left by current practices does not prevent future societies from receiving the same benefits and standard of lifestyles that we assume today.

The environmental footprint of most Western countries still remains far from sustainable. It is estimated that even in relatively small and 'green' countries such as the Netherlands, their footprint requires a landmass 14 times their size to satisfy domestic consumption (W.E. Rees, see Bibliography). The UK still landfills 150 million tonnes of waste each year (equating to nearly 3 tonnes per person), of which at least 3 million tonnes is recoverable packaging waste (from INCPEN, see Useful Addresses). Humans produce more than three times the sulphur dioxide and more than twice the nitrogen dioxide that is produced by natural processes (P.M. Vitousek, see Bib). These figures alone prove that the lifestyles we lead and the processes required to maintain and support them are leading us towards an uncertain and even tumultuous future.

THE CALL FOR AN EVOLUTIONARY SYSTEMS PERSPECTIVE

Concern for the environment, as has been briefly illustrated, can hardly be regarded as a contemporary theory. Many societies throughout history have managed their environment with impeccable devotion, with some proving more successful than others. The Aborigines are one of the most successful of these. Having survived for 40,000 years managing and adapting their environment with enduring diligence, they can perhaps be regarded as the true masters of sustainable living.

In contrast, contemporary Western societies might be regarded as anything but sustainable. In a comparatively short space of time we have come from the grasslands and forests as humble hunter-gatherers to become the most developed and complex societies on earth. This accelerating pace of change is an important feature of our journey through time and increasingly challenges our abilities to cope with complexity. Such accelerated development has arrived at a cost, as we now face systemic collapse of the many life-supporting systems that have for so long provided us with nutrients, shelter and security. Coping with this increasing complexity can be seen as one of the key challenges of our time.

It comes as a worrying reminder, therefore, that when modern societies come in contact with the ancient and enduring cultures of the world, we do little to enhance or improve their evolutionary potential. The evolutionary conclusion facing the Aborigines of Australia is no exception. This is not to suggest devolution back to our hunter-gatherer roots is required. In fact quite the opposite is true. If we learn from evolutionary systems theory, it is understood that just two outcomes are obtainable from an evolutionary juncture – one extending towards progress and increasing complexity, leading to greater evolutionary development, the other leading us to stasis and devolution, leading eventually to systemic collapse. Without the capabilities of dealing with complexity we appear to be heading for the latter.

Many would argue that today our globalised society is at this juncture. It is up to us as a highly advanced and conscious species to choose the path we wish to take and ensure that our designed responses to the challenges we face are both appropriate and enduring. It is we and we alone who have created an abundance of social and environmental problems, and therefore solutions can only come from us.

The reality for us is that if we were to come through this process having learnt to deal better with such insurmountable challenges, we face the very real possibility of achieving further evolutionary development, bringing greater

understanding, forbearance and cooperation. This transcendent path has always moved in the direction of higher levels of order and self-definition. A newly coalesced society forged within the confines of our own global boundary might be better suited to deal with these higher order problems facing our species and those with whom we share this planet. Globalisation in this light is certainly a desirable and inevitable process, but can only work effectively when all essential systems are sustainable and a greater degree of equity exists amongst these systems.

'What has this to do with packaging?' This will become clearer, but the complexities surrounding packaging and the many arguments for one form over another often detract from the fundamental principle at stake. This calls for a need to focus our

will achieve lasting success in the form of sustainability, rather than focusing on shorter-term goals which are likely to cause greater problems over time.

Economic rationalism is inextricably tied up in contemporary, reductionist thinking. With its goals founded on the objective of increased profit, it makes little economic sense to 'care' for our environment – or indeed for anything – not at least until it threatens not to sustain life any longer. By this stage it is often too late to implement practical measures aimed at solving problems. There is a need to redress this imbalance and understand that economics is a vital and valid part of the web of life that humankind has created, but only in balance with the myriad other things in life, such as politics, ecology, sociology, psychology, creativity and

'System science can look at a cell or an atom as a system, or it can look at the organ, the organism, the family, the community, the nation, the economy, and the ecology as systems, and it can view even the biosphere – the Gaia system – as such. A system in one perspective is a subsystem in another. But the systems method always treats systems as integrated wholes of their subsidiary components and never as a mechanistic aggregate or parts in isolable causal relations.' E. Laszlo, *Evolution: The General Theory*

13

attention more closely and accurately on the problem at source rather than plugging the leaks further downstream. This is the vital point to establish at this stage. This book advocates a systems perspective to view this problem, with evolutionary thinking as a basis from which to seek more enduring and lasting objectives, while also being able to assess the inherent failings of others. An endearing quality of this approach is that it transcends much of what is taken for granted or assumed to be correct simply because it is the norm. Through a clearer understanding of the past we might better identify the patterns and means by which to create a brighter future.

This thinking enables us to look beyond contemporary reductionist thinking, allowing us to view situations with greater clarity and truth. This new perspective, like any new experience, will bring uncertainty, but by adhering to a systems framework, we are given the means to live with and manage uncertainty. With our sights set on such goals we can begin to seek the solutions that

spirituality, that share equal importance. Redressing existing imbalances by fostering other areas of human activity will inevitably be a priority if a more holistic approach is to be sought.

The packaging industry is one microcosm of these larger, higher-order systems that operate in the world. It is a member among the many subsystems that constitute the world in which we live. It therefore carries its own unique responsibility in ensuring that it does not degrade other systems with which it interacts and relies on. Systems thinking does not allow a cessation of responsibility at the boundaries of other subsystems, but rather extends responsibility throughout the entire range of extensive links and chains of interactions between and beyond each component part. This raises important implications for dealing with complexity and managing change. In the context of packaging, a material or process that is seen as preferable to another on an individual level is highly undesirable when the transportation of raw materials, manufacturing

processes, disposal and pollution from wasted resources are considered.

A key argument often used to support the virtues of packaging highlights the amount of wastage caused by a lack of packaging in countries where distribution networks are not as advanced as those in the most developed countries. The figures for food wastage are between 30–50% and 2–3% respectively. Reductionist thinking would conclude that the former is a terrible waste. However, the importance of systems thinking highlights how the problem would be further confounded if these countries were to have the modern distribution networks in place to transport, store, refrigerate, and dispose of all the food and packaging material that modern distribution networks use. A loss of food is considered improper in economic terms, but the lifestyles that are part of this system are very much less demanding on the environment in most other ways and therefore far outweigh the sole issue of food waste.

For example, plastics consumption per capita in the US in 1999 was 100kg, whereas in Africa it was just 6.5kg (from the Verband Kunstofferzeugende Industrie, see Bib.). The additional costs in producing, processing and distributing this plastic provide a significant additional burden to the environment. This is not to say that packaging, or specifically plastic packaging is not vital, it simply must respect the environment in which it is used. If food cannot be distributed over long distances then it is grown more locally and tends to be grown on the basis of demand, with bulk storage compensating for the fluctuations in yields that naturally occur.

Systems thinking provides an understanding of the more holistic dimension to the problems that we face when making better sense of complexity. One practical outcome of systems thinking is the development of Life Cycle Analyses (LCAs), though these are not immune from simplified analysis.

The Life Cycle Analysis of a product or package is the process through which all the environmental effects resulting from its production can be fully identified and understood throughout every stage of the product's life. Each stage is measured and analysed for the effects that it has on the environment, and therefore any inefficiencies or waste streams can be identified and at best eliminated, or, at least, fed back into the system where such waste can be treated appropriately. LCA has flourished in the past decade due to many companies embracing a more holistic approach to the inputs and outputs that result from their commercial activities. LCA

software allows a company to assess very practically what stages of those inputs and outputs are wasteful and polluting. These can then be corrected. It is becoming increasingly critical that these mistakes are prevented in the first place, as the damage inflicted on the environment is now so severe that it will take very few additional burdens to destroy irrepressibly the ecosystems that sustain life in that region. It is only a matter of time before the same process threatens the larger ecosystems supporting life on this planet. The oceans and bio-sphere are already showing signs of irreversible damage and socially and economically we are already paying the price for altering this almost eternal balance.

Despite humankind's far from commendable environmental record, we must remain optimistic if we are to believe a better future is obtainable. Humankind has come a long way in developing the environmental improvements that previous generations established, although the primary problem in relation to these improvements is that while improvements are being made, the rate of production is accelerating almost exponentially. The overall outcome for the environment, therefore, remains grave. With 10% of the world's population consuming over 80% of its resources, we are not ideally placed for achieving sustainable living. The fact that developing nations are understandably striving to achieve a similar standard of living as the top 10%, we cannot afford to develop along the same trajectory that we have been used to over previous centuries. This would require a further 5–10 fold increase in the world's economic output (W. E. Rees, see Bib.). Since World War II the increase in fossil-fuel consumption alone has risen by a factor of 25.

It can be argued that an evolutionary leap is required if we are to avert long-term catastrophe. This may be likened to the fundamental changes that occurred during the Industrial Revolution, facilitating a restructuring of our entire social and technological framework and abating our appetite for development founded on the consumption of non-renewable resources. Many would believe such a time to be upon us, with the dawn of information technology leading to much less energy and less materially intensive means of production. With information being the prime commodity of the 21st century, this might revolutionise the way we lead our lives. With the continued miniaturisation of products and a greater emphasis on the virtual medium, there is plenty of scope for a significant decline in the need for raw materials and energy-

intensive means of production and distribution.

Any evolutionary transition, of course, will not be smooth. Transitions bring change, and this brings uncertainty, which in turn can lead to periods of chaos within systems. This need not insinuate any apocalyptic scenario. More optimistic outcomes are not only desirable but also easily obtainable in these periods of critical instability. Such occasions are often breeding grounds for innovation and creativity as we are forced by necessity to seek solutions to the problems at hand. Our greatest strength as a species is our ability to learn and adapt to new circumstances. The process leading up to this transition started a long time ago, but it has undoubtedly accelerated in the last few decades. In this respect, we have much to draw from previous pioneers in environmental movement that have paved the way for greater acceptance, understanding and adherence to a greater depth of environmental theory. Without such pioneers we would be far from where we are today. We would not have the environmental

legislation in place that we have today; we would not have the information support tools to help us assess and prevent the damage that we may have otherwise made with previous techniques; we would not have the systems in place to assist in resource recovery and recycling; we would not have the specialised expertise and technical support used to assist in maintaining and improving the many processes of manufacturing, transportation and disposal and we would not have the cognitive tools on which to base new theories and patterns of development and improvement. We clearly owe much to those that have worked so strenuously in the past to achieve the momentum that the environmental agenda has today.

By providing a wide range of environmentally sound examples of improvements in the field of packaging, it is hoped that this book will help facilitate the continuation of this momentum in its own small way. Sustainability might be remote, but failing to achieve it would indeed be inviting the unthinkable.

THE ROLE OF DESIGN

The statement about designers on the following page, from Victor Papanek in 1971, might now be construed by many in the design fraternity as somewhat antediluvian. Over 3 decades later, what should be most alarming about the content and delivery of this statement is how little has actually changed since this time. In fact things might be seen to be far worse. Papanek goes on to adjudge that, 'as long as design concerns itself with confecting trivial "toys for adults", killing machines with gleaming tailfins, and "sexed-up" shrouds for typewriters, toasters, telephones and computers, it has lost all reason to exist'. If he were alive today he would doubtlessly be dismayed by the institutionalisation of adult toys in Expos titled with bold masculine epithets such as 'Big Boys Toys'. The tailfins on our 'killing machines' have long since been replaced by the more acceptable 'sexy', 'organic' curves that have permeated every design discipline from hi-tech gadgetry up to modern city skyscrapers in an attempt to soften the hard-hitting techno-imagery of mid–late 20th-century design. As for the '"sexed-up" shrouds' on our domestic

and commercial equipment, many computer and electronics manufacturers have proven to us that this old trait is alive and well, persuading the consumer again that form stands steadfastly in front of function. Brightly coloured semi-transparent plastic shrouds serve to envelop our products, symbolising the age in which we live. Transparency is the watchword of this generation, assuring us of the supreme trust that we have in our institutions. This transparency does little for unpacking the guts and the dirt to be found in the workings of all things, and instead is used to reinforce the fact that we live dangerously in a world that places style well before content. We are little closer to solving the world's problems today than we were when design was first becoming recognised as an autonomous and credible profession. By virtue of the fact that we have designed so many more problems since this time, we might be seen to have stepped backwards in our quest for development. Indeed, this very quest for development within the bounds of our current materialist thinking, completely ignores the reason for our existence.

Design itself, as a purposeful, conscious effort to establish order from chaos, replicates almost exactly what evolution is constantly doing to all matter. In seeking evolutionary lasting principles for design it might be deemed essential to rethink the human purpose.

This has brought us to a troubling paradox in design. If we leave things as they are we face certain failure, though recent history dictates that any changes we make are likely to be to the detriment of the broader society. To move forward in terms of design requires a change in the way we think. Past practices, being firmly rooted in the mechanistic paradigm have proven to be limited in their capacity for providing enduring solutions for the benefit of all. If we were instead to embrace the metaphor of the living organism in our work we might sooner arrive at those solutions that do not satisfy the isolated, self-oriented goal of material wealth and acquisition, but seek to fulfil the human purpose of which we are all a part. It is in all of our interests to build a society that benefits all, as we are all inescapably part of the human society.

There are many areas in which we have established greater environmental sensitivities which could lead to improved design frameworks in the future. We have created embryonic systems that will, in time, support the bewilderingly complex design processes that allow products to be fully conceived, manufactured and tested before a single machine tool has been worked. Internet-based tools such as virtual-reality prototyping and interactive computer-aided design will redefine the real values of globalised information networks.

The ability to test every element of a product's impact before it has been manufactured offers great savings in materials and resources. The support tools to assist designers in making the right decisions will offer enormous efficiencies in terms of time and effective product development. However, it is important to note that all these things are only tools. Regardless of their complexity or the scope of their artificial intelligence, the ethical and moral basis on which all design decisions must be built has to come from designers. This will always remain a uniquely human experience and one that will always determine the outcome of the design process, for better or worse. To ensure that this is achieved requires an inevitable crossdisciplinary approach to our work, bringing with it a greater understanding of one another's contributions in a complex and extensive design process. No one task can be seen as exclusive, as all are vital to the ultimate success of the derived outcome. Generalists and

'By creating whole new species of permanent garbage to clutter up the landscape, and by choosing materials and processes that pollute the air we breathe, designers have become a dangerous breed.'

V. Papanek, *Design for the Real World*, p.ix

specialists alike will be required to bring their unique and vital skills to bear on a project.

This is as true in packaging design as it is in any other design discipline. The key issue for designers in these changing times is that of their role. The designer has often been considered something of a go-between, servile to the client's demands and inhibited by the manufacturer's capabilities in the lengthy process that forms between the critical figures in a product development team. With skills in and an understanding of most areas of the production process, the designer might often be regarded as Jack-of-all-trades and master of none. It is emerging that such a role is now changing.

The multiplicity of factors involved in the design process could appear truly daunting. Highly specialised teams involving technicians, nutritionists, materials specialists, engineers, designers and marketers all take part. Design teams no longer rely on individual designers working into the night to come up with the next packaging innovation to hit the shop shelf. The call to simplify the package, concentrate the product and reduce the space surrounding it, requires a confluence of professional input.

The design generalists, having a broad understanding of the key components of the production processes together with the skills to contribute at their every stage, might readily find themselves being vital negotiators and facilitators within this production system. All the samples in this book are the result of these extensive and often costly processes that have encompassed research, development, design, manufacturing, distribution and disposal. Without careful consideration at each of these stages, those involved in the design and production process will be without vital information that could ultimately jeopardise the outcome of the product or package.

Without this collaborative crossdisciplinary effort, it would have been impossible to have made so many long-term improvements to so many of the packaging systems that we now take for granted, such as recycling systems, the lightweighting of items, the slimming of the drinks can, better transportation systems and greatly improved materials technology and understanding. Even countries that are largely isolated from global economics are changing their thinking towards more ecologically minded solutions. One company in China has established itself on the production of starch-based products and is already producing 5 billion chopsticks and 3.5 billion food containers to satisfy part of the demand for an estimated 12 billion disposable chopsticks and 10 billion food containers that the Chinese use each year. By using over 200,000 tonnes of sweet potato, this operation is also expected to benefit over 100,000 rural workers, providing an excellent example of further good coming from positive design change.

The very problem with previous notions of 'designing' was their fundamental lack of deep-rooted and purposeful design thought. Design, in all its guises, cannot have regarded the solving of problems to be the primary basis on which to instigate change or else we would not be facing such critical problems today. Conscious, purposeful change relies on a longer-term and more holistic perspective that has gone largely unnoticed. It is hoped that this consciousness is soon realised so that a paradigm shift can occur which will open up our creative abilities for the fulfilment of the common human purpose. Rethinking the purpose of design is a vital first step.

Packaging has undergone significant improvements in weight and material use over the years, evident from these case studies (left and facing page). All images courtesy of the Design Council, far left image copyright of Eurographic Ltd.

PACKAGING SYSTEMS

The following systems have been highlighted as key areas in the realm of systems thinking in packaging design. Before illustrating the individual designs themselves, it is necessary to understand the systems currently in place that enable us to retrieve and reuse many of the resources utilised in the packaging industry. Without these systems much of what we produce today would be turned into waste. With these systems in place we are able to obtain the value inherent in every material again and again. The systems are explained in terms of their current technologies, though most are improving all the time, making cheaper and better-quality recycled material as a result.

'Throughout the ages, we have found that work on and with the soil has meant fertility, health and prosperity; but as soon as man began to exploit it for gain, or neglect it from sloth, fertility ceased, the life departed from the earth, soil erosion followed... with the result that once fertile country was turned into desert... and the process still goes on.'
M.E. Bruce, *Common-Sense Compost Making*

Aluminium and Steel Recycling

Metals are a popular packaging material, with aluminium and steel being the two most commonly used. Both are widely utilised in a broad range of packaging such as foils, food containers, spray cans, drinks cans and cosmetic containers. They are easily and frequently recycled, with many systems already in place to enable their efficient recovery from the waste stream. Both tend to be collected together and sorted at the processing plants, rather than relying on consumers to sort the material. The most effective way to sort these two metals is by using magnets, as steel is drawn to the magnet, while aluminium is not.

Aluminium is a relatively new material in the commercial sense. It is a chemical element that cannot be found in the earth in its pure form,

therefore extraction becomes quite a complex and energy-intensive process that takes aluminium oxide from bauxite and then removes the oxygen in a smelting process to produce aluminium. The recycling of this material is a relatively easy process which saves up to 95% of the energy required to refine it after original extraction. This significantly increases the need for keeping refined aluminium within the material stream rather than letting it become waste, thereby placing a premium on its recycling. As a very versatile metal, aluminium is being increasingly utilised in packaging products due to its significant weight-saving properties and its stability.

Steel is made from iron ore and coal and can be recycled without any loss of quality. It is estimated that over half the world's steel currently used came from scrap. Improvements in production processes and design have made steel much easier to produce. In the last 50 years the amount of fossil fuel needed to produce 1 tonne of steel has been reduced by 40%, whilst design improvements have meant that steel cans utilise 30% less material now than they did 20 years ago.

After the post-consumer waste metal has been collected, it is shredded into small pieces for further refinement. This process removes the impurities through a modern process using eddy currents, and separates the various metals by using magnets to divide the non-ferrous from the ferrous metals. Steel is attracted to the magnet and removed, while aluminium continues the process. All the remaining shredded aluminium is then heat treated at approximately 500 degrees Celsius in a process called pyrolysis, which further removes other remaining impurities such as paint, adhesives, paper and other coatings. These impurities are removed in a gaseous form or as a solid residue, which is sieved and used elsewhere in the process. Following pyrolysis, the material is then smelted into liquid form when it is reconstituted into ingots for storage before remanufacturing. In the early stages of the remanufacturing process the ingots are rolled into sheet aluminium, which is used to manufacture packaging or new products such as car components and construction materials. Other remanufacturing processes may include casting or extrusion depending on the requirements of the new product.

The Metal Recycling System

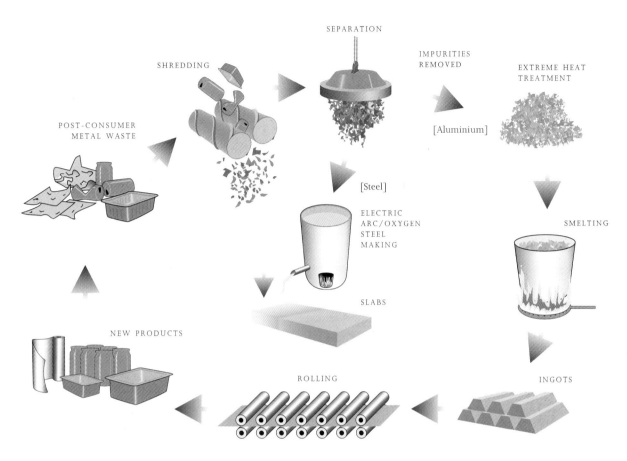

SEPARATION

SHREDDING

IMPURITIES
REMOVED

EXTREME HEAT
TREATMENT

POST-CONSUMER
METAL WASTE

[Aluminium]

[Steel]

ELECTRIC
ARC/OXYGEN
STEEL
MAKING

SMELTING

SLABS

NEW PRODUCTS

ROLLING

INGOTS

Meanwhile the extracted steel is passed through its own recycling processes, where there are two common practices. One is basic oxygen steelmaking which can use up to 20% scrap and makes up two-thirds of steel production, while the other is electric arc steelmaking which makes up the other third of steel production and can use 100% recycled material. Packaging is created from the basic oxygen steel-making process, where steel is created from pig iron through an oxidisation process utilising waste plastic packaging to cause the oxidisation. This process causes extreme heat and so scrap metal can be used to lower the temperature of the metal mixture. When molten, the steel is alloyed to achieve the various characteristics required by the final product, and it is then formed into slabs from which steel sheet is rolled for manufacturing new products.

Glass Recycling

Glass is an ancient, abundant and reliable packaging material, with a diverse range of colours, shapes and textures available from the manufacturing process. It purveys a certain quality that alternative materials such as plastic seldom achieve, therefore making it a common material in packaging luxury items such as perfumes, liquor and certain food ingredients, as well as being heavily utilised in other, more functional, packaging domains. Glass is a highly effective recycled material and a very stable, non-toxic material when disposed of.

Glass constitutes a relatively large proportion of domestic waste by weight, making up approximately 6–10%. Traditionally, the system employed to recycle glass relied on the consumer transporting used materials to local 'bottle banks'

where they are separated by colour before being collected for recycling and remanufacturing. However, as governments and local councils are becoming increasingly aware of environmental considerations and the potential to save or obtain revenue from used packaging materials, there is a greater level of door-to-door collection of glass.

Glass recycling is heavily dependent on the appropriate colour separation of the material. Clear glass currently accounts for nearly 50% of all recycled glass. It tolerates very little additional colour in the recycling process and therefore relies on either the purity of the recycled material or of new, virgin material. Green glass, however, is far more tolerant of additional colour variations and is therefore constituted of approximately 90% recycled material compared to just 30% in clear glass. For every 10% of recycled glass used in making new glass, up to 3% of the total energy can be saved, and furnace life is increased through lower temperatures required for manufacturing, compared with production from raw material. In addition to colour considerations, glass recycling must remove other impurities that are common in the waste stream such as tin plate, porcelain, ceramics, cork

and paper from labels, which all cause problems in the subsequent manufacturing process. If more than 5 grammes of metal is present in each tonne of recycled glass, the resulting melting process will produce an unacceptably flawed product.

The first stage of sorting is at the point of collection, where the consumer is required to place their used glass in one of three different sorting bins. These are then transported to a reprocessing plant where they are kept separately and crushed into tiny fragments. In the most sophisticated and advanced plants, additional colour sorting is carried out after crushing where the tiny fragments can be colour-separated by optical sensors. Other optical sensors remove impurities such as ceramics and porcelain by passing light beams through the fragments, where those objects that do not allow light to pass through are removed. Magnetic extraction and floatation are used to remove metals and paper or wooden objects respectively. The pure, separated and crushed material is then heated to a liquid in the melting process prior to being re-blown or moulded into new products.

The success of recycling glass is evident in the continual growth and development of the recycling

The Glass Recycling System

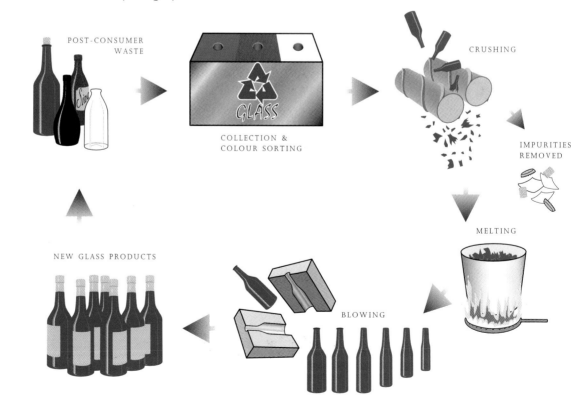

POST-CONSUMER WASTE

COLLECTION & COLOUR SORTING

CRUSHING

IMPURITIES REMOVED

MELTING

BLOWING

NEW GLASS PRODUCTS

industry that facilitates it. Since the inception of the Duales System in Germany in 1990, the percentage of all produced glass that is being recycled has risen from 53% to in excess of 80% today, a remarkable rise when compared to a figure of just 6% in 1973. Aside from the momentous achievements made by the recycling system, this may also indicate the declining use of reusable glass vessels. In order to encourage further gains in recycling, it is important to ensure a greater number of collection points or council collection services, as well as encourage the use of a greater proportion of green rather than clear glass. This is just one way to further the continued use of recycled glass over virgin material, thereby providing a demand that will continue to match the supply of recycled material. Too little demand in the current system has led to an over-supply of recycled material in some countries, such as Germany, in particular, which has stockpiles of recycled material which have been made redundant as a result of poor demand. It is essential that we continue to encourage the reuse of recycled material, such as glass packaging, in our new products in order to prevent the overuse and extraction of virgin material.

Plastic Recycling

It is hard to believe that just over half a century ago our lives were little affected by plastic. Today there are few areas of our lives that it has not infiltrated; from the packaging of our goods to the vehicles that transport us, plastic is one of the most remarkable material innovations of the 20th century. However, its enormous spectrum of uses poses a major problem to the way in which it is disposed of. A number of different options are available in dealing with plastic waste, though few can be considered close to sustainable. Incineration for example, does provide us with a source of energy and although some plastics have a greater energy per weight ratio than coal, the by-products of the incineration process are considered highly toxic and need filtering to prevent gases and heavy metals reaching the biosphere and other ecosystems.

However, certain plastics can be very efficiently recycled. Depending on legislation and infrastructure, various countries implement a wide range of different methods of recycling and choose to target specific types of plastics. A number of techniques are used to recycle these plastics and some

The Plastic Recycling System

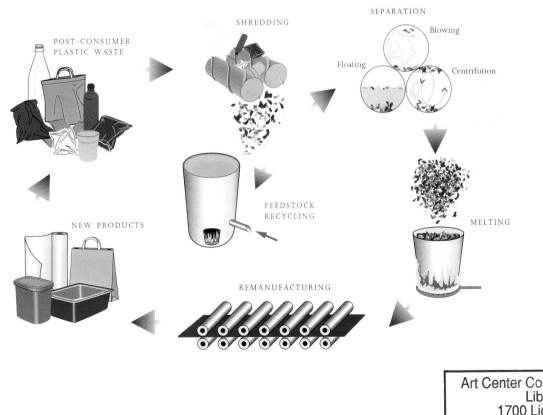

POST-CONSUMER PLASTIC WASTE

SHREDDING

SEPARATION

Floating

Blowing

Centrifution

FEEDSTOCK RECYCLING

MELTING

NEW PRODUCTS

REMANUFACTURING

countries embrace these to a much greater extent than others. There is little doubt that the most widespread system for recycling plastics in Europe is in Germany. The systems put in place in the early 1990s are now becoming highly effective and the technology used to sort, recycle and process all the waste material is becoming very sophisticated. In 1992, 41,000 tonnes of plastic were recycled. By 1996, 535,000 tonnes or 53% of plastic sales were recycled. Since 1997, more than 90% of plastic sold has been recycled (from the Duales System Deutschland, see Bib.).

The primary problem with plastics recycling is cross-contamination of resins. If one type of plastic is recycled with another it can significantly degrade the quality of the end product, therefore a careful process of sorting is required to ensure this does not occur. Two categories of sorting exist in the form of mechanical sorting and automatic sorting. Mechanical or manual sorting is used to separate the products according to their physical categories, such as bottles, cups, films, etc. Automatic sorting is used to sort the rest of the waste. The ratio between product-specific waste and mixed waste is usually 1:2 respectively.

The techniques used to sort plastic automaticallly vary depending on the types of waste. First the material is washed and then bags and films are removed using blowers or suction devices which separate the lightweight material from the heavier material. This is either done when the material is passed along a conveyor belt or when dropped from a height. Other techniques include emersion in water to utilise the polymer's specific density to separate the material. Centrifugal forces are then applied to the mix as it is spun in a cylindrical drum to allow the dense materials to separate from the less dense materials. The most modern techniques for sorting use infrared radiation, where different plastics reflect a specific light spectrum and are extracted by blasts of air, though this is still in its infancy as a method of retrieving material.

Once the materials have been sorted they can then be remanufactured using a number of different techniques such as extrusion, blow moulding and injection moulding, and reused in many different product applications including a wide range of packaging functions. Certain packaging functions do not allow the use of recycled material, particularly packages for foodstuffs. However, this does not detract from the wide range of possible uses for recyclate.

Another key use of plastic recyclate is as feedstock. Mixed plastic material is used in various industrial processes such as the reduction process which converts iron ore into pig iron. The use of this plastic recyclate replaces the need for oil in the reduction process. In this process the recyclate is fed into the bottom of the furnace at an extreme temperature and the chemicals in the plastic react with the oxygen in the iron ore, thereby extracting the oxygen from the ore to leave pig iron. Other materials that can be drawn from feedstock recycling processes include synthesis gas, methanol, paraffin, sulphur free oils and slag for roads.

Paper Recycling

The recycling of paper and cardboard is perhaps the most easily attained and longest standing of the recycling packaging systems. Due to the quantity of paper utilised by so many different industries, including packaging, the scope for a reliable and abundant material source makes paper one of the most effective recycled materials.

Technological developments, along with more stringent legislation, have resulted in significant improvements in the quantity of paper recycled, rather than landfilled. The advantages of paper recycling are manifold. The paper industry produces enormous quantities of paper on a daily basis in order to satisfy the needs of many different industrial sectors, while the packaging industry alone uses paper for anything from low-grade cardboard pulp for secondary packaging through to high-grade print papers for luxury goods.

For the paper recycling system to work effectively, a broad and efficient system of waste paper collection is required. The collection of waste may be part of the local council refuse service, or be provided at places of work or in public areas. Once there is an effective system of collection in place, the rest of the recycling system is relatively simple.

The waste paper is put into bails and taken to paper mills to be refined and remanufactured into new paper. Although different systems may vary in the methods they use to recycle paper, the most common system starts with the process of soaking. This process separates the individual fibres and pulps the material by mixing the paper with water and stirring. All the pulped material is removed from the water prior to cleaning. The cleaning process removes all the impurities from the pulped material by spinning it around in a conical drum. This process forces those items that are lighter than

22

The Paper/Cardboard Recycling System

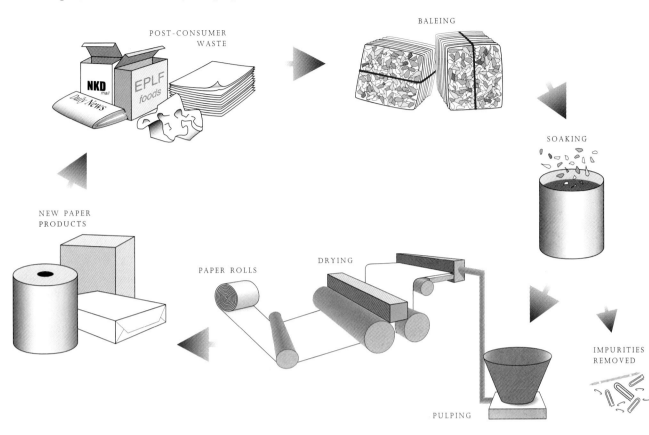

POST-CONSUMER WASTE

BALEING

SOAKING

NEW PAPER PRODUCTS

PAPER ROLLS

DRYING

IMPURITIES REMOVED

PULPING

paper to rise to the top, while heavier items are extracted from the bottom. Such items may include paperclips, plastic and adhesives. The next process is de-inking. This stage removes the many different inks that have been used in the waste paper. It may involve either a method of floatation, which washes the pulp with caustic soda and soap, forcing the ink particles to float to the surface where they are removed, or washing through the use of a mechanical process. After this the pulp is ready to enter the final stage where the clean fibres can be reconstituted into paper. The fibres are laid out on flat beds where they are put through a process of rolling, drying and smoothing when finally ready to be rolled up for reuse as paper.

The quality of the recycled paper depends entirely on the process and content of the material. Paper cannot be recycled forever. Each process reduces the fibre length, thus reducing the ability of the fibres to stick together without the use of further adhesives. Most recycled paper therefore requires a certain level of virgin material to be added to the mixture in order to assure a consistent

level of quality. However, there are many uses for 100% recycled material, particularly in secondary packaging and low-grade packaging requirements.

Returnable Packaging

Returnable packaging has faced a recent revival due to a number of factors including increased consumer awareness, increasingly limited space in landfills and a growing awareness at the commercial level that this system makes economic sense. Also, numerous light-weighting techniques achieved through improved design or materials and manufacturing technology have improved the environmental footprint of reusable packaging. There are essentially two methods to encourage the reuse of packaging. One requires a large enough market with standardised containers such as breweries, some soft drinks companies and the British milk delivery system. The second uses a financial deposit to encourage the consumer to bring the container

back to the point of purchase, where the supplier collects it for reuse. A system could also adopt both these strategies, as occurs in Finland. The financial incentive is most appropriate where the perceived cost of the product negates the desire to return it to the system. In communities where the perceived cost is very high, the system works effectively without requiring additional deposits on a container as it has a higher 'value' than other waste. In some countries this value can be converted to income when these materials are collected in bulk – a chilling augury for the 'developed' world, given its persistant disregard of the true value (as opposed to economic value) of the earth's resources.

As with all packaging systems, the reuse of containers has many positive and negative aspects. Reusing packaging is commonly considered to be preferable to recycling in the 'reduce, reuse, recycle' hierarchy, and it negates further energy use in reprocessing a material, as is often the case in recycling systems. The initial cost of manufacturing is therefore invested in that package until it is finally destroyed or recycled. The counter-argument to this method of packaging questions the considerable additional energy required in transporting these, often heavier, packages from the producer to the consumer and back again with the added consideration of energy and chemicals used in the cleaning process.

However, providing each unit is used often enough in its lifetime, efficiencies are realised. It is considered that each milk bottle used in the British milk delivery service is used at least 12 times and Finnish glass drinks bottles up to 50 times.

The system of returnable packaging relies on a complete cycle of collection, transportation and product distribution where the containers are collected locally then transported to the factory where they are individually washed, both inside and outside. This process removes the various impurities and contaminants such as labels, adhesives and old liquid. After this, the containers are refilled, sealed and rebranded ready for redistribution. Ideally, once the container has come to the end of its useful life, it remains in the system by being recycled and remanufactured into another container. The materials remain in the system and do not become part of the waste stream.

The Returnable System

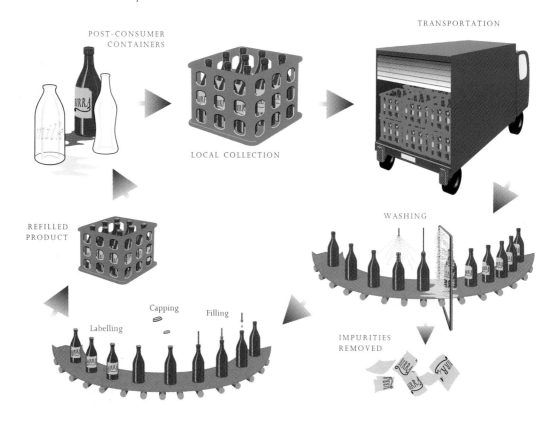

POST-CONSUMER CONTAINERS

LOCAL COLLECTION

TRANSPORTATION

WASHING

IMPURITIES REMOVED

REFILLED PRODUCT

Labelling Capping Filling

Refilling

Though this packaging system is no longer favoured in many parts of the world, it remains a vital and often fundamental part of commerce in certain areas of the globe, particularly in countries with less developed infrastructures and food distribution networks. This system, unlike the returning system, relies on the consumer returning to the point of purchase with their empty container and filling it from a bulk container delivered to the shop, thereby preventing the need to purchase a new product and package every time. This method dispenses with any temporary primary packaging and relies solely on secondary packaging and an established network of shops that sell goods in bulk. Without stiffer penalties for not using reusable containers, or higher incentives for using reusable containers, this system remains difficult to prove environmentally beneficial, as each container tends to be heavier, stronger and more resource intensive than disposable packaging.

The refilling system was used extensively during the 19th- and early-20th century as a means of selling a wide range of goods from basic foodstuffs through to cosmetics and medicine. However, its popularity is now confined to small-scale retailers such as organic or health food shops. The nature of the product is particularly significant in this system as it depends on produce that has a high turnover, such as dairy produce, or imperishable foodstuffs, therefore preventing extensive packaging waste. Modern health and safety regulations, and often personal standards, have prevented this method of packaging for more sensitive items such as medicines and certain foods.

Despite these contemporary consumer preferences towards hygiene, there still lies a potential for such packaging to be utilised in other retail areas that do not demand such strict standards. These might include the sale of certain hardware items and garden or home products. Unfortunately, the current distribution systems that serve the retail industry descend from a reductionist ethic, placing a disproportionate level of attention on the individual item. In this light, this refilling system is often deemed unworkable and inefficient. Instead, we appear to have opted for a system whereby each

Refilling

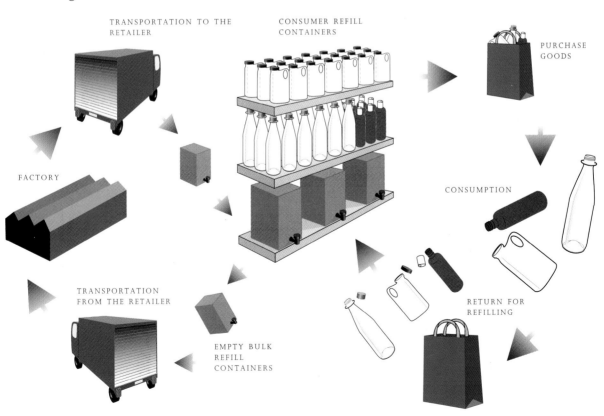

TRANSPORTATION TO THE RETAILER

CONSUMER REFILL CONTAINERS

PURCHASE GOODS

FACTORY

CONSUMPTION

TRANSPORTATION FROM THE RETAILER

EMPTY BULK REFILL CONTAINERS

RETURN FOR REFILLING

and every item of fruit or vegetable is wrapped in plastic to maintain an almost perverse level of hygiene, which might be seen as satisfying superficial aesthetic demands more than functional needs. Despite nature's free, biodegradable and nutritious packaging, we still prefer to place artificial packaging over much of what we buy.

Not only do certain issues of hygiene conflict with this system but also product imagery and branding are given less of a priority compared to singularly packaged items. The job of the marketer, designer and advertiser is complicated when promoting a product with no chance of branding.

It is important therefore that, despite it relying on a certain degree of effort on the part of the consumer, this system be made efficient and easy to use, and adopt a style that is suitable to its function. The Body Shop has succeeded in this field by choosing a minimalist style of refill packaging.

Composting

The large-scale use of composting has not yet proved popular as a recycling process in many countries. Germany, Australia and the US are the first to embrace it, as it is a system that holds enormous potential. The EU considers up to 60% of its 2,000 million tonnes of household waste compostable. Composting relies on an efficient and effective system of material retrieval and end use. Though this method of recycling might be common on a smaller scale in many households, its translation into a viable large-scale industrial process remains problematic. The enormous quantities of composted material from industrial processes need to be deposited somewhere appropriate, so that the compost can be readily distributed for use. The material going into and coming out of a composting plant should not be transported over long distances, as the additional transportation causes further environmental burdens. As with all disposal methods, composting needs to be implemented close to both a suitable source of material and an appropriate user of the end product.

Composting is remarkably simple, requiring the vital elements of just heat and oxygen to begin the process of decomposition, as microorganisms decompose the waste materials. Composting sites need to be carefully prepared. Large amounts of methane, carbon dioxide and other chemicals are produced in the composting process which must be prevented from contaminating other eco-systems. Though a key source of nutrients for plants in small quantities, these chemicals can be highly toxic if

The Composting of Degradable Material

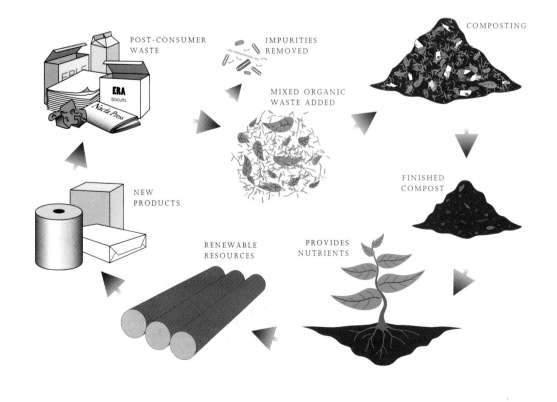

POST-CONSUMER WASTE

IMPURITIES REMOVED

COMPOSTING

MIXED ORGANIC WASTE ADDED

NEW PRODUCTS

FINISHED COMPOST

RENEWABLE RESOURCES

PROVIDES NUTRIENTS

concentrated. However, the composting process encourages materials to break down quickly and completely, therefore providing an invaluable alternative to landfills for our household waste.

In a composting system the discarded waste is collected and separated so that no contaminants impair the composting process. Appropriate materials are office waste, food wrappings and other applications where contaminated material might otherwise cause problems in other recycling systems. Other compostable industrial wastes are foods and liquid- or sludge-based materials. These materials cannot be composted alone but require natural green materials to aid the process.

Composting converts a balanced mix of organic compounds and green-based materials into a rich dark-coloured soil additive. Heat produced from this process ideally maintains compost at a minimum of 55 degrees Celsius for at least 15 days, though most organic recyclers leave compost for up to 16 weeks to decompose all materials fully.

Matured compost improves levels of organic matter and nutrients in soil and also its structure and moisture retentiveness. After a heat-generating composting process, weeds, seeds and pathogens are destroyed. One use of the compost is to provide the nutrients for trees in sustainable production of pulp for the paper or construction industries.

Reconstitution

If, for whatever reason, the systems of material recovery are not sufficient for the reuse of packaging in some other way, there remains another method whereby the material does not have to be lost to landfill or incineration. Reconstituting the recovered packaging material to produce other products not only prevents the permanent loss of material but also provides a cheap source of material for other markets. Though the use of reconstitution might apply to any packaging material, it is those materials that are in most abundance and have a reliable supply that are most appropriate for reuse. There also needs to be a positive reason for choosing recycled materials. For example: the cheaper cost of recyclate compared to extraction of virgin material; the quality of virgin material being comparable to recyclate; and the recycling and remanufacturing infrastructure accepting the recyclate. Certain plastics, glass, steel and aluminium all have potential for reconstitution. These markets still remain largely untapped while a great deal of potential lies in the cooperation between different industrial sectors linking these supply chains.

One important reason for this reconstitution to take place is the existing and unnecessary accumulation of waste material due to strictly enforced

Reconstituting Packaging

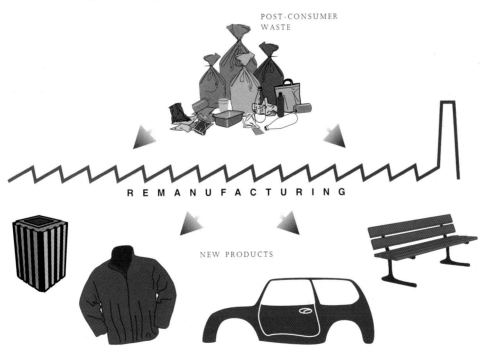

POST-CONSUMER WASTE

REMANUFACTURING

NEW PRODUCTS

recycling systems. Recyclate should be regarded as a valuable resource and will increasingly become so as virgin stocks deplete. All systems need to be closed loop, otherwise a build-up of material will cause inefficiencies in the process. This is currently the case in the recycling system imposed by the EU, where stockpiles of recyclate have no outlets as the demand for the material fails to meet supply. However, as is often the case during the early stages of complex systems implementation, the subsidiary systems on which the greater system relies are slow to adopt the sorts of changes necessary for overall success. Companies utilising recycled material are currently far outweighed by those contributing to it as part of their waste collection schemes. Despite the perception that this is a major failing of the EU waste management system, many people might suggest otherwise. The system itself has established the means by which material can be efficiently and effectively recycled. It is only a matter of time before industry and society accept recycled materials as on a par with virgin materials.

Despite certain indolence from many industrial sectors, examples abound where recycled material has become a vital part of a company's success. In many of these cases entirely new product lines have been established, creating new wealth and jobs in the most unlikely circumstances. Production of furniture, clothing (see page 31), jewellery, transportation products, construction materials, housing and even bridges are just some areas where discarded packaging materials have been successfully reconstituted to become useful, practical and often beautiful products.

EXAMPLES OF REDESIGNING PACKAGING

The scope of packaging can often go far beyond its primary purpose of product protection. In fact, it can often be a secondary purpose that determines the nature or form of the primary package. These are things that the designer should bear in mind as a means of extending the useful life of the material or manufactured form of the package itself. The following examples are just a few of the innovations that have provided life after life for some of the packaging that we commonly use. Some utilise the recycled material and reconstitute this to form other products, while others have relied on the innovative and creative skills of designers to give a different form to the package, to achieve a secondary use with ease.

'Everything has its use – and then another use.'

Eritrean proverb

Heineken

In 1960, Alfred Heineken of Heineken Breweries visited the island of Curaçao in the Caribbean Sea. Shocked by the sight of discarded Heineken bottles littering the beach, he began to think of a solution to the irresponsible practice of exporting products to countries that did not have the infrastructure to deal with the waste produced by imported goods. While each beer bottle in Holland is returned for refilling and lasts approximately 30 journeys in a lifetime, in the Dutch Antilles the bottle becomes worthless after the beer is consumed. This practice continues today, with the ten largest breweries in the world producing 100 billion bottles each year.

On returning to Holland, Alfred Heineken set about conceiving the first ever bottle designed specifically for secondary use as a building component, thereby turning the function of packaging on its head. By this philosophy, Alfred Heineken saw his beer as a useful product to fill a brick with while being shipped overseas. It became more a case of redesigning the brick than the bottle.

Early prototypes offered many different forms of bottle, all of which proved to be unworkable for reasons of manufacturing, functionality or construction. In terms of functional bottle design, a vessel needs a neck from which to pour the

contents. This sets the first design challenge of how to connect two bottles together with a protruding neck. The redesign this would require caused considerable concern outside the project sphere.

Such a radical departure from the standard cylindrical bottle could have major implications for Heineken's image as well as their manufacturing processes. Cylindrical bottles also tended to be produced faster and cheaper than other shapes of bottle, so a redesign of profile would have to justify itself in terms of cost. In a production run of 6 million bottles a day, any increase in manufacturing cost would soon add up. Cylindrical bottles also display the strongest overall characteristics required of a bottle, with square bottles being particularly fragile when laid on their side – the most likely orientation for a brick.

Finally, a simple design solution was reached that utilised the strengths of both the cylindrical and square bottle. The profile was flat on two opposite sides and slightly curved on the other two sides. It provided the strength of a cylindrical bottle with the functionality of a brick. The problem of interlocking the neck was solved equally simply, by designing a recess in the base of the bottle into which fits the neck of the other bottle. Each bottle could be bonded using cement and mortar with added adhesion provided by small protrusions on the flat surfaces. The result was an ingeniously simple design and a brilliantly rethought solution.

What followed was, sadly, a process only too familiar to those creative enough to rethink the boundaries of design conceptualisation. Despite manufacturing 50,000 of the two sizes of green-tinted Heineken WOBO bottles in 1963 and the filing of patent applications worldwide, Alfred Heineken's design became so beset with problems presented to it from outside the realm of functional design, it became unworkably compromised. The workable solution, which came from a radical rethinking of a problem in the form of a brilliantly simple bottle design, was an insurmountable leap for others in the industry. As a familiar and worrying example for those wishing to instigate positive change, Alfred Heineken, so disheartened by the recurrent obstacles aimed at his WOBO bottle, was forced to abandon the project.

All too often inspired ideas, concepts and suggestions are beaten back by an easy and simplistic barrage of reasons why not to do one thing, rather than encouraged by the helping hand of cooperation that works at a problem until the optimum solution is achieved and put in place. Anyone in the position

of actioning purposeful change would attest to the demoralisation caused by the inflexible and almost impracticable processes that hinder successful implementation. It is little wonder, therefore, that we are so often hindered by our own incapacity to change, and hence, face ever more critical problems as a result of our own ignorance and disinclination to transform things for the wider good. In the case of the WOBO bottle, Alfred Heineken can take heart from the fact that he will be seen as a pioneer in designing packaging for reuse – an example that is certain to inspire many others to succeed within this field.

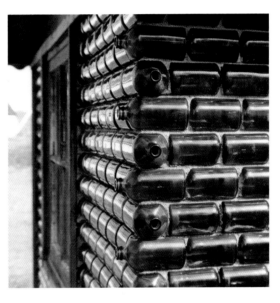

Completed building construction using Heineken bottles (left). Image courtesy of Alfred Heineken.

29

EMIUM

EMIUM has arguably succeeded where Heineken failed, having embarked on a new design of drinks bottle that would not be considered waste after its use, but instead become a valuable resource in a society where waste and waste management is becoming a major problem. The radical departure from conventional bottle design allows each bottle to become a building block that can be attached to others to fulfil a wide range of recreational or functional structures. The bottles can be attached to one another lengthways or sideways by pressing the protruding knobs of one into the cavities of another. By collecting a number of these bottles, the options for reusing each one and its valuable material become limitless.

These containers can be made using most machines designed for automatic bottling and they can be manufactured using any of the standard plastics used in making disposable plastic containers. Labelling, capping and palletising are also not a problem as the bottle's closure and transportation dimensions do not differ greatly from conventional bottles. The range of possibilities for bottle design is also extensive – work is being carried out on containers that take the shape of prisms, cubes and even cylinders.

The unlimited scope for different product applications might include children's toys or play houses, furniture, shelving, boxes, partitions or even floating pontoons. Bottles could even be filled with sand or other materials to build larger structures such as greenhouses or be used as garden paving, for example.

By redesigning the shape of the bottle the designer has provided entirely new uses to come from an otherwise squandered resource. Without this rethinking, the materials used in this product and the added value provided by the manufacturing process would instead be wasted. Indeed, for every brick that is used in the US, there are six bottles on the shop shelf. When scaled up to the trillions of bottles produced each year, this wastage can be seen as a major environmental concern. By adding value to a 'worthless' product, this design challenges people to rethink the way they treat wasted packaging and begin to understand the inherent usefulness which is provided by the original manufacturing process.

The EMIUM bottle has received the most prizes of any container in the world. Following a number of successes in Argentina, it received international awards from the World Intellectual Property Organisation; the 25th International Inventions Exhibition; the International Federation of Inventors' Associations; the Swiss Commercial Development Office award for environmental friendliness, and most recently, the World Packaging Organisation's WORLDSTAR award for innovative packaging.

Environmental Plastics of Puerto Rico

The increasingly wide range of products manufactured from recycled plastic is fuelling a growing demand for both the products and the materials that are created from plastics recycling. Waste plastic will often end up as litter or in landfill.

Among many different ways in which plastic can be recycled and different means by which it can be usefully reused, creating plastic wood stands out. This is one increasingly popular method of remanufacturing recycled plastics such as high-density polyethylene (HDPE). It is often used in heavy-duty, outdoor applications to replace traditional hardwoods, whose use is one key contributor to rainforest logging. As well as HDPE, other materials can be mixed into the recycling process to make composite materials for specific needs. These materials include wood fibres, glass fibres, rubber and other plastics. The possible uses for these materials range from park benches and signage to railway ties. It has positive attributes that often outweigh those of many alternative materials such as wood and metal. For example, plastic wood, unlike natural wood, does not decay, split, warp or splinter, and unlike some metals, does not rust or stain and is resistant to water, UV light, insect attack and extremes in temperature. As a result, the life expectancy of plastic wood materials is estimated to be in excess of 50 years, or up to 20 years for marine use.

As well as these physical attributes, plastic wood requires no ongoing maintenance like most other materials. This greatly reduces additional environmental burdens caused by sealing, painting or other treatment processes. Dyes can be used in the manufacturing process to colour the plastic, thereby obviating a lifetime of painting.

There are many companies that now produce recycled plastic material as a construction material.

Greenhouses and plant pots are two possible applications for this innovative bottle design (below). Image courtesy of EMIUM.

Environmental Plastics of Puerto Rico (EPPR) is one such company that has contributed greatly to the success of this recycled material. EPPR was founded in 1992, and developed large primate cages made from recycled plastic and fencing for the horse farm community in Puerto Rico. Despite attempting to establish plastic collection systems in Puerto Rico and neighbouring Caribbean communities, the constant and reliable supply of raw material was the greatest threat to success. This meant that EPPR could do little more than bail and grind a total of 100 tonnes of plastic for resale to US markets.

However, ongoing cooperation with the Caribbean Recycling Foundation, civic organisations, environmental groups and numerous municipalities meant that EPPR was able to establish Puerto Rico's first significant recycling program. EPPR was soon processing 1,350 tonnes of plastic as well as significant quantities of other collected materials, including glass, paper, cardboard and aluminium.

EPPR now manufactures fence posts, benches, plastic pallets, parking bumpers and railway ties that have been used in the Dominican Republic and Puerto Rican railroad systems. Such a large potential of market applications provides a great deal of hope for countries where plastic packaging and waste has no useful purpose and where construction materials are expensive and difficult to source. It is estimated that India alone uses 70 million railway ties each year, while the US uses up to 700 million for the maintenance of its railway network. At 90kg a tie that makes for approximately 1,200 used milk bottles for each tie – that is a considerable market for old plastic packaging!

Many other applications for plastic wood are available such as decking, children's playgrounds items, posts, flower baskets and street furniture, and as this material improves so will its physical and mechanical properties. Already work has been carried out to build larger constructions such as bridges and buildings with this material.

Patagonia

Synthetic fleeces have become a very popular garment, particularly with the steady rise of the travel industry over the past few decades. Crude oil has always been used to manufacture fleece material – until Patagonia became the first company to adopt post-consumer recycled fleece into their product line. Post-consumer recycled fleeces are manufactured from polyethyleneterephthalate (PET) soft-drinks bottles, which are a major resource in most countries. Japan produced approximately 360,000 tonnes of PET bottles in 1999 (from the Institute of Packaging Professionals, see Bib.) and the US manufactures approximately 4 billion plastic bottles each year, two-thirds of which end up in landfill.

By utilising this valuable material the manufacturing of these fleeces is not only diverting valuable resources away from landfill or incineration, but also preventing further use of virgin crude oil in manufacturing. The extensive cost of extracting and refining oil is becoming increasingly severe, and will continue as global stocks diminish. As new areas of the globe, previously untouched by the hands of the oil industry, are facing exploitation and potential ruin from oil drilling, there is a call for reducing our demand for virgin material by using as much post-consumer waste as possible. Utilising quantities of used crude-oil in the form of plastic is one step towards slowing the process of oil exploration down and dealing with the problem until more lasting alternatives are found.

From 3,700 recycled 2-litre plastic soft-drinks bottles, 150 fleeces can be manufactured. This saves a barrel of oil (190 litres) and avoids approximately half a tonne of toxic air emissions being released into the atmosphere. By utilising this largely untapped resource, Patagonia alone has diverted approximately 40 million 2-litre plastic soda-bottles from going to landfill or being incinerated. Equated to the use of a car, this comes out at approximately 10,000 refills of a 180-litre petrol tank.

31

A wide range of outdoor applications exist for plastic wood, such as garden furniture (below left). Image courtesy of British Polythene Industries Plc.

Fleece manufactured from recycled PET (below right). Image courtesy of Patagonia.

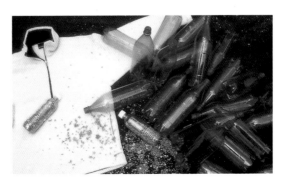

Bär & Knell and the DKR

There is an increasing need to find new applications for the plentiful resource of used plastics so that recycling programmes can be encouraged and buyers of the recyclate can be guaranteed. Without this guarantee, the collection systems have no incentive to collect the material and it gets stock-piled and becomes unwanted waste. In Germany it has been a long process that began from the first attempts to recycle using plastic sales packaging with the Green Dot, to the development of marketable recycled products. Now there is a wide range of products that has forged a complete change of image for recycled products, such as the design objects by German designers Beata and Gerhard Bär and Hartmut Knell made from used plastic packaging.

Bär & Knell were dissatisfied during the early years of packaging recycling, when the used plastic packaging with the Green Dot was processed only into products such as one-coloured drainage pipes, poles and flower pots. The designers sought a way of closing the loop by demonstrating that plastic waste is in fact a versatile material with a high potential for recycling and creating new products. Sponsored and supplied with the material by the Deutsche Gesellschaft fur Kunstsoff-Recycling (DKR) Gmbh, (sole guarantor for the recycling of plastic sales packaging marked with a Green Dot, collected by the Duales System Deutschland), Bär & Knell create their objects from a small amount of the 600,000 tonnes of recycled plastic packaging each year.

The original idea for Bär & Knell's products arose from their archaeological curiosity in the layers upon layers of waste that lie in landfill sites, which in turn led them to appreciate its cultural significance. Each layer tells of changing fashions, consumer preferences, materials choices and marketing trends. This curiosity led to a radical departure from the alternative plastic recycling methods that produce

Utilising the peculiar beauty of recycled plastic in a caravan interior (left). Image courtesy of Bär & Knell and the DKR.

the dark brown or black material used in heavy-duty applications. Instead, Bär & Knell wanted to capture both the individuality of the material and the historical nature of the packaging, and recreate products that would proudly flaunt this new identity.

Their work is distinct from that of other equally innovative designers who have sought to manufacture products from the colourful but uniform and anonymous recycled plastic boards. Bär & Knell sought to use the very individuality and vibrancy of used plastic materials to their advantage and have created some astounding forms and colours that strongly validate the use of plastic waste in a wide range of product areas.

Their long product list includes chairs, sofas, armchairs, stools, tables, benches, lights, partitions, screens, cushions, book covers and even caravans. With their aim of producing goods that are fascinating and unique, or 'one-off mass-productions' as they like to call them, Bär & Knell hope to shape consumer attitudes and change preconceptions so that people see the beauty, the value and the spirit of used plastic. In producing these items Bär & Knell attempt to encourage individualism in an age where the trend is towards a 'faceless society in which not only sheep but also lifestyles and consumer habits are cloned'.

By embracing plurality and ecology Bär & Knell have created an art form that is not only a fasci-

33

Bär & Knell's innovative design and manufacturing provide a wide range of eye-catching product solutions (above). Images courtesy of Bär & Knell and the DKR.

nating retrospective on our past consumer attitudes but also strongly upholds and promotes the values required in an age where waste can no longer be regarded solely as such, and where consumers might be encouraged to accept the images of their past. Whether distorted and contorted or beautifully kaleidoscopic, such materials serve to stimulate the senses whilst also closing the loop on plastic waste and providing us with objects that convey a beauty in their own composition.

CASE STUDIES

In addition to the efforts of those that seek to reuse packaging materials in other useful forms, there are those who seek to minimise waste before it is created. This must be considered the most important prerequisite to any packaging solution. This implies that it is vital in a systems perspective that the total waste produced by a package must be reduced to a minimum. For example, reducing material content might prove in some cases to be more efficient at the level of the individual package, but less efficient at a wider level. Equally, reusing a package might be more detrimental than utilising a disposable package in other circumstances.

What follows are a range of case studies aimed at highlighting the efficiencies that can be made at the systems level of a company, an event, a nation or an entire continent. As yet such effective systemic solutions have not been reached at a global level, although not only is such a system achievable, it is also inevitable, providing we encourage the open, unconditional and democratic dialogue between nations and continents. The following examples are testament to the fact that change can be achieved at a broader level than individual products. Each raises important issues pertaining to change and challenges a myriad of perceived norms that could otherwise be radically improved.

'It is a weird form of suicide for we are bleeding our planet to death... I wonder what the attitude will be if, in a hundred years time, our starving grandchildren can see that this decimation of their inheritance was recognised, cures for it were available, and still nothing was done?'

G. Durrell, Forward to *The Gaia Atlas of Planet Management*

RAP

Fast-food packaging could be regarded as one of the key catalysts for consumer worries concerning packaging. Although packaging waste does not constitute a large proportion of all the waste we produce, its presence as litter is a perpetual symbol of the wasteful lifestyles we lead. Reducing this waste to a minimum and finding new materials and packages in which to contain fast foods so that their environmental impact is greatly reduced has been – and still is – a goal of most fast-food outlets.

Rapid Action Packaging (RAP) is a design and manufacturing company that was conceived to attain this goal. Established in 1997, RAP was set up when packaging design consultants Pethick & Money and the Telstar Entertainment Group began a joint venture to manufacture the award-winning Flexible Food Wrap (FFW). In developing this system, RAP's aim was to produce a pack that fulfilled structural and functional requirements, while maintaining an aesthetically pleasing appearance and providing the necessary scope for the creative use of graphics for product branding.

The FFW system was developed in response to the questioning of the materials used in the European fast-food industry. Such materials had led to calls by consumers to radically cut the quantities previously used and also to replace non-renewable materials with more environmentally acceptable alternatives. In response to this demand RAP

embarked on a lengthy design process that resulted in early concepts constructed from a combination of paper and cartonboard. The ingenious cardboard engineering allowed for significant material savings and for each pack to be supplied flat-packed to the user, thereby saving considerably on storage, transport and shipping costs. In addition to the savings on material consumption, the FFW structure and composition also increases heat retention, thereby allowing a longer shelf-life for the product. The FFW not only uses less material but being biodegradable it also does not remain in the environment as litter for long.

The pack transforms with ease into a fully recyclable, semi-rigid container with a product-wrapping facility suitable for holding a wide range of food items such as burgers, kebabs, chips and hot baguettes. More recently the range has been extended to incorporate a wide selection of cold food items which, for reasons of hygiene, use a polyethylene film instead of paper to package cold food items like sandwiches, bagels and baguettes.

With such a high volume market, bespoke manufacturing machinery was essential in order to fulfil customer requirements. Discussions with specialist manufacturers in Europe and the US resulted in a decision being made in favour of the Americans, whose approach to machinery development appears to differ fundamentally from that of the Europeans. The high volume and high speed runs which the US are used to result in a simplification rather than over-engineering of their products.

In an increasingly competitive market, with higher environmental standards being achieved all the time, RAP continually works on developing barriers and coatings in conjunction with world-wide chemical and paper/board manufacturers in order to maintain the 'environmentally responsible' claims of the FFW packaging systems. As one example of this ongoing commitment, RAP's new heat-sealing paper will soon be progressed to full production, allowing all products to be recyclable, compostable and biodegradable.

The FFW is set to challenge the old generation of packaging as it offers clear advantages to the customer, consumer and the environment. Currently being trialed by McDonalds and Burger King in the UK, the FFW has already been adopted by many food retailers including Starbucks, Prêt à Manger and Marks & Spencer.

In recognition of its work the FFW has received awards from the UK's Starpack Packaging Awards and BBC Design Awards.

McDonald's

McDonald's could be regarded as one of the largest-ever corporate success stories. Established in the US in 1955, McDonald's can now boast having in excess of 28,000 restaurants in 119 countries and is without a doubt one of the most famous brand images of all time. By the turn of the millennium, its total sales were over $38 billion, operating income was over $3.3 billion, and there were over 15 billion customer visits, the equivalent to two and a half times the world's population.

The scale and size of a corporation like McDonald's has unavoidable effects on the environment. In fact, throughout much of the past couple of decades, fast-food chains have been pressured into changing their packaging to become more environmentally responsible. First it was the removal of CFCs from the blown polystyrene burger containers and then it was the containers themselves that had to be removed, replaced by an ultra-thin paper wrapper and a belt of cardboard. However, it is not only the burger packaging that was required to clean up its act. The drinks containers, the straws, the cutlery and the trays have all received modifications to bring them into line with what many consumers saw as minimally acceptable environmental standards, especially for packaging such short-lived products as fast food. In

RAP's designs provide a broad spectrum of packaging solutions for fast food (facing page).

Comprehensive improvements have been applied to this packaging range from McDonald's (left).

all cases of fast food, the packaging remains long after the food has been consumed, leaving a considerable legacy of litter and wasted resources.

Due to ardent pressure from consumers, McDonald's Sweden was faced with a choice of either having a very poor public reputation which would undermine financial success, or improve its packaging to minimise its environmental impact

further than was normal for the chain. It met with Swedish environmental organisation The Natural Step, which helped them to gain an understanding of ecological principles and how to incorporate them into their strategic approach. After considerable research and development, the results suggest that McDonald's in Sweden can now boast having the most environmentally friendly fast-food packaging of all its international outlets. With starch-based salad packaging, paper cups, wooden cutlery and paper-tissue wrappers for its burgers, McDonald's Sweden has reduced its wastage considerably and has allowed for the waste to enter effective recycling streams without contamination. The reduction in material content and in numbers of materials used has made recycling simpler, and types of materials now being used avoid significant pollution caused by previous packaging materials.

During the Sydney 2000 Olympic Games, in which McDonald's was one of the major sponsors, it was stated by the event's coordinators that, 'McDonald's has failed to produce a thoroughly integrated waste minimisation programme. At present, environmental initiatives appear to be driven by the promotional dollar rather than concentrating on trialing and delivering innovations in event waste management.' (*Green Games Watch*, see Bib.) McDonald's Sweden having made this highly commendable step towards environmentally friendly packaging, it remains to be asked why such steps cannot be replicated in all fast-food chains that utilise the same type of packaging?

Tri-Wall

In the case of many secondary packaging manufacturers like Tri-Wall in the UK, the use of high-performance heavy-duty corrugated fibreboard is becoming increasingly accepted as a renewable and highly effective packaging material. Instead of costly and heavy packaging alternatives such as metal, wood and some plastics, fibreboard provides a lightweight and highly protective barrier against damage. However, to realise the full potential of this material relies on good design solutions.

Enhanced designs, such as the Robotic Arm pack, provide widespread improvements to Tri-Wall's transit packaging (right). Images courtesy of David S Smith Packaging and Tri-Wall.

The following examples are just some solutions that have resulted in significant environmental, economic and practical savings through the use of exceptional corrugated design.

The Robotic Arm pack was designed specifically for a major manufacturer of robotic welding equipment for the European automotive industry, which also operates an arm-reconditioning service, thereby needing reusable packaging. The arms, worth up to £20,000 each, were previously packed individually and strapped to specially blocked wooden pallets surrounded with pallet collars. Transit damage resulted in extended assembly-line downtime, poor customer relations and expensive replacement costs.

The new corrugated pack developed to replace the old method of packaging can be safely unpacked and stored or shipped flat before being reused. The individual arms are held securely with a die-cut fitting assembly that easily slots together. The upper and lower lateral dividers prevent vertical movement, while end pads assist with the security of the assembly and prevent horizontal movement. Buffers are also included at the shaft end as a precaution against any violent handling. After the pack has been slotted together, a self-locking cap completes the pack, which is then strapped to a pallet for shipment. This redesign

accounts for a 33% reduction in packing time; damage down from 15% to 0; decreased storage space and fully reusable and recyclable materials.

Polystyrene cradles for delivering 12 rolls (three layers of four per pallet) were used by a major supplier of rolls of breathable membrane material to the building industry. The price of the cradles comprised a significant part of overall costs and were increasingly difficult to dispose of.

The new Material Roll Unitiser pack's die-cut self-locking design incorporates pop-out tabs that serve two purposes. Primarily they interlock with each other, creating a stable load. Four rolls of material are placed side by side on the transit pallet and two semi-erected end caps are positioned. The next layer of caps is then placed on top, located and held secure by the tabs. This is repeated for each layer. Compared with the polystyrene cradle, the new fitting has also reduced the gap between each layer of rolls by at least 15mm. This, and the added security of the load, allow for extra products on the pallet, giving a 16-roll unitised load instead of 12.

The overall savings created by this redesign account for a 56% saving through flat-packed end caps; a 12% saving in product handling costs; a safer load and stacking; 25% increase in transportation load; 25% saving in transport charges and fully recyclable and renewable material for the end user.

Finally, the Automotive Door-Pillar pack for car assembly lines has fully eliminated the need for polystyrene and timber pallets. The number of packing elements have been reduced from five to three, storage requirements reduced by 18% and overall pack weight reduced from 75kg to 25kg.

Kor-Kap Flat-Glass Packaging System

The Kor-Kap Flat-Glass Packaging System is a patented, innovative way to store and transport flat glass, which is often shipped to fabricating facilities in cut-to-size sheets. There it is made into various products such as automobile windows or residential windows and mirrors, before being shipped to suppliers and manufacturers.

Conventionally, these flat-glass products have been shipped in disposable wood crates or wood end-caps or, since the 1960s, on heavy, returnable steel shipping-racks. Even when those are used, a considerable amount of expendable dunnage is used to prevent the glass moving and causing damage.

The Kor-Kap system safely ships many sizes of rectangular flat-glass products while only weighing 45kg or as little as 15% of conventional glass packaging systems with almost no expendable dunnage. This system provides considerable savings in energy and raw material, with efficiencies made in transportation and storage.

Conventional flat-glass packaging employed additional packing to hold the glass in a larger container. A combination of some or all of the following packing materials were used: corrugated pads; solid fibre pads; expanded polystyrene foam; building board pads; fabricated paper fillers; angle boards; wood braces; nails; staples; plastic banding; steel banding and stretch wrap. In addition to the ecological and economic costs and waste involved in using these materials, there is significant labour time required in applying them.

The Kor-Kap system takes advantage of glass's great compressive strength by using the product to support itself by transferring the load through the glass, instead of conventional methods that allow the wood crate or steel rack to bear the load. This is significant as the total weight of the 100–400 glass sheets contained in the Kor-Kap package can range from 900–3,600kg. If the packs are stacked in a warehouse up to five high, the bottom pack needs to withstand 11 tonnes. A designed safety factor allows it to support 55 tonnes.

With the Kor-Kap system only four identical steel corners are used to contain the glass sheets, and four steel bands are threaded through the corners to secure the glass tightly in place and eliminate movement. This greatly reduces glass breakage in

Consumers seldom acknowledge secondary packaging improvements, but their positive impact can be far-reaching, as with Kor-Kap's flat-glass packaging (right). Images courtesy of Kor-Kap.

handling or transit compared with conventional packaging systems where breakage from shifting glass is common. Because of the significant reduction of packaging size the utilisation of warehouse space is increased by 20–40%.

There are significant savings in the freight cost as approximately 230 containers per truckload can be returned to the glass factories compared with 50–60 empty steel racks in conventional packaging.

This redesign proves that ecological and economic savings are often coupled. Based on replacing over 200,000 steel rack shipments and 27,000 wood end-cap shipments with the Kor-Kap system, it is independently estimated that, when freight, labour, disposal of waste, handling and storage costs are taken into account, the total saving equates to over $6.5 million per year. With 5,328 fewer truckload shipments of an average 800km per year, approximately 4.3 million fewer km are driven yearly, or over 100 trips around the world. At around 2.2km to the litre, this saves 2 million litres of diesel a year. In addition to these savings there are also annual material savings of 80,500kg of plastic packing film and just under 1 million m of building insulation board for padding, all of which would end up in landfill.

Worthington Steelpac Systems and Harley Davidson

Worthington Steelpac Systems and Harley Davidson have created an innovative reusable steel package system for motorcycles. This high-performance, lightweight design reduces environmental impact through source reduction, reuse and recycled content in comparison to alternative methods.

The complete package is made up of a base assembly, two upright assemblies and a half slotted carton, all held together with sheet-metal screws. It replaces the use of disposable and unreliable wooden crates, which hold moisture and insects, contain knots that compromise their overall strength and require additional chemical treatments. The inherent strength and consistency of steel contributes to the excellent protective properties of this package. In over 20,000 shipped units only one minor incident of damage was noted.

Cost reductions have been achieved in several ways with this package: when reused, the per use cost of the steel package leads to significant savings over the single-use wood package; the steel package is 27% lighter than the wood package, yielding significant transportation savings; since the steel package is easier to handle and unpack, savings are realised throughout the distribution cycle, all the way to the end user; the steel package also provides better protection, reducing product damage and eliminating the possibility of injury from wood splinters and metal staples.

Source reduction is primarily achieved through the package's reusability. Each time the base assembly is returned, refurbished and reused, the need for creating a new base assembly is eliminated. Source reduction is further achieved through precise placement of the steel structure to avoid excessive use of materials. The consistency of steel means that components do not need to be oversized to compensate for inconsistent properties such as knots and cross grains found in wood. The ability to use thinner gauges of steel selectively on components where high strength is not necessary also provides a significant material saving.

Being the most recycled material in the world today, steel allows for easy recycling. It currently

Ease of use and functionality are integral to the environmental improvements in this design (right). Images courtesy of Worthington Steelpac Systems.

has a scrap value of approximately 7 cents per kg, which provides an incentive for recycling the package when it can no longer be reused, thereby providing an income from waste instead of expense. As with most steel, the steel used in this design, contains 30–100% recycled materials and is completely recyclable.

Migros

Migros, established in 1925 as a plc by Gottlieb Duttweiler and transformed into a cooperative in 1941, is now Switzerland's largest retailing organisation. With over 80,000 employees, a daily transportation network that utilises 440 railway wagons, 750 trucks and an annual turnover of over CHF 19 billion (Euro 12 billion), the Migros Group is justifiably concerned about its social and environmental impact. Not surprisingly, the Migros Group bases its commercial activities on a sound respect for the environment. Its environmental management policy maintains and furthers environmental improvements through its entire operations.

Implemented in five-year periods, Migros' environmental policy aims to target specific areas of business. This way each five-year period can be evaluated against the previous, and decisions made based on the performance of previous policies, from which the future policy frameworks could be established. A system that is simple and efficient to operate across all Migros' structures and systems would provide valuable support to those areas where ecological issues are often forgotten behind the daily business of commercial enterprise – a problem that most companies could identify with.

Not only does the Migros Group promote environmental protection as one of their primary policy goals, but it also seeks to ensure that this systemic thinking encompasses every aspect of a product. This is symbolic of the relationship between environmental issues and wider consideration in all fields of activity. Fair-trading and animal welfare are just two areas in which Migros is working to ensure that standards are maintained or raised in compliance with stringent ethical codes. It has led to a number of successes including the implementation of codes of practice for better conditions in the clothing industry; a social clause with Del Monte to ensure that working conditions are set above the social and economic average for that respective country; and the free provision of information to producers, dealers, suppliers, distributors and customers informing them of Migros' codes of practice for animal welfare. Migros also undertakes cross-organisational dialogue with other bodies to benefit from one another's expertise. These include government departments, energy suppliers, health groups, environmental organisations and food groups. This cooperation represents a strong bond between those bodies in a position to provide comprehensive improvements to existing problems.

Migros assesses all its packaging against its company computer program, 'Ecobase'. This program was developed to assess the environmental cost of each product in terms of its energy use, air pollution, water pollution and waste production. This program was integral to Migros introducing a compulsory levy on all PET bottles to ensure a 96% return rate. This is a much higher rate than those bottles on which no deposit has been paid, saving

up to 5,500 tonnes of waste PET per year, which is then used to make new bottles. Swiss law states that no recycled material must come into direct contact with foodstuffs. To overcome this, a common technique of sandwiching recycled PET between two thin layers of virgin PET uses up to 50% recycled material, with new techniques aiming for 80%. This would bring the environmental cost down to a level comparable with returnable bottles.

Migros favours no individual material when seeking to minimise environmental impact. Due to the light-weighting benefits of plastic, its share of the packaging market exceeds 40%, pushing paper and cardboard into second place. Migros recognises the importance of utilising these renewable materials, and retaining them in closed-loop systems by using as much recycled material as possible. This provides

The Migros Group shows that large corporations do not have to sacrifice profitability for environmental performance (above). Image courtesy of Migros.

valuable demand for a plentiful resource. For example, its plastic margarine cartons are 95% recycled, its biscuit trays 25%, its chocolate wrappers 72% and its meat bags 73%. Migros also values reusable secondary packaging, utilising over 6 million reusable plastic containers for product distribution. This saves an estimated 60,000 tonnes of cardboard per year.

FASTTrack Systems and Amway

Void filling may often be one of the key considerations of a packaging specification. The capability of a packaging system to fill the space around a product in transit can be critical to a business' success, particularly if the business ships a high proportion of its products. If the product is not suitably protected, it will be prone to damage in transit, causing return, disposal and reorder costs, which also have their own environmental costs. There is a fine balance between protecting a product effectively and not using too much material in the process. Over-packaging a product can be equally harmful to the environment as damaging the product in transit. The total cost of packaging materials and transportation must be kept to a minimum whilst maintaining the security of the product within.

Void filling seeks to achieve this compromise in numerous ways. A common method of achieving high levels of protection with little weight uses

expanded polystyrene pellets. These pellets are ideally suited to fitting around complex shapes and can be fed at very high speeds into the shipping container. However, the environmental cost of these pellets as waste is significant. As a result, a new generation of biodegradable starch pellets is now available for many product applications.

In addition to these improved methods, a new system of void filling utilising post-consumer recycled paper has been developed by FASTTrack Systems. With the same feed speed as polystyrene or starch pellets, this method offers an environmentally friendly packaging solution and no speed reduction in the production line. The paper is fed from a roll through the feeder head where it is crumpled to provide cushioning and fed into the shipping container at speeds of up to 2m per second. This speed is up to two and a half times faster than other systems, making it a financially viable competitor to other methods of void fill. The paper comes from post-consumer recycled sources and is reusable, recyclable and compostable.

FASTTrack Systems developed the machinery that feeds the paper and has introduced it into the distribution facility at Amway, an international retailer. Amway's packaging requirements cover a broad range of products including household goods and appliances, health and beauty products and cooking equipment. These goods are shipped to over 40 different countries by up to 2.5 million distributors worldwide, making effective packaging a vital part of their business.

Amway previously used polystyrene pellets as a void filler, a process that required filling two 3,500 cubic ft hoppers feeding overhead dispensers that then fed the pellets into the shipping container. This process not only utilised a considerable volume of the company's distribution facility, but also the pellets and the fine polystyrene dust caused significant health and hygiene problems for the workers. The environmental cost of shipping truckloads of expanded pellets was also considerable. As a contrast, each roll of FASTTrack paper comprises 600m of post-consumer recycled material and is equivalent to seven 14-cubic-ft bags of polystyrene pellets. By using the rolled paper feed, Amway made large savings on space, dispensation of material and cleaning, prevented a health hazard and reduced dunnage by 40% per container with no additional transportation costs.

The environmental benefits are wide-ranging. The use of paper prevents the production and use of a non-renewable resource, maintaining equal, if

not higher standards of light-weighting, effective protection and material feed time. It also ensures a higher standard of working environment by eliminating potentially harmful dust and reduces dunnage. By utilising this renewable post-consumer resource, FASTTrack Systems provide a valuable outlet for the vast amounts of paper produced each day in other areas of industry, closing the loop on the valuable resources we use.

Visy and Sydney 2000

The Olympic Games is now regarded as one of the largest global public events. Sydney's hosting of the Games in 2000 was no exception. Hosting such an event required many years of preparation, the combined help of thousands of people, a huge re-development of infrastructure and a considerable cost to the environment. However, Sydney's bid differed from previous ones on environmental grounds, or 'Ecologically Sustainable Development (ESD)'. Sydney 2000 was the first-ever Olympic Games to be overseen by an independent environmental body to ensure that the bold environmental promises were fulfilled. Despite some causes for concern, Sydney 2000 did implement most of their environmental objectives laid out in the Games bid. For example, the Olympic site itself was a regenerated toxic industrial site, and 2 million trees were planted before the Games began; construction materials were recycled where possible and new environmental benchmarks were established on all Olympic venues, with up to 90% of waste material reused or recycled; and modern technology was exploited where possible for its ability to carry information electronically rather than on paper. The environmental successes that came out of the Olympics provide a lasting legacy for the future.

A strict systemic approach was applied to the inevitable problem caused by millions of people demanding fast food throughout the 16 days of Olympic Games and ten days of the Paralympic Games. Despite efforts to avoid and minimise waste it was still estimated that over 10,000 tonnes of waste would be generated at the Olympic Games alone. This posed a potential ecological nightmare. Targets were set to divert 80% of this waste from going to landfill, with 50% of the waste being compostable and 30% recyclable.

Visy, as official provider of packaging and recycling services to Sydney 2000 was responsible for the major logistical problem of collecting and sorting waste. Waste bins were designed to assist in separating waste into compostable (food and paper), recyclable (PET, glass and aluminium) and residual waste streams for collection and reprocessing. This required significant public support and awareness, which became the basis for community participation in residential waste management after the Games. Information systems, clear graphic design and signage and colour coordination of bins and packaging were used to enable the efficient collection of material. This was vital to avoid waste stream contamination at the point of disposal.

In addition to the clear categorisation of waste streams, each piece of packaging supplied to the Games was carefully considered in terms of recyclability, biodegradability and disposal. The product range consisted of over 190 products including plates made from sugarcane; cutlery, straws, cup lids and bin liners made from corn starch resin; and coffee cups made from specially patented insulated cardboard. 4.5 million pieces of corn starch cutlery, straws and cup lids, 7 million sugarcane plates and bowls and 6 million insulated cardboard coffee cups were manufactured. This compostable material is used in landscaping sites such as those used by the Olympics.

The remaining 30% of the waste, or 3,000 tonnes, that could be recycled included aluminium and PET for the manufacturing of drinks cans, beer

Sydney 2000 provided extensive improvements as part of a systems approach to the packaging problems caused by large events (left).

and wine glasses, sandwich containers and salad bowls. Over 2 million PET (soft drink) bottles, 630,000 aluminium cans, 165,000 glass bottles and enough paper and cardboard was recycled to save over 7,000 trees from being felled. The remaining 20% of waste was landfilled.

Finland's Reusable System

Companies, countries and even continents have different policies on how to deal with different categories of packaging most efficiently. Often the most effective packaging policies cannot be implemented due to a lack of coordination or cooperation amongst participating parties. There are many packaging applications for which systemic compliance to certain guidelines or design standards might allow for greater unity amongst producers, thereby opening up possibilities of co-sharing packaging in returnable packaging applications.

The Finnish bottling system for all takeaway soft drinks and alcoholic drinks bottled in Finland is one such exemplary example. The returnable bottle system in Finland is truly systemic, encouraging the use of a standardised design for all glass and plastic bottles of all sizes. Regardless of producer, the bottles, being a standard shape and design, may be returned for refilling at any drinks supplier whose filling systems are all designed to match the standard bottles. This agreement and compliance amongst most drinks suppliers has enabled the existence of a returnable bottle system in Finland that is unmatched.

In a country with a population of just 5.1 million, Finland consumes annually 650–680 million litres of beer and beverages. Over 90% of this is packaged in returnable, refillable bottles. Beer bottles are identified by being brown glass while other beverages are bottled in clear glass and PET. Each of these types of material is available in four different sizes: .33-, .5-, 1- and 1.5-litre (beer is not available in 1.5 litre). Wine and liquers bottled in Finland also have a 70% bottle reuse rate. The average useful life of a glass bottle is expected to be between five and ten years, with approximately five fillings each year.

Consumers pay a deposit on each bottle (the larger the bottle, the higher the deposit) and have this refunded when they return the bottle to the store. The bottles are retrieved by the supplier who is able to pick up returned bottles when delivering new supplies. This way, the delivery trucks take no unnecessary journeys.

Some might argue that such a system is autocratic and denies the supplier any individuality in product expression or identification. Perhaps this is a price we should be prepared to pay for the environmentally responsible management of our drinks distribution, and for other types of packaging, though it also intensifies the task of the graphic designer to

forge an interesting brand identity. Finland uses a similar system for their own-grown fruits and vegetables, whereby each is distributed in standardised crates and boxes to each store countrywide. Imported fruits and vegetables arrive in corrugated boxes and if wholesalers need to repackage these foodstuffs they will use standardised reusable crates. Whether it is ideologically sound or not, the proof of its success is certainly clear in the figures. Even the large multinationals comply with the system, with Pepsi using the refillable Finnish bottles, although Coca-Cola still uses its own bottle.

Finland produces much less packaging waste per capita per year on average than any other European country. The use of refillable packaging has helped considerably. 85% of glass, 70% of plastics and 90% of metal is reused. From the 1.2 million tonnes of these packaging materials used in Finland each year, 810,000 tonnes is reused. Cardboard is not included in these statistics as it is seldom reused and more often recycled. In addition to the impressive reuse rates, Finland had also met and exceeded its 2001 targets set by the EU Packaging Directive for recycling fibre and glass by 1997, with metals and plastics close to meeting targets by 1998.

As Finland proves, this type of systemic approach to packaging does not have to be specific to a product or corporation – countries and continents could also aim to solve these problems at a higher systemic level, which requires a greater deal of cooperation among packaging producers, suppliers, packers, the retail trade and distributors. This is no simple task and requires dealing with a high degree of complexity, but the rewards for the environment are clear and the cost to the consumer is largely

Finland has solved environmental problems caused by its bottles by implementing a high-level returns management system (right).

Sorting waste at a German plastics recycling plant (facing page). Images courtesy of Duales System Deutschland.

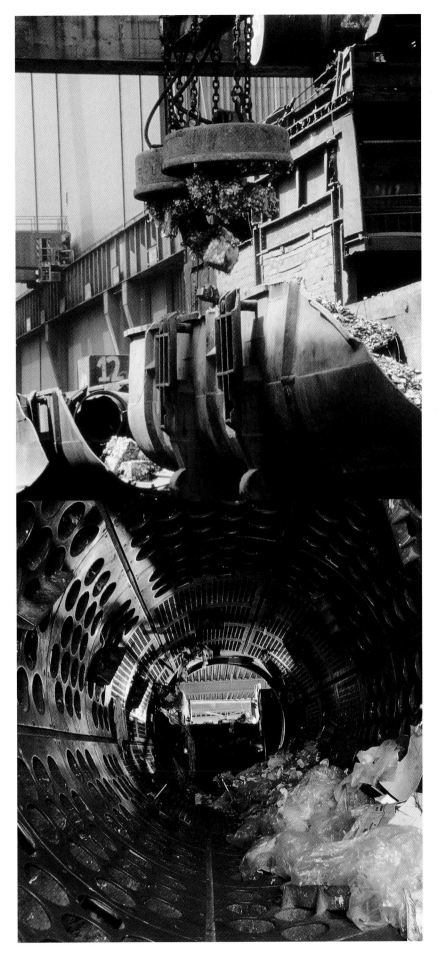

symbolic. Finland has implemented this system on the basis that to ensure environmental responsibility no products or materials should be lost. Packaging is fundamental to ensuring that this can happen, as well as being part of the potential problem. By keeping all the products and materials within the returnable loop, little to no loss is incurred in the process.

The German Experience

Perhaps the most famous systems approach to the packaging problem comes from the German experience. On June 12 1991, the German government introduced the Packaging Ordinance in response to claims that the packaging industry was to blame for overflowing landfill sites and continued production and misuse of potentially valuable materials. At this time packaging accounted for 30% by weight and 50% by volume of household waste. The aim of the Packaging Ordinance was to prevent and reduce packaging waste and collect and recycle packaging materials so that they are returned to manufacturing processes, thereby creating a closed-loop economy.

This system obliges industry to take back all primary, secondary and transport waste, placing responsibility firmly in the lap of the producer. In addition to this, consumer recycling systems were established to ensure that collection, sorting and recycling was available to all households. The collection system of sales packaging is currently overseen by the Duales System and relies on the licensing of the Green Dot symbol for financing effective sorting, recycling and recovery of sales packaging. It was an instant success, reducing packaging consumption in Germany in 1991 for the first time ever, and this has continued to decrease. Since then the Packaging Ordinance has been taken up in the Product Recycling and Waste Management Act of 1996, which has spawned the Ordinance for Electronic Scrap, the Used Car Ordinance and a Battery Ordinance, all based on the same principle and success of the Packaging Ordinance. The success of implementing this system in Germany has also been transposed into European legislation where efforts are being made to synthesise the waste management and recovery of EU members and secure this in national law. The targets set for the EC Packaging Directive stipulate that all members should recover at least 50% of their waste by 2001.

43

The Duales System Deutschland is a non-profit-making organisation receiving revenue only from licensing of the Green Dot trademark, which indicates that trade and industry are making a financial contribution to the waste management system. The more materials used in a package, the higher the licensing fee, encouraging companies to reduce their packaging and adopt alternatives such as refillable systems. Many systems exist in Germany for the recovery, sorting and recycling of waste, but there remain two principle means by which waste is recovered. This is through kerbside collections, which rely on the consumer sorting household waste at source, or the 'bring' system, whereby consumers are required to take waste material to collection points in public areas such as supermarket car parks, town centres, parks, etc. Plastics, glass, paper, aluminium, tin plate and composites are all collected for recycling and their respective recyclate material is contractually guaranteed by companies that oversee the process. The DKR (see page 32) is one such company overseeing plastics recovery.

The entire German experience of sales packaging relies on a highly complex systems approach to the problem. Each part of the system is vital for the efficient operation of the whole. Early in its development, failure to account for the enormous consumer participation led to German recycling plants running to full capacity and actually having to refuse more waste. This excess was then sent abroad and caused a great deal of negative publicity as neighbouring states felt that over-efficient waste collecting on the part of the German public resulted in a supply that could not meet current demand. Much has been done since to increase their capacity to deal with such enormous volumes of waste whilst creating a demand for the resulting recycled material. Meanwhile recycling security for the various post-consumer sales packaging from Duales System collections has been achieved. Technological improvements in the field of recovery and recycling are paramount to the ongoing success and efficiency of this system and the quality of the recycled material.

The success of such a pioneering system can be seen in its results. 17,000 jobs have been created by the Duales System since 1991. 14,900 tonnes of material is recycled each day. 5.7 million tonnes of packaging waste was collected by the Duales System in 1999, with over 5.5 million tonnes being forwarded for recycling, including stocks from the previous year. Of this amount 610,000 tonnes of plastic was recycled while costs per tonne for recycling dropped steadily for the third year in succession. The proportion of this recycled plastic is split approximately 55/45 between feedstock recycling and mechanical recycling, preventing up to 350,000 tonnes of heavy oil being used in the production of pig iron each year. The other collected and recycled materials, including paper, aluminium, tin plate and glass make up the rest of the 4.9 million tonnes of waste to be retained in the recycle loop every year by each of their respective guarantors.

Aluminium packaging being compacted before recycling (left). Image courtesy of Duales System Deutschland.

Materials Key

PLASTICS

PET – Polyethyleneterephthalate. *Tough and often clear.*
International code number (INC) 1
HDPE – High-density polyethylene. *Flexible, with all-purpose characteristics.* (INC) 2
PVC – Polyvinyl chloride. *Hard plastic that resists many common solvents and oil-based cleansers.* (INC) 3
LDPE – Low-density polyethylene. *Highly flexible and almost elastic.* (INC) 4
PP – Polypropylene. *Hard and brittle.* (INC) 5
PS – Polystyrene. (INC) 6
PO – Other resins and complex composite materials. (INC) 7

WOOD

WO – Wood
CdB – Cardboard
CtB – Cartonboard
PA – Paper
PU – Pulp

STARCH

StW – Wheat starch
StP – Potato starch
Stc – Corn starch

METAL

AL – Aluminium
ST – Steel

OTHER

GL – Glass
FH – Flax and hemp
CE – Cellulose
LE – Leaf

Icon Key

USE/POST-USE CHARACTERISTICS

Recyclable: *Material can be recycled (e.g. paper, aluminium, steel, identified plastics)*

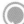
Reusable: *The packaging can be reused (e.g. bottles, bags, boxes)*

Biodegradable: *The materials in the package degrade harmlessly to their natural base elements*

Promotes sustainable consumer practices: *The package assists in establishing a sustainable lifestyle*

Greater transportation efficiency: *A combination of design and weight saving has allowed for greater transportation efficiency*

DESIGN CHARACTERISTICS

Reduced material content: *The package contains less material than previous designs*

Reduced material count: *The package contains fewer materials than previous designs*

Reduced material waste in production: *Improved design or manufacturing has resulted in less material waste during manufacturing*

Reuse of post-consumer material: *The package is either partially or entirely made from post-consumer waste*

Space saving: *The package design allows for a greater number of units to be packed into the same volume for transportation*

Lightweight: *The weight of the package is reduced from previous designs*

Reduced dunnage: *Less material is discarded as waste*

MANUFACTURING CHARACTERISTICS

Elimination of previous pollutants: *Pollutants resulting from previous designs have been eliminated through improved design or materials selection*

Reduced energy in production: *The new manufacturing process has resulted in less energy being used to produce the same number of packaging units*

Reduced air pollution in production: *The new manufacturing process has resulted in less air pollution*

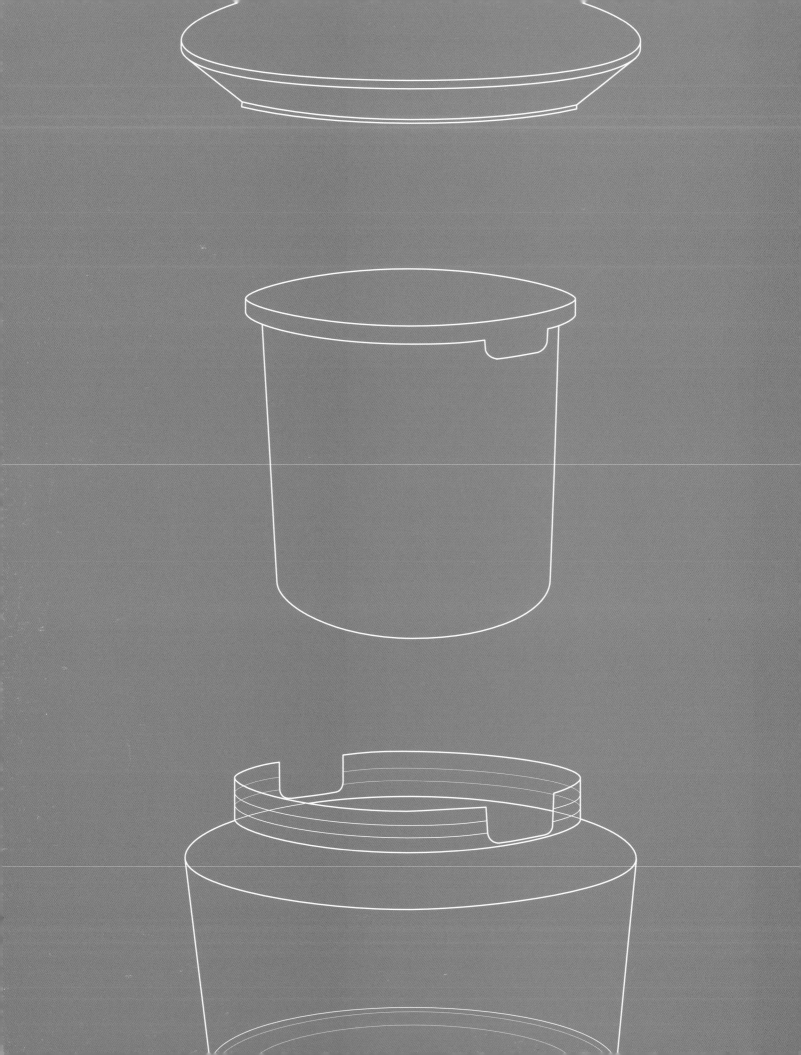

THE DESIGNS

The aim of this book is not to highlight the mistakes that we have made nor to illustrate the preponderance of poor packaging design nor to condemn the lifestyle choices made by each of us, but instead to highlight the efforts and successes that have been made in reducing our impact on the environment through thoughtful, innovative and effective design decision-making.

What follows is a broad aggregation of previous and contemporary packaging designs whose commonality lies in their brief to achieve higher standards of environmental responsibility and to minimise their ecological impact, while maintaining and often improving the function of product protection. Their improvements may be slight or extensive, diverse or alike, systemic or individual, but they are all related by their approach to achieving long-term ecological improvement, while being confined to the particular context in which they were first conceived. The samples are not intended to be a comprehensive product list of 'eco-friendly' designs, but rather a diverse range of packaging examples designed to inform, incite, provoke and illustrate to designers and, more broadly, consumers, the numerous and unbounded possibilities that exist to reduce waste, increase efficiency and prompt large-scale change through personal actions and decisions.

Each design is accompanied by a small piece of text to explain context and specific characteristics, while a list of icons and abbreviations serve to illustrate more general characteristics and material content respectively. The icons are not to be seen as strict guidelines or as a form of grading system, but simply indicators of key environmental characteristics that make a product less harmful than previous or alternative designs. The materials abbreviations after each closing line of text are there to provide the reader with a quick and simple method of seeking material information on each product. Often it is the material that might provide the key environmental improvement for a package, while other examples might rely less on their material choice. It is hoped that through easy referencing with the abbreviations, new, less harmful design decisions can be realised for many packaging designs in the future. Where materials are specific to certain suppliers, the reader may find the necessary contact details in the Useful Addresses section.

While every effort has been made to include as many designs as possible in this book, there was a strict limit to the number that could be reasonably illustrated in a book of this size. The authors apologise to those that could not be included, and extend their gratitude to all those that were magnanimous enough to provide material. All the designs have been gratefully received and have not been selected by any other criteria than to cover the widest range of packaging applications possible. It is hoped that the reader may find the final selection interesting and informative, but above all else, that the samples inspire a change of thinking among those that are learning or practising in the field of design so that our environmental impact can be greatly lessened.

47

This product is biodegradable, disposable, hygienic and an inexpensive alternative to conventional paper, or reusable (metal, ceramic, plastic) plates and bowls. Developed in India, leaf plate products have been used for many years for serving dry or moist food. They are made from a variety of partly dried biomasses, derived from trees and plants which are common to the tropical areas of Asia, Africa and Central and South America. They can also be used as packaging for short-term storage or shipping of a variety of goods. They will retain shape and rigidity for long periods if stored in low-humidity environments. In an environment with little or no waste management or recycling infrastructure, these plates can be reused, but are often discarded, causing no environmental damage compared with alternative materials. • LE

48 **LEAF PLATE**

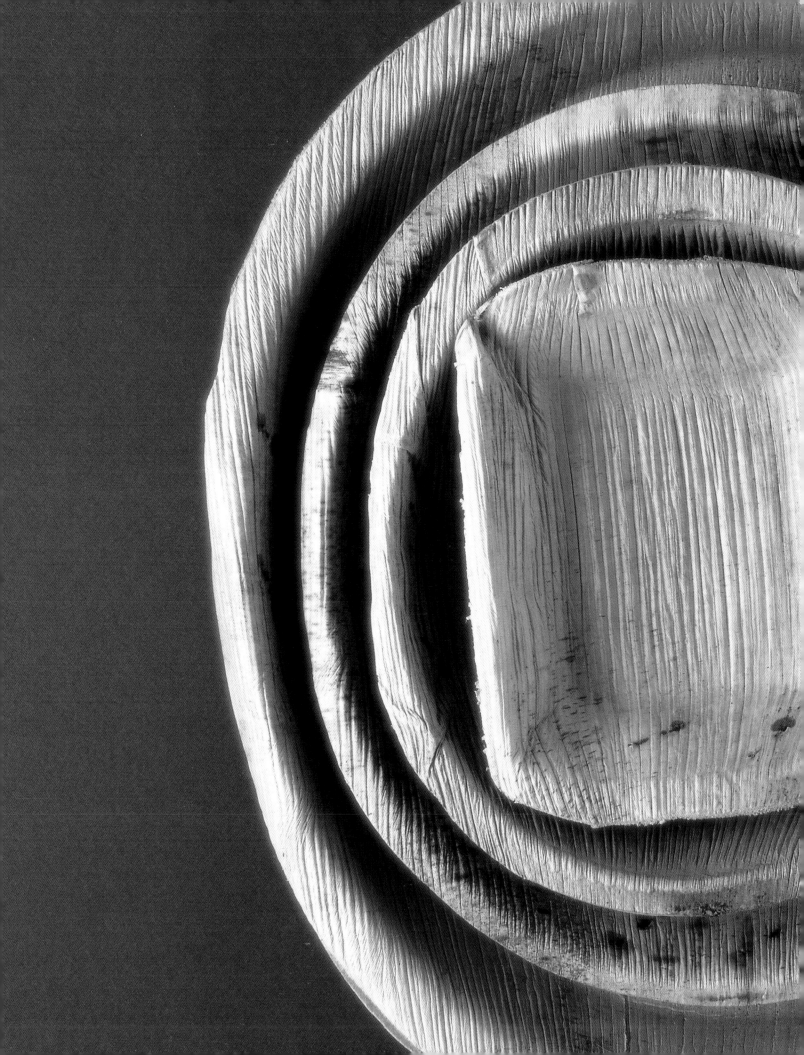

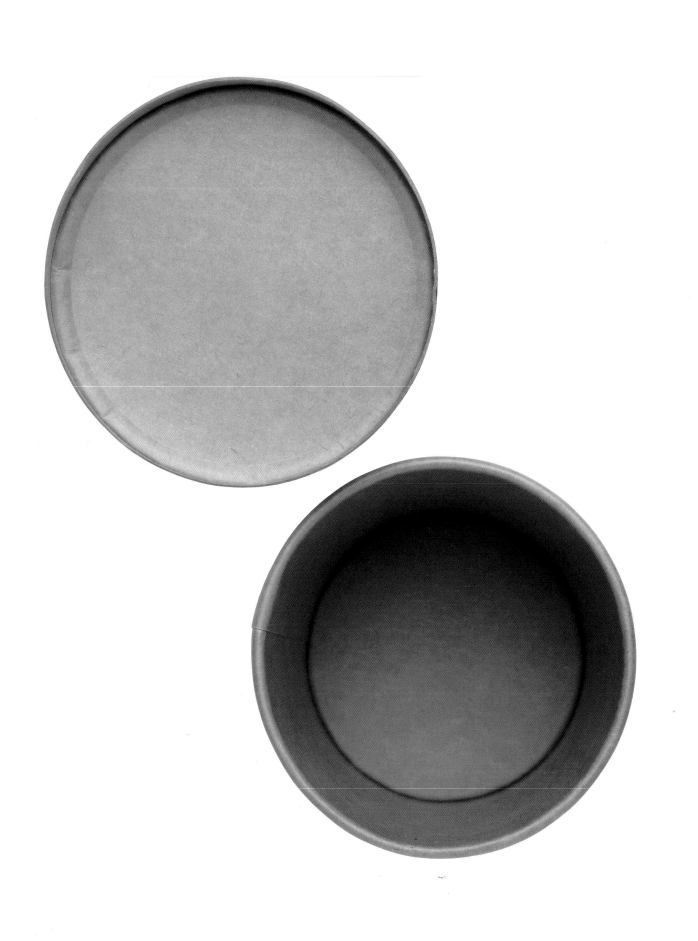

This unbleached paperboard carton has replaced a bleached material. The transition to unbleached products for Ben & Jerry was far from simple. Sourcing a viable material that conformed to the various food authority standards as well as being manufactured to precise volume specifications and printable on, made for two years of extensive research and development. The new product is currently being used all through the US and has helped to reduce the widespread use of toxic organochlorines that seep into our rivers and waterways causing significant pollution to many ecosystems. • CtB

ICE-CREAM CARTON 51

Ben & Jerry

The use of local materials and the appreciation of cultural sensitivities can often provide a more valuable and environmentally sound solution to packaging problems than can the import of foreign materials. In this instance handmade paper made from recycled post-consumer waste has provided the packaging for an attractive gift box for local produce that is exported worldwide. In using a common resource to manufacture this package, this product provides a valuable outlet for waste material, while also adding value to the way local produce is presented and sold. • PA

Akbar Brothers Ltd.

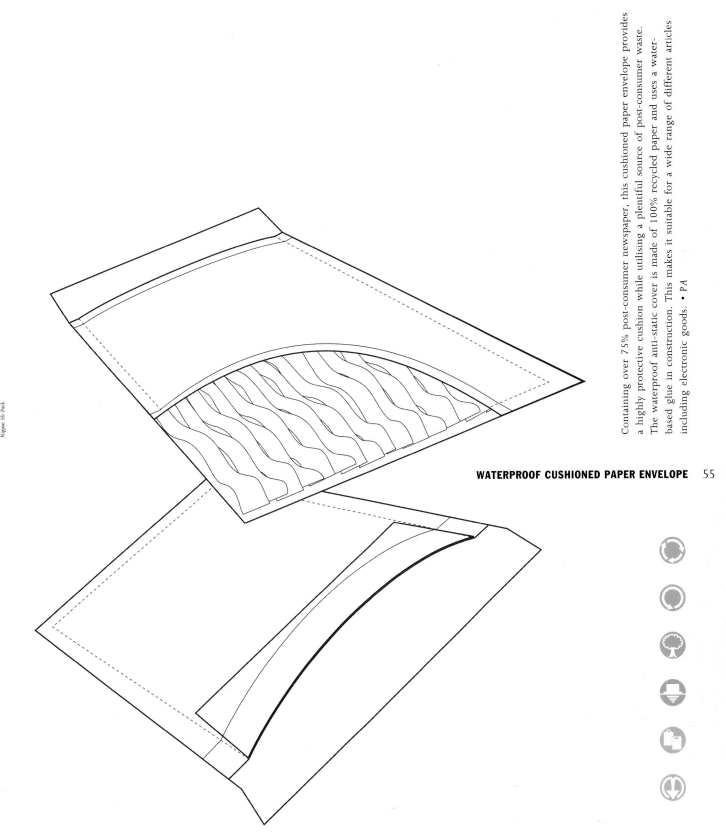

Nippon Hi-Pack

Containing over 75% post-consumer newspaper, this cushioned paper envelope provides a highly protective cushion while utilising a plentiful source of post-consumer waste. The waterproof anti-static cover is made of 100% recycled paper and uses a water-based glue in construction. This makes it suitable for a wide range of different articles including electronic goods. • PA

WATERPROOF CUSHIONED PAPER ENVELOPE 55

Made entirely from polythene, this lightweight, waterproof, fully recyclable envelope was designed to prevent the ongoing wastage of material caused by single-use envelopes. The strong laminated polythene provides a tear-resistant and fully reusable pouch that easily withstands the rigours of the postal system. With a cushioned inner liner, the contents are protected against damage. The use of plastic provides a 50% space saving over equivalent paper envelopes and makes it lighter weight, while providing significant monitary savings compared with other leading envelopes. • HDPE

SELF-SEALING ENVELOPE

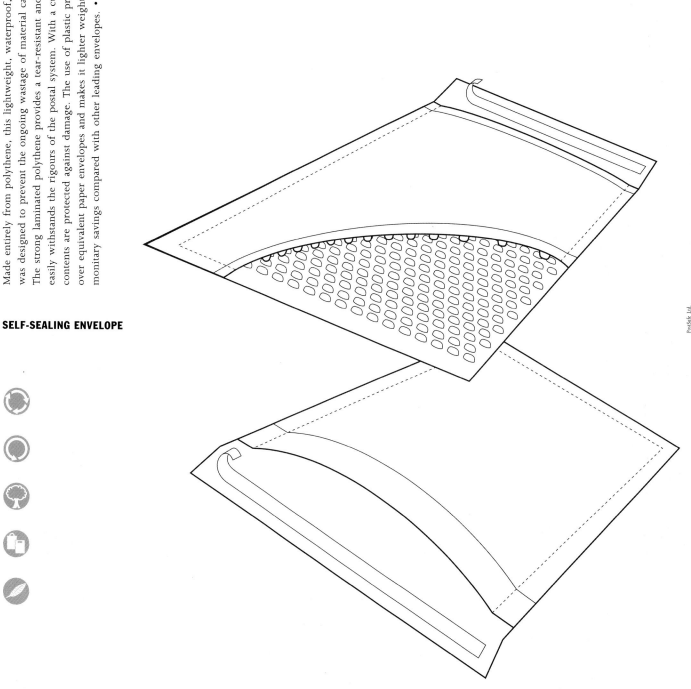

PostSafe Ltd.

Sybacurl

Until the onset of plastics, most goods were shipped in wood chips or carvings. These biodegradable and reusable shavings are the by-product of the logging industry in Vermont and would otherwise be left as waste. They are made from aspen that has not been chemically treated and can have non-toxic, water-based colouring added. They are designed to provide maximum cushioning by curling the wood shavings during production. Excess dust and fine shavings from this process are used as livestock bedding and pumice in hand soap. • *WO*

NATURAL WOOD VOID-FILL 59

Much of the packaging of items such as tea is delivered in cartonboard boxes wrapped in a cellophane sheath. This packaging redesign for Tetley UK provided a conceptual change to the way in which their tea had been previously packaged. By using a resealable label on a single layered bag, this package was able to reduce space by up to 40% during production and delivery and constantly reduce size throughout use. 30% less packaging also means less waste produced, less shelf-space needed and easier recycling of materials. • PP

60 TAMPER-EVIDENT RESEALABLE LABEL

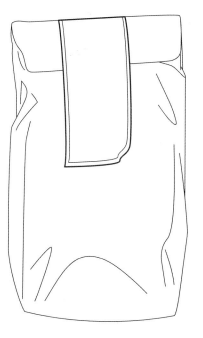

Macfarlane Packaging Ltd.

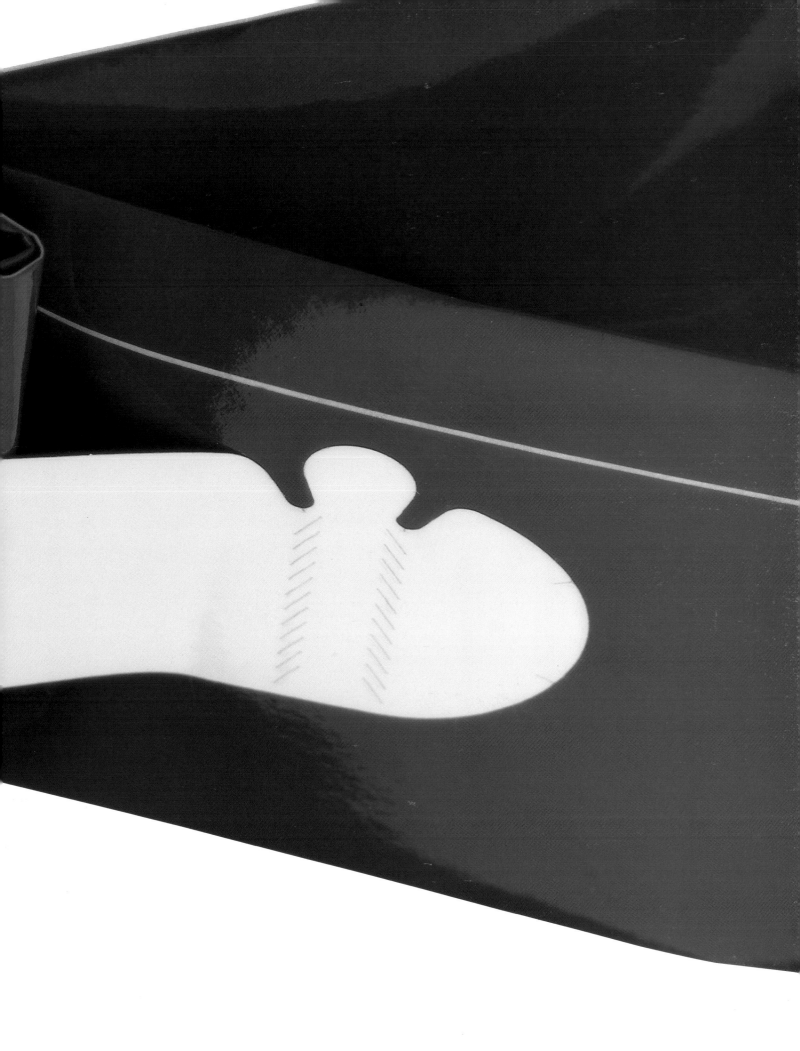

Kent Paper
Sweetheart Cup Company Ltd.

Disposable, single-use drinking cups are a common cause of litter and can be deemed a waste of non-renewable resources. These paper containers provide a more efficient and less damaging alternative to the polystyrene cups that are more commonly used. Manufactured from a single disc of paper, this container also uses less material than similar products made of the same material and causes less waste from the cutting process. It is fully recyclable and biodegradable. • PA

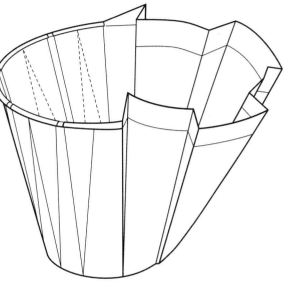

PLEATED PAPER PORTION CONTAINER 63

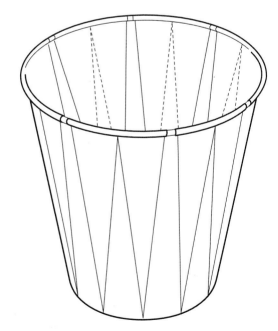

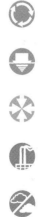

This flexible food-wrap packaging system has been designed to meet the increasingly stringent requirements of current and future packaging legislation, particularly in the fast-food sector. This innovative piece of cardboard engineering (PCT/GB96/01941) provides a waste-efficient alternative to plastic packaging that can be delivered flat-packed, enabling savings in storage and transportation. It is easily erected and contains an integral paper wrapper to envelop the product in the cartonboard container to contain heat and provide a barrier to grease. Its positive characteristics include source reduction, less waste, easier recovery and disposal of material. • PA [LDPE coated], CtB

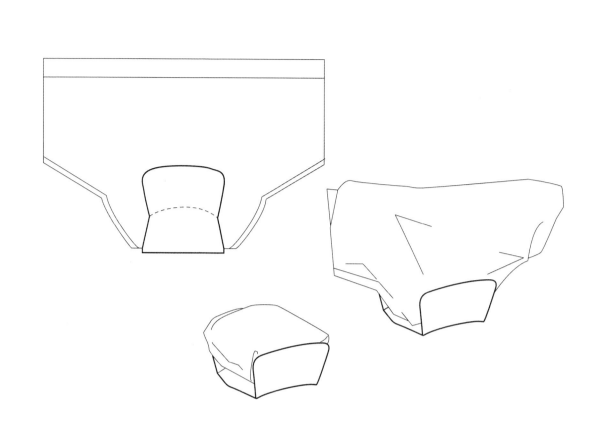

64 CARTONBOARD PACKAGING FOR HOT FAST-FOOD

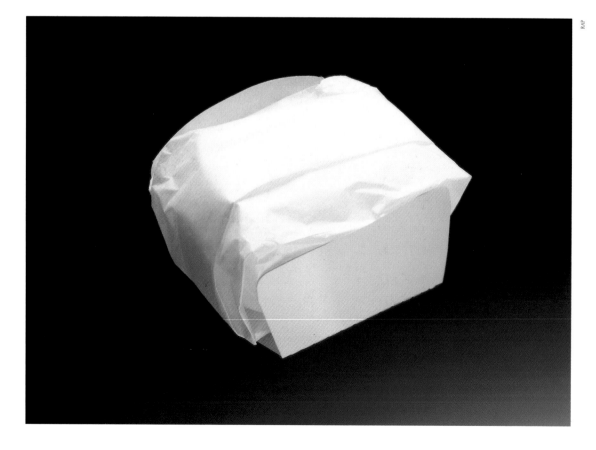

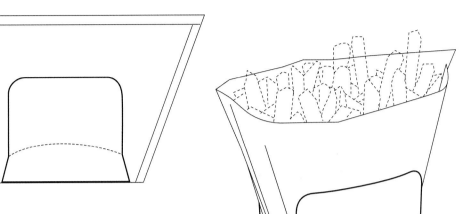

Containers for items of fast food are often over-packaged and when disposed of form a large proportion of litter in the environment. This cartonboard container (PCT/GB96/01941) is designed to reduce material use and provide a natural alternative to existing packaging on the market for short-term food requirements. The paper wrapper avoids the full use of cartonboard, saving material and weight. Delivered flat-packed, this package saves storage and transportation space and can be easily erected before use. • CtB, PA [LDPE coated]

HOT FAST-FOOD CONTAINER 65

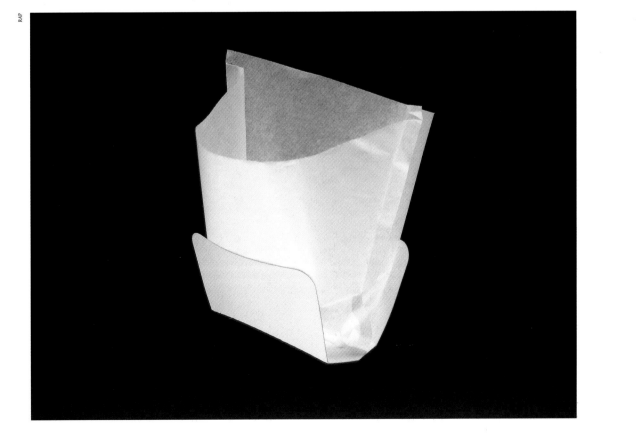

In addition to the benefits offered by other flat-packed carton packaging for fast food this container (PCT/GB96/01941) also provides product protection through the use of a cartonboard lid. This lid allows products to stay hot and securely contained while being transported or stored for a short period of time after purchase. Each container uses a minimum amount of material. Delivered flat-packed, this package saves storage and transportation space and can be easily erected before use. • CtB, PA [LDPE coated]

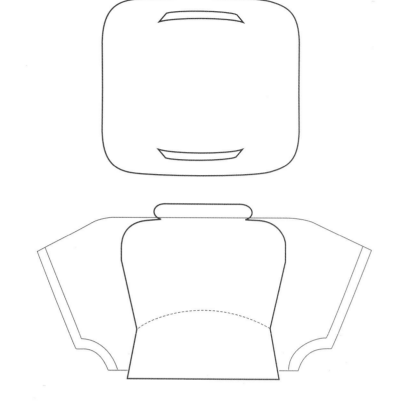

66 **HOT FAST-FOOD CONTAINER WITH LID**

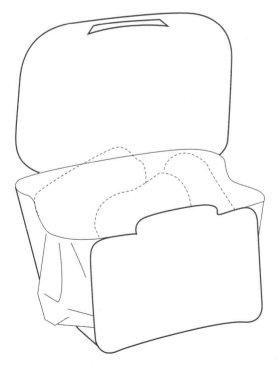

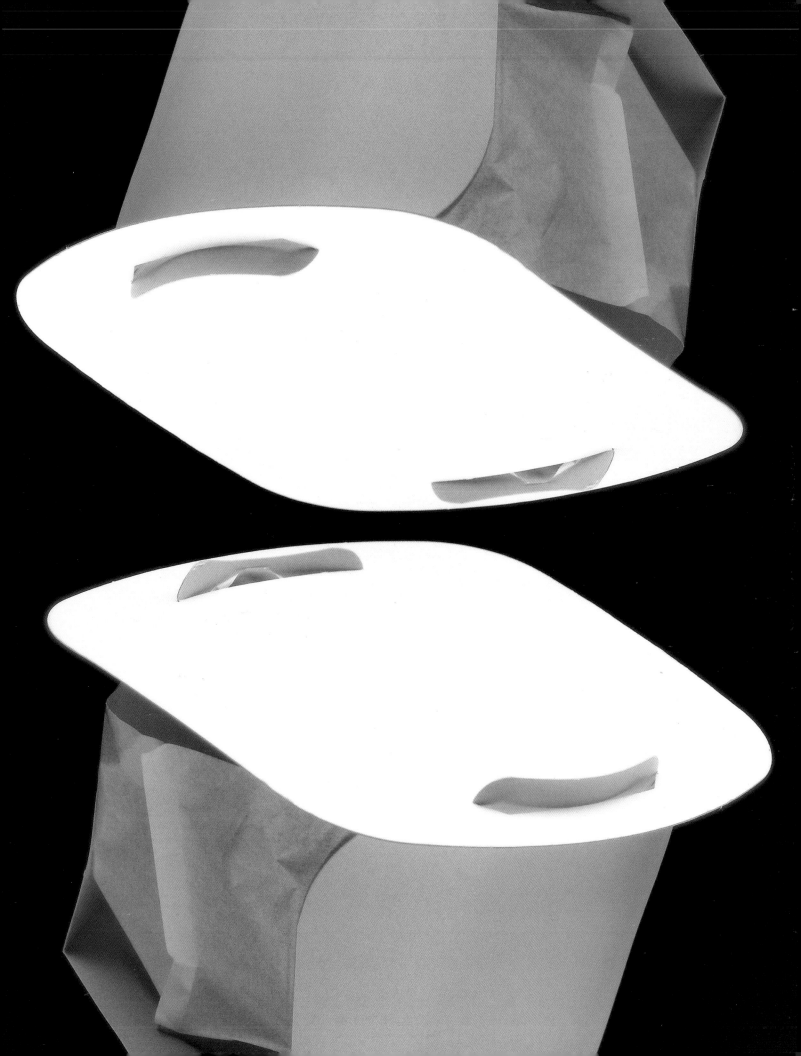

The innovations that led to the production of similar packages in this range formed the basis of this cold fast-food package (PCT/GB99/02318). Due to different product requirements for hot and cold food, this package was manufactured using a thin polypropylene wrapper instead of paper to provide sufficient protection and give a fresh homemade appearance. This type of wrapper also provides good product visibility. It is delivered flat-packed, saving storage and transportation space and can be easily erected before use. It is lighter and uses less material than alternative packaging. These materials can be easily separated for recycling. • CtB, PP

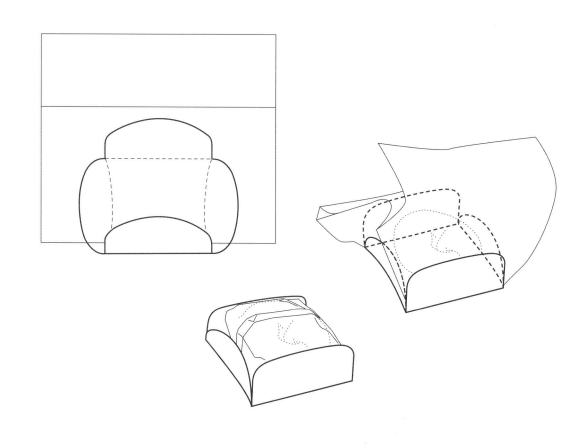

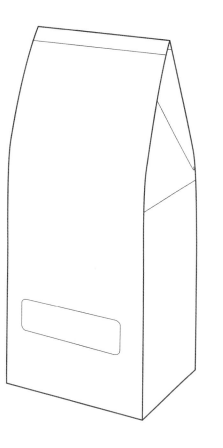

Due to local legislation, recycled material could not come into direct contact with the product contained in this package, which in this case was organic sugar. The manufacturer's brief was therefore to design a fully recyclable carton product which also displayed the contents. The problem was solved by using cellulose for the window, which provides a strong transparent barrier and dissolves harmlessly in the recycling process. • CtB, CE

RECYCLABLE PAPER CARTON WITH WINDOW 69

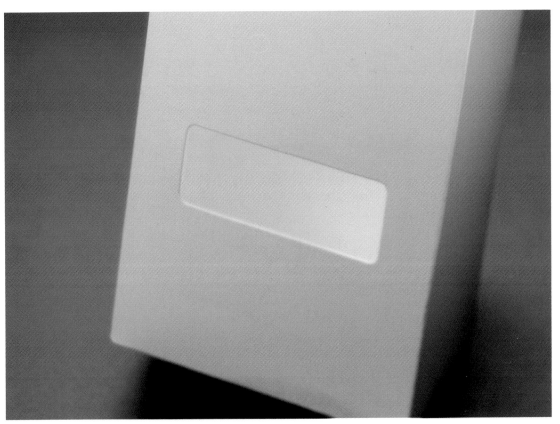

The inefficient use of space and materials caused by alternative packaging for this type of product initiated a radical rethink of possible packaging solutions. This innovation utilises recyclable and renewable cartonboard and a minimal use of plastic to create a triangular carton that can be distributed flat-packed to save space in transportation and storage (PCT/GB98/03467). It can be easily erected before use. The small plastic sheet provides a window to display the product. The materials are easily separated for recycling and the board biodegrades to minimise litter often caused by takeaway food packaging. • CtB, PP

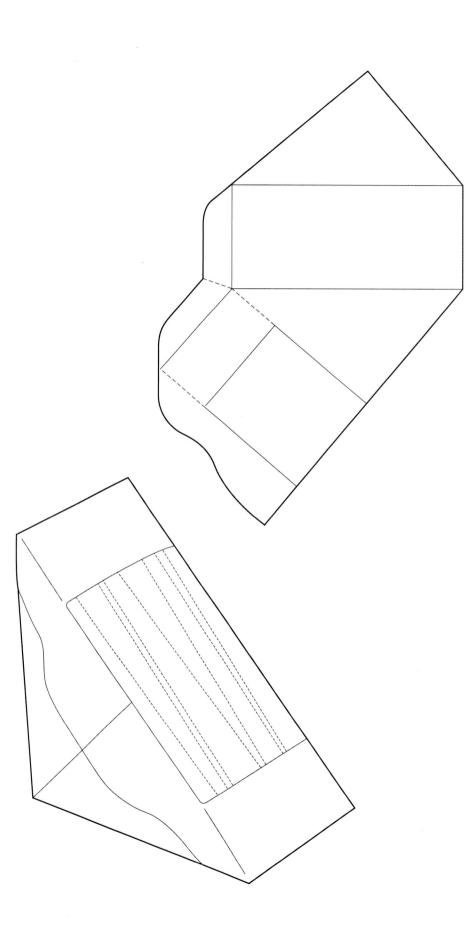

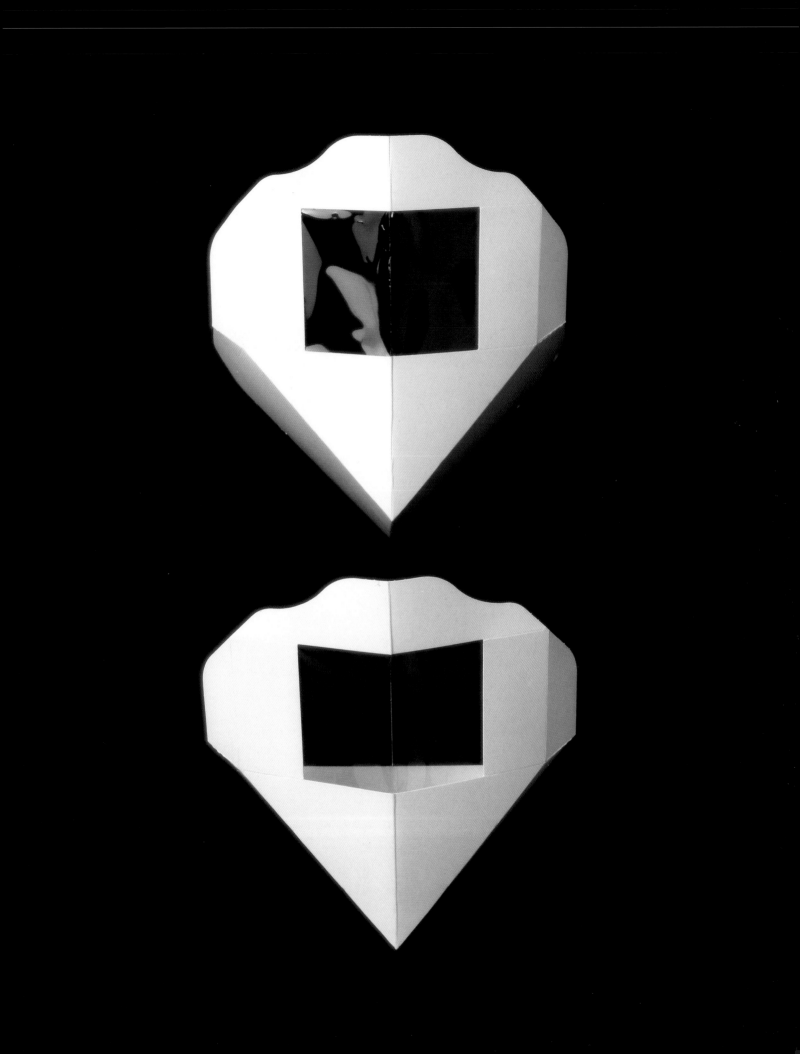

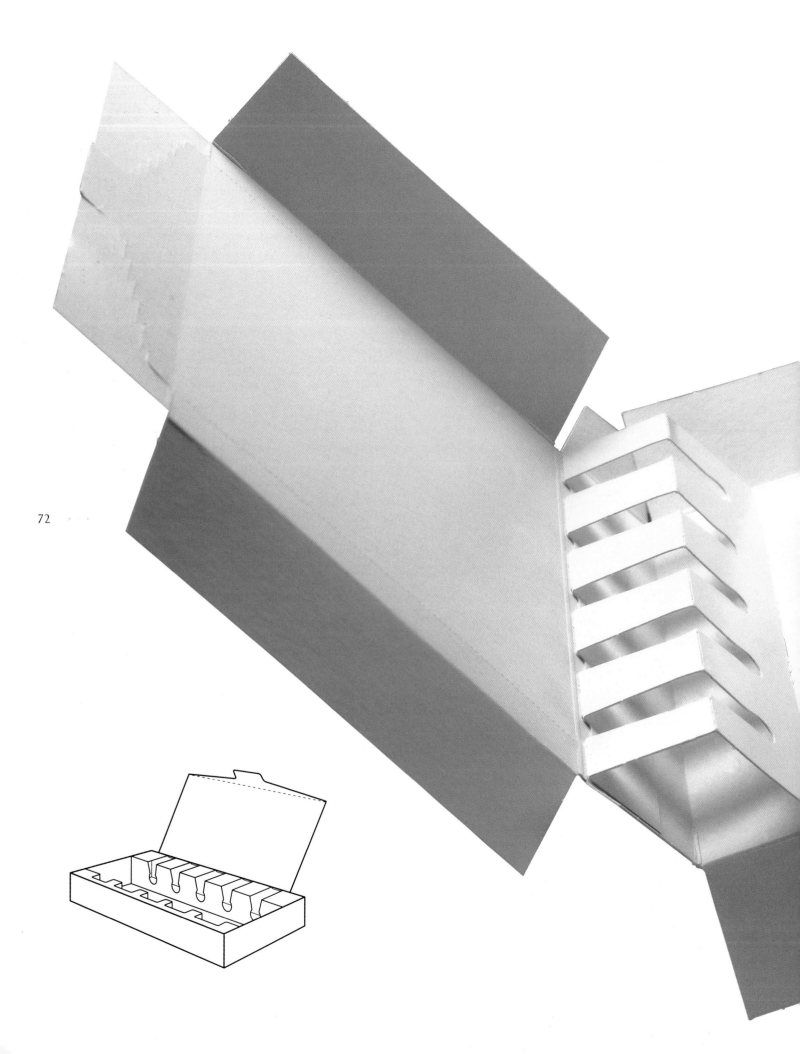

72

This cartonboard container replaces a former package that used two expanded polystyrene inner components plus a carton sleeve which were packed manually. A redesign of this package has produced a recyclable pre-glued carton utilising a single material. On the production line, these cartons can be automatically packaged with up to 3,600 ampoules per minute. The innovative engineering provides strong protection for the glass ampoules and can be supplied flat-packed for efficient space-saving. It is reclosable after use and fully recyclable when empty. Economic savings include a 20–25% reduction in packaging cost with additional savings in transportation. • CtB

Metsä-Serla Oyj

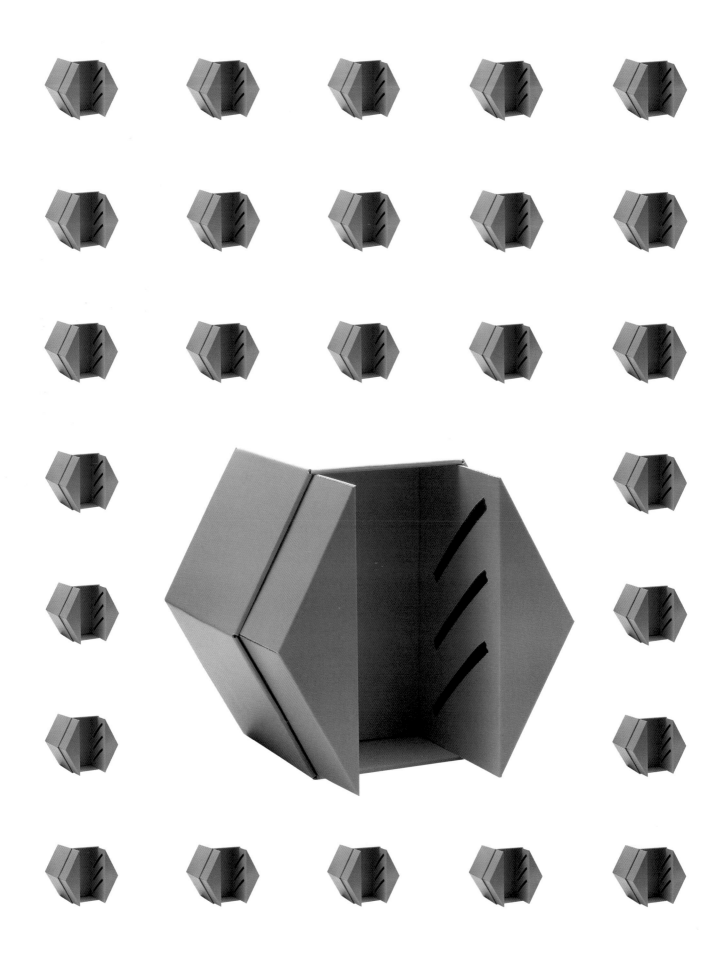

This package provides a one-piece corrugated inner fitting that protects and locates the product inside. The box is designed for reuse as a hatbox after the product and inner fittings have been removed. Each component is manufactured entirely from corrugated fibreboard for easy recycling and has eliminated the need for extensive use of bubble wrap and loose-fill chips to protect fragile items of differing size. Each uses over 78% recycled paper and other virgin materials. Varied packaging designs can fit a wide range of product requirements. The damage return rate caused by incorrect repacking has been significantly reduced. In the case of vase packaging, this has been reduced to less than 1%. The single material pack is more readily recycled and it reduces storage space by 40%, and is used in the production of subsequent corrugated packaging. • CtB

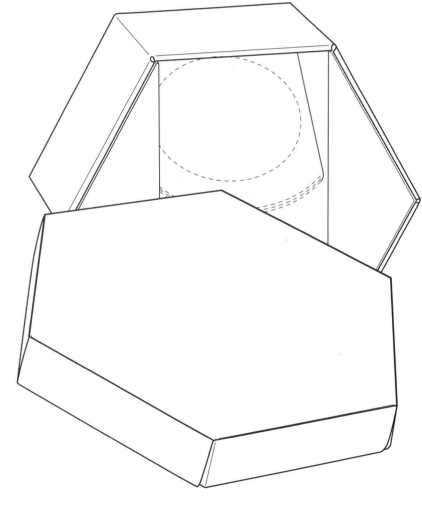

This product is made from fully renewable and biodegradable raw materials. Consisting of 50–70% wood chips, 20% ground corn and other natural resins, it has a wood-like finish and is comparable to some types of manufactured wooden fibreboard. The material is versatile, can be manufactured in many different forms and is suitable for a wide range of applications, including those traditionally favoured by plastic and wood production techniques. It can be processed in traditional plastic-processing machines. Water resistance remains for several months, though biodegradability is achieved in a few hours if totally immersed in water, or days if composted in soil. • WO, CE

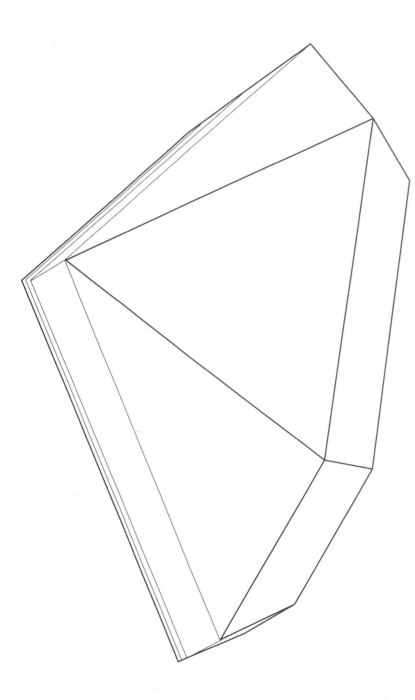

Design4u BV

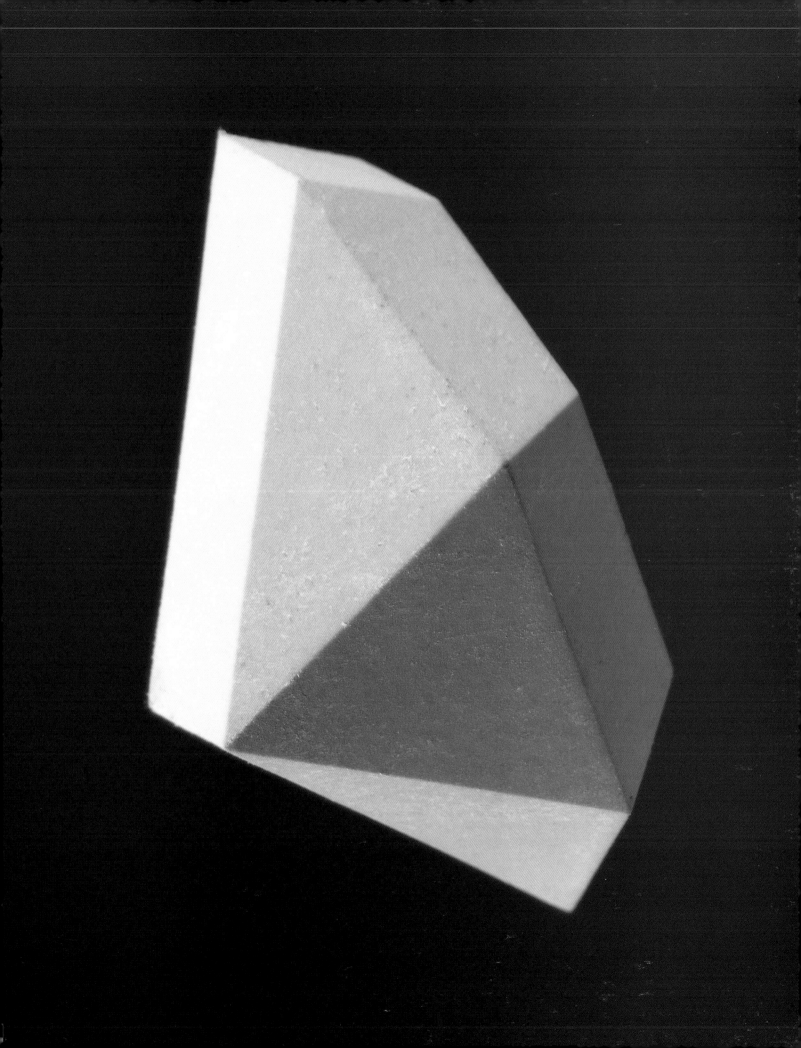

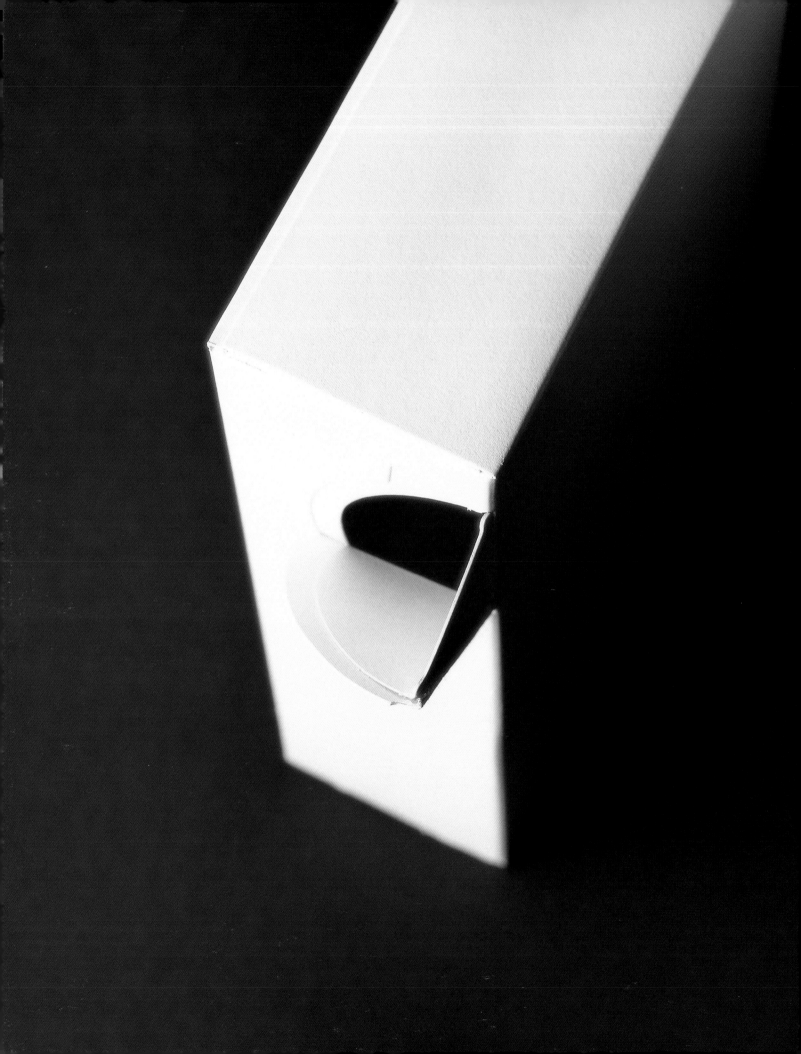

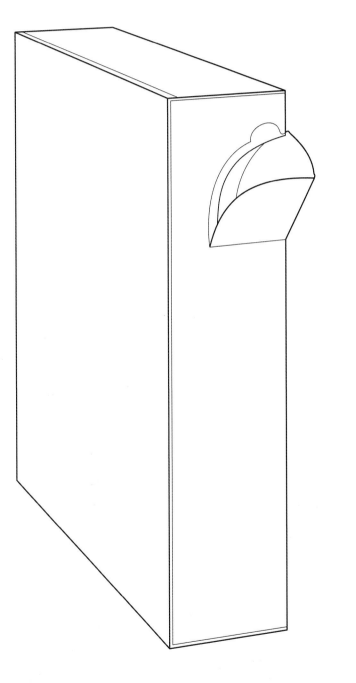

Many of the cartonboard boxes that are sold today still contain an inner plastic pouch to maintain freshness and provide a barrier to contamination through the outer board. After use, this plastic pouch seldom gets recycled and usually ends up as landfill. Stora Enso of Finland provide their customers with a coated paperboard that requires no inner pouch to maintain freshness. This eliminates the need for additional plastic materials, making the carton lighter and recycling more efficient. • CtB

POUCHLESS DRY-FOOD CARTON 79

Dry battery packaging typically consists of two pieces of packaging. These usually comprise a vacuum-formed plastic cell glued to a card backing-board. This battery packaging eliminates the use of plastic and utilises only one piece of paper material with an open window through which the product can be viewed. The use of a single material makes this package easily recyclable, whilst also being biodegradable. Different designs suit different sizes and shapes of batteries. • CtB

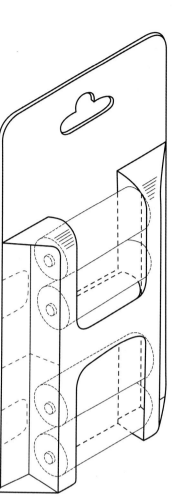

Sony Corporation

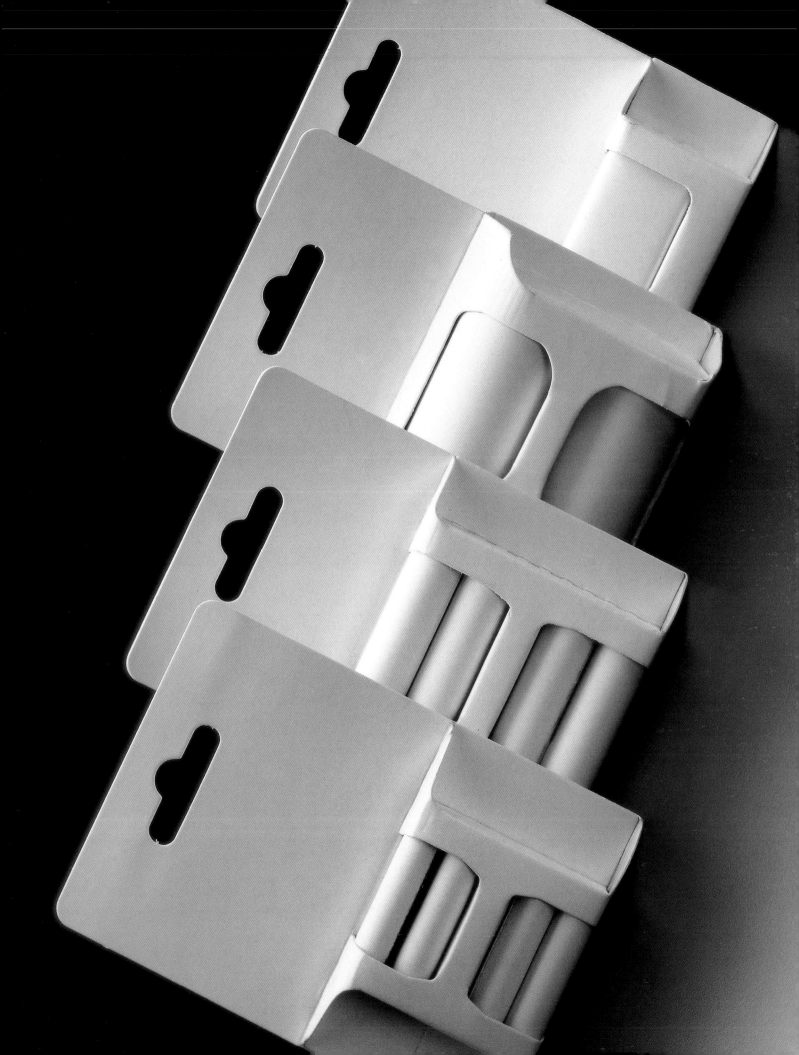

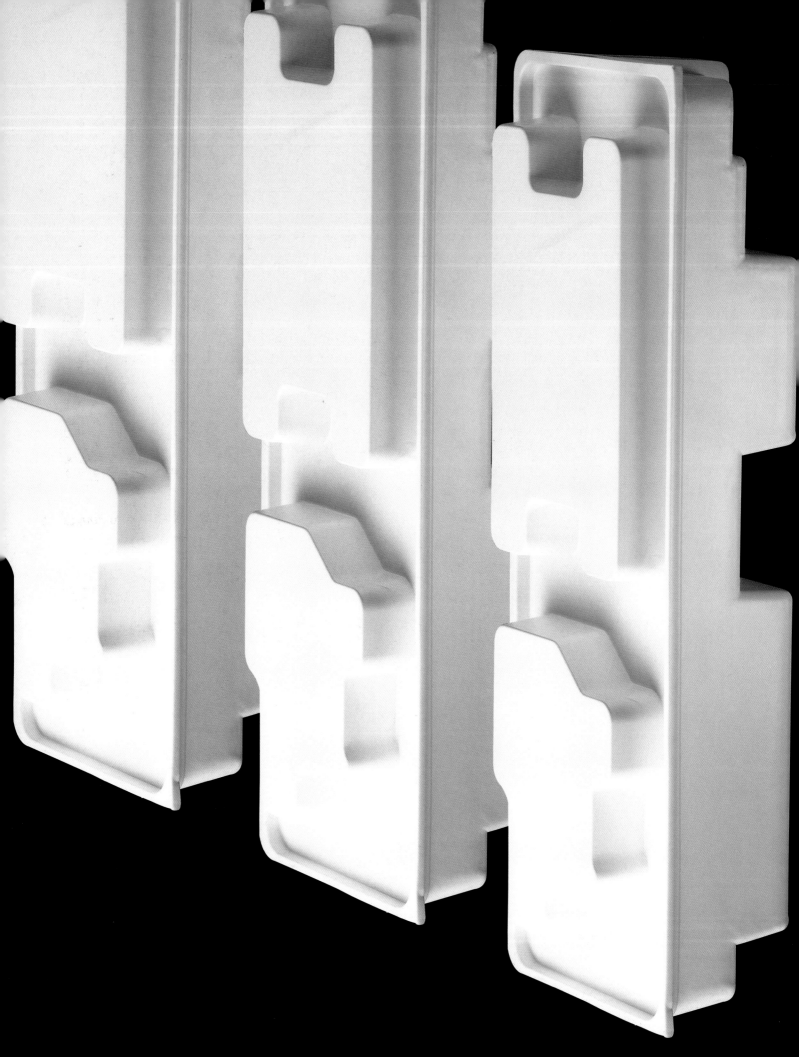

Berkley Industries

This polystyrene vacuum-formed single moulding designed for ink-jet printing cartridges holds three components and replaces a previous package that was made of die-cut chipboard. The simplified package provides greater efficiency in packing and a cleaner working environment due to the reduced amount of board and dust. Manual involvement in packaging the cases is reduced by 25%, thereby shrinking assembly space. Manufactured from 100% post-industrial high-impact polystyrene, the deep reservoir holds the cartridge in its base and has two cavities in its lid for other components, providing strong and secure protection. All internal components are also made from 100% post-industrial material. • PS

CLAM-SHELL CONTAINER 83

This paper carton uses new multilayer paperboard and only 20% plastic as a thin layer on the outside and inside, and so significant weight reduction has been achieved. Today Stora Enso is able to manufacture coated paperboard which provides 50–80% more cartons from the same wood volume than was possible 30 years ago. In order to get the required barrier properties, a single layer of plastic is used for milk and a multilayer used for water and juices instead of aluminium foil. • CtB, PP

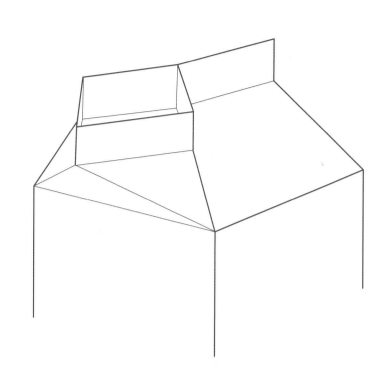

84 **PAPER GABLE-TOP CARTON**

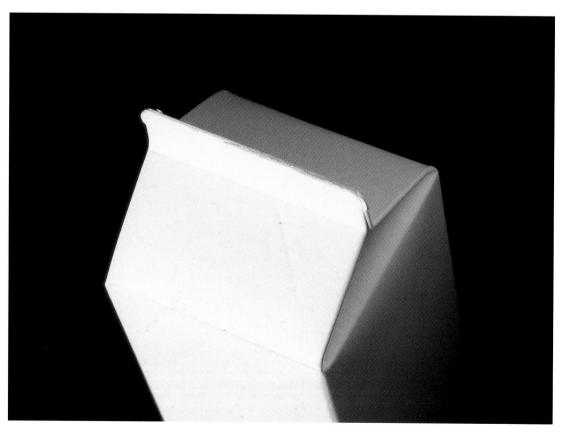

Stora Enso Oyj

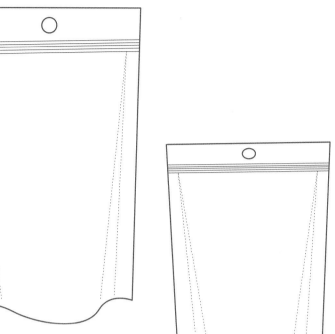

This is the first stand-up pouch designed for products as hard and abrasive as fertiliser spikes. As a package destined for outdoor retailers and garden outlets, it provides a fade- and weather-resistant package while replacing previous packaging materials. These included packages ranging from PVC trays sealed to a pegboard to cartons with a PVC wrapper. It is resealable and waterproof. Compared to the plastic-wrapped box, this package reduces packaging materials by up to 50%, while providing greater space and cost efficiency. • PO, LDPE

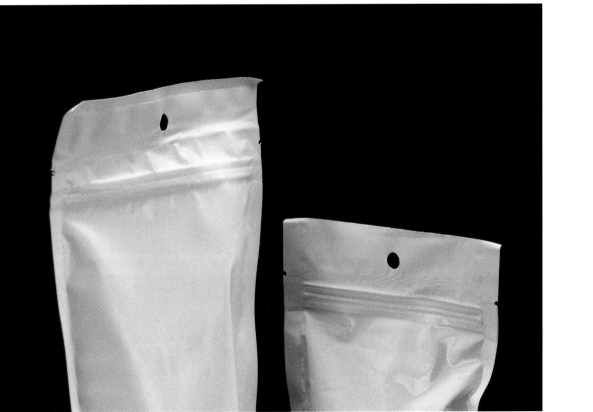

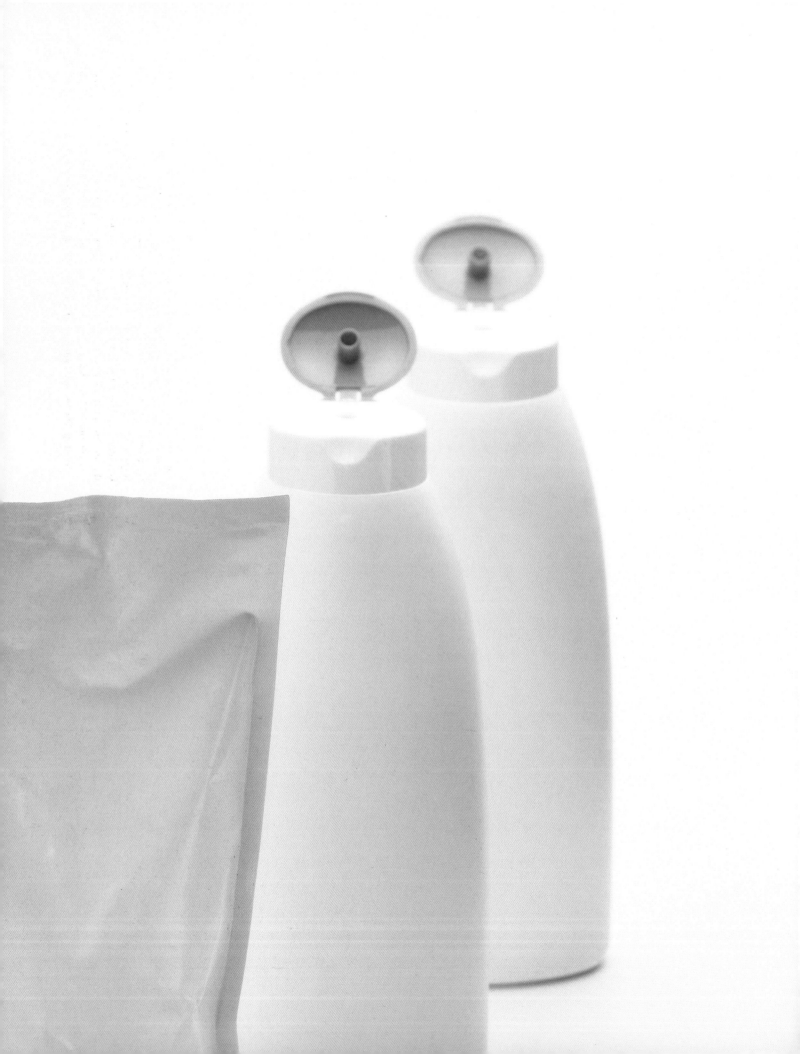

Yves Rocher

Concern for the substantial wastage of individual bottles after their use led to flexible packaging alternatives being developed. Now widely available in a number of product categories such as domestic cleaning products, this method of packaging remains unpopular in markets catering for personal hygiene and higher-end applications where consumers still prefer to use complete, one-off products. Yves Rocher has maintained this method of flexible packaging as a way of providing a refill for its hair- and skin-care products. These flexible pouches use considerably less material than one-off bottles, and being flexible and lighter weight cause substantial savings in transportation. • LDPE

FLEXIBLE REFILL 87

This liquid container is designed for outdoor activities and collapses for easy storage in any size pack after use. It can withstand both freezing and boiling temperatures with a useful working temperature range from -29 degrees Celsius to 104 degrees Celsius. The neck will accommodate all major filters and purifiers made for outdoor use and also provides easy access for cleaning. This makes the vessel fully reusable, while maintaining high standards of safety and hygiene. • PO

88 **FLEXIBLE LIQUID VESSEL**

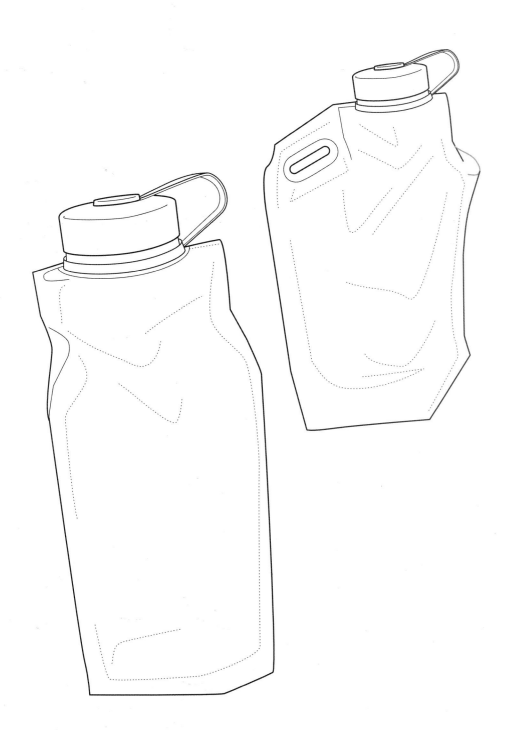

Nalgene
Pactech Engineering Inc.

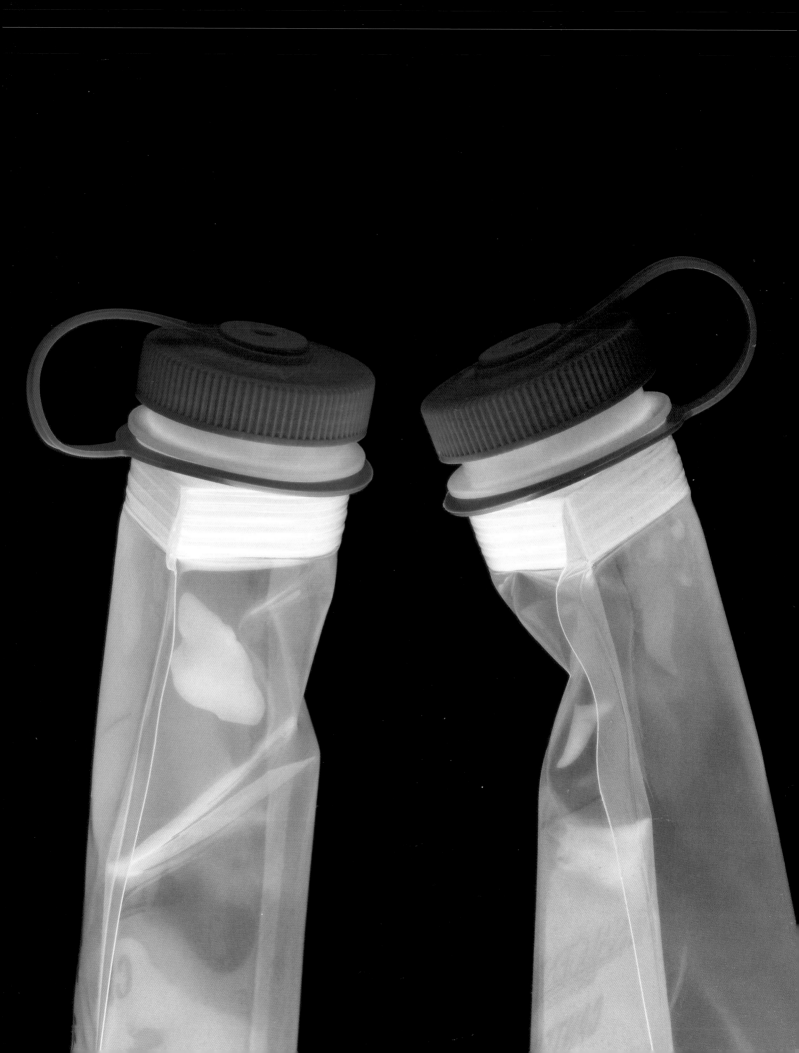

This pre-measured, 2-ounce packet of grease is designed to provide a clean and efficient approach to the process of greasing the fifth wheel of a truck. It replaces 55-gallon drums of grease and the special tools for applying it, as well as contributing no waste to landfill. To use, drivers just put the packets on the fifth-wheel plate or on either side of the kingpin before coupling the trailer to the tractor. The weight of the trailer ruptures the pouch and spreads the grease. The friction between the plates causes the thin plastic packet to disintegrate. The packs are made from food-grade film usually used for bakery wrapping, with an outer coating that accepts a water-based ink. Work is being carried out to use bio-based or biodegradable lubricants and films to contribute further to this product's environmental credentials. • PP

SINGLE-USE GREASE POUCH 91

These two plastic films are manufactured from a cellulose-based material and dissolve rapidly in water under 50 degrees Celsius, leaving no harmful elements. Both can be heat-sealed to provide an effective barrier against contamination from oils or solvents. Such heat-sealing processes can be operated on machines designed for unsupported polyethylene films. One of the unique characteristics of one of these films is that it is edible. This film becomes insoluble above 54 degrees Celsius and so is particularly useful in systems centred on heat-sensitive processes. Colours and flavours can also be incorporated into the film for specific interest or identification. These will be released into the solution upon the film dissolving. • CE

WATER-SOLUBLE & EDIBLE PLASTIC FILM 93

Emik Ltd.

The most efficient way to package an item utilises no material at all. This package exploits this by using air to provide cushioning. The outer and inner layers of this package consist of laminated plastic that provide superior strength against puncture and tearing while offering long shelf-life. The materials are available non-static-coated and coated, to protect static-sensitive electronic products. The static-coated materials have two laminated outer and two coextruded inner layers. An airtight seal is maintained up to 19,000 ft when airfreighted (most aircraft are pressurised to a maximum of 8,000 ft). Compared to alternatives this infinitely reusable cushion provides up to a 30% saving in packaging cost, 35% shipping cost, 90% storage space, 99% dunnage saving and 99% dumping cost in landfill. After testing, breakage was reduced to zero. • LDPE

94 **PROTECTIVE AIR BOX**

APTI

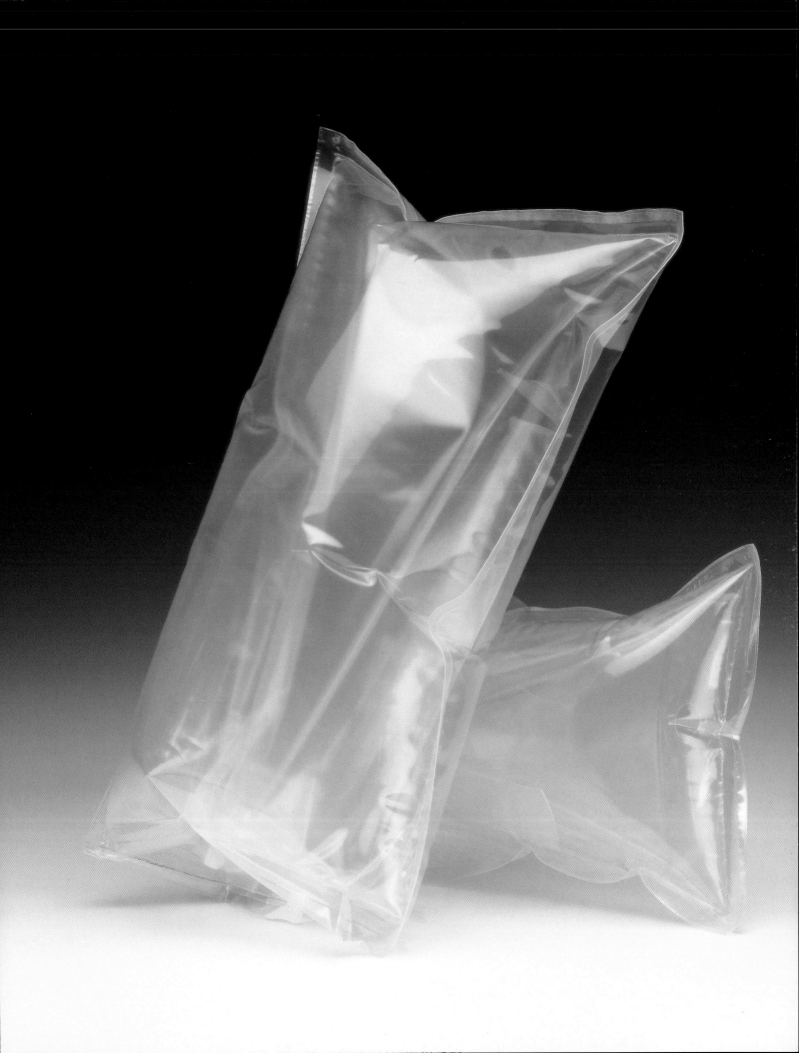

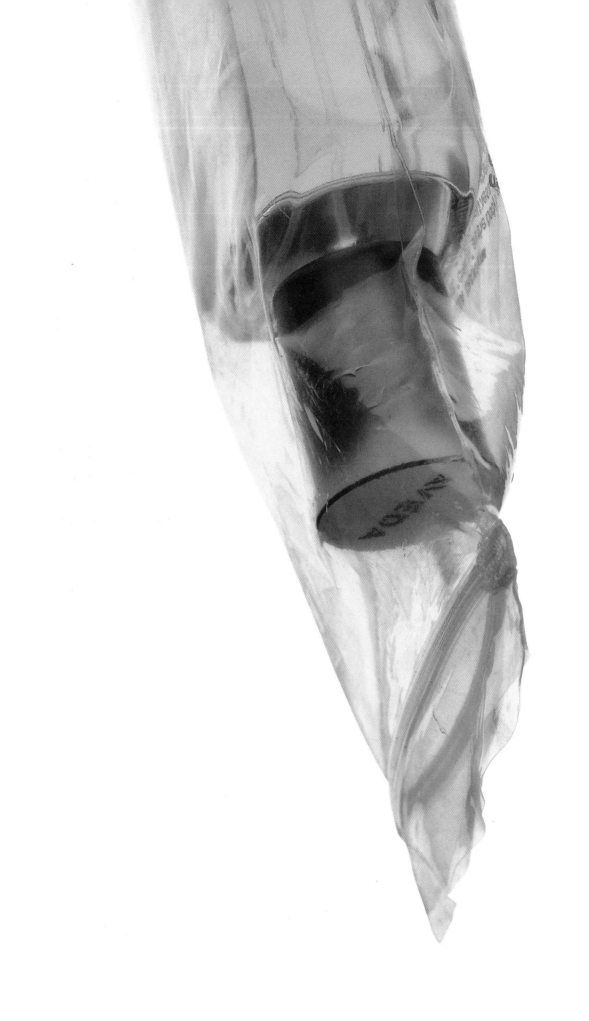

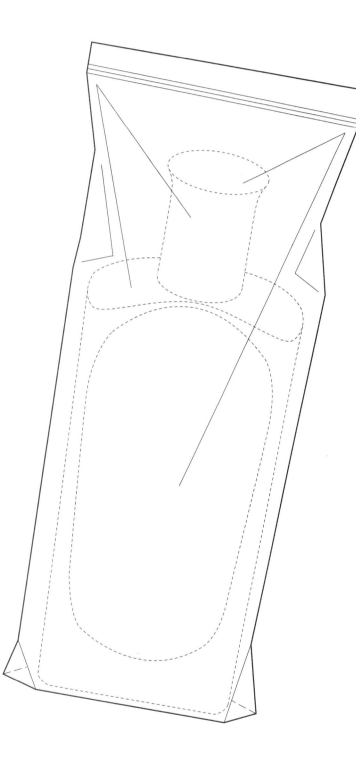

Aveda

This reusable LDPE pouch is used to contain high-end products such as fragrances. Made with 10% post-consumer content, this lightweight packaging option allows considerable space and weight savings to be realised in transportation, while also providing an attractive and practical means of displaying the product within. This option saves 3.6 tonnes of paper per year and reduces the environmental impact involved in cartonboard manufacturing by 74%. • LDPE

SPRAY DISPENSER POUCH 97

To widen the scope of this packaging range further, this elongated package was designed to contain longer foodstuffs such as baguettes and kebabs (PCT/GB96/01941). This package is available for hot and cold foods, though the use of plastic is required in the cold packaging to provide a barrier and product visibility. The hot food option is made entirely from recyclable paper materials. It is delivered flat-packed, saving storage and transportation space and can be easily erected before use. It is lighter and uses less material than alternative packaging. These materials can be easily separated for recycling. • CtB, PP, CE

RAP

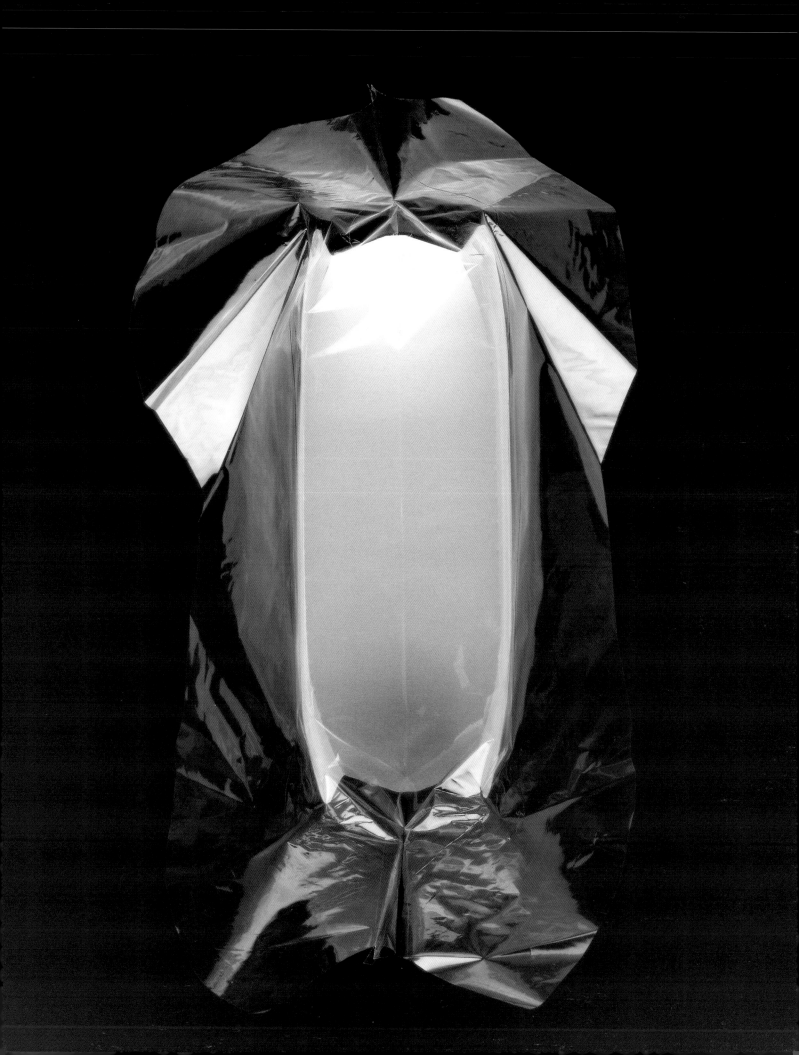

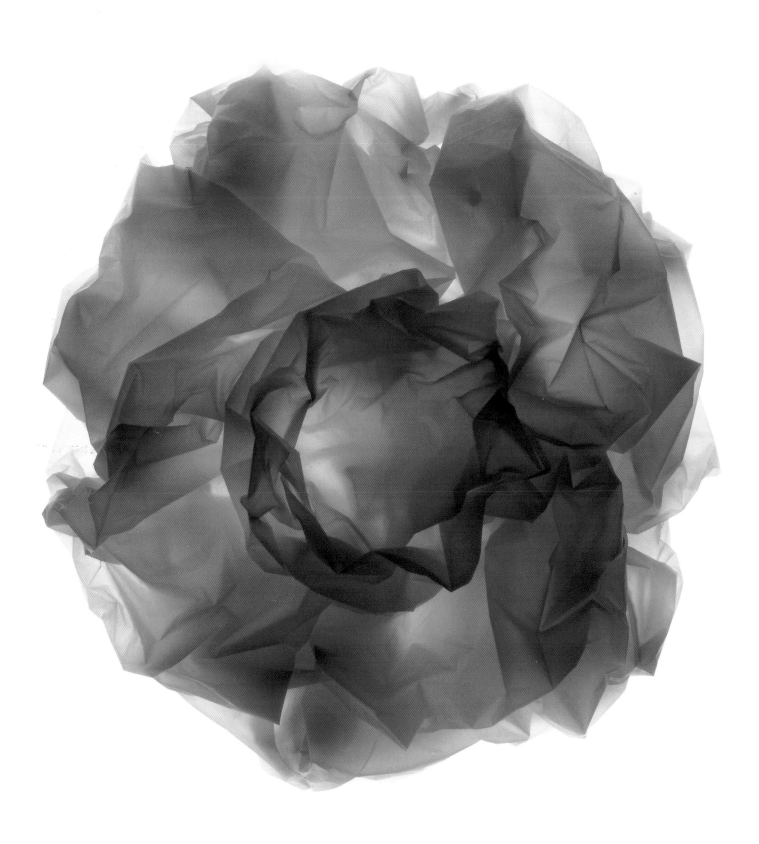

LOMBARD Pty Ltd.

In addition to products and foodstuffs that require packaging responsibly, even our waste needs to be packaged at some point. This too should bear equal environmental concerns. Efficient systems of collection and retrieval necessitate containers to carry waste to be disposed. These containers should perform their task without adding to the waste already generated, and thus should be durable and degradable during and after use. These biodegradable starch bags provide these characteristics by containing the waste effectively prior to final disposal before disintegrating harmlessly. In landfill, this helps speed up the process of decomposition that takes place as materials are exposed to oxygen and water. These bags are also ideal for collecting waste to be composted, as the entire package can be composted without separation from the outer container. • StC

BIODEGRADABLE RUBBISH BAG 101

This range of packaging utilises air and the space around a product for packaging with great effectiveness. It uses the space created by a container to suspend or retain the product and keep it away from any impact incurred on the shipping container. This may be done in a number of ways, either between two layers of elasticised low-slip plastic in tension or held firmly against a backing board within a corrugated frame that fits inside the shipping container. The packs store flat, thereby reducing space in storage and transit. Packaging materials are reduced by up to 78% and can be reused. They are made from at least 30% recovered paper fibre and can be fully recycled in most pulping facilities. • CtB, PO

102 **SUSPENSION & RETENTION PACKAGING**

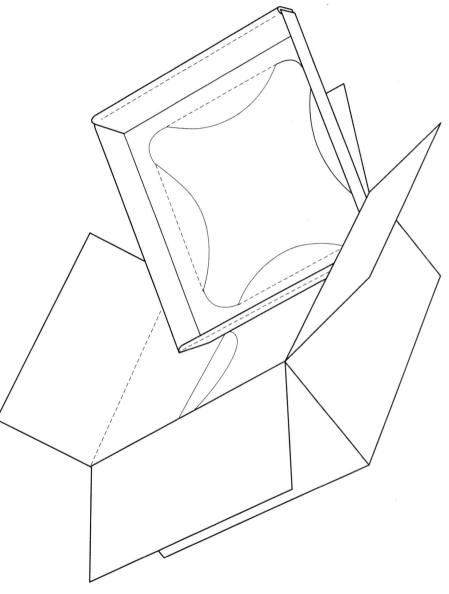

Sealed Air Corporation

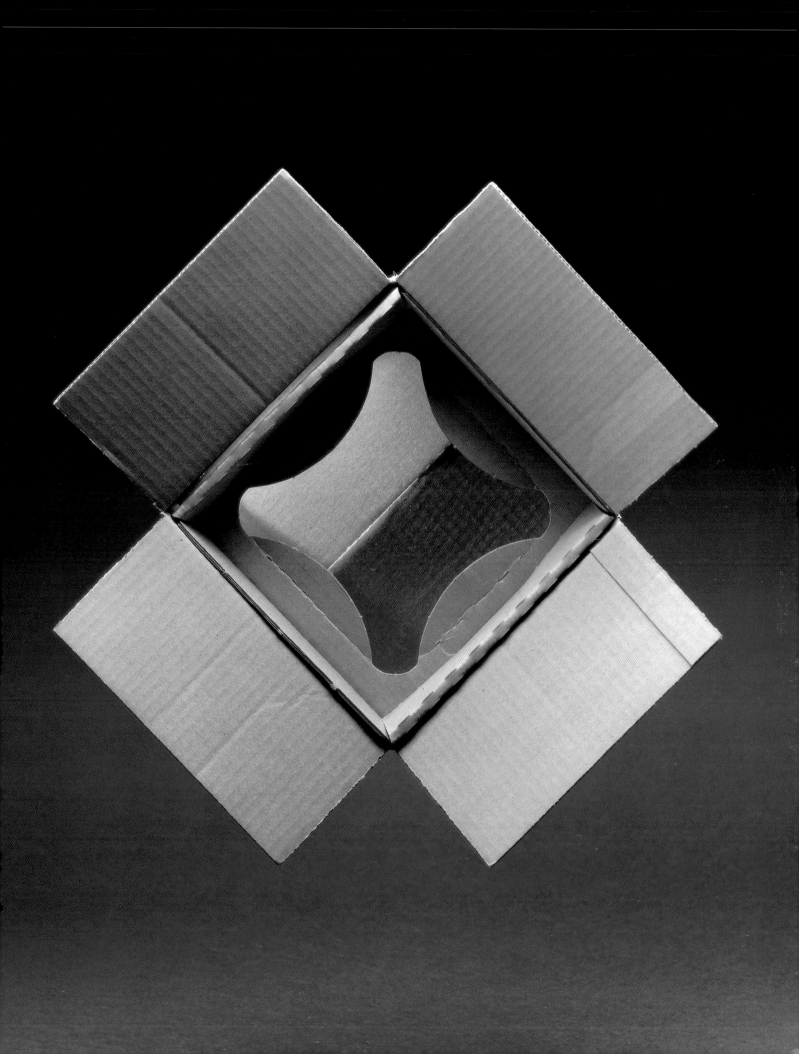

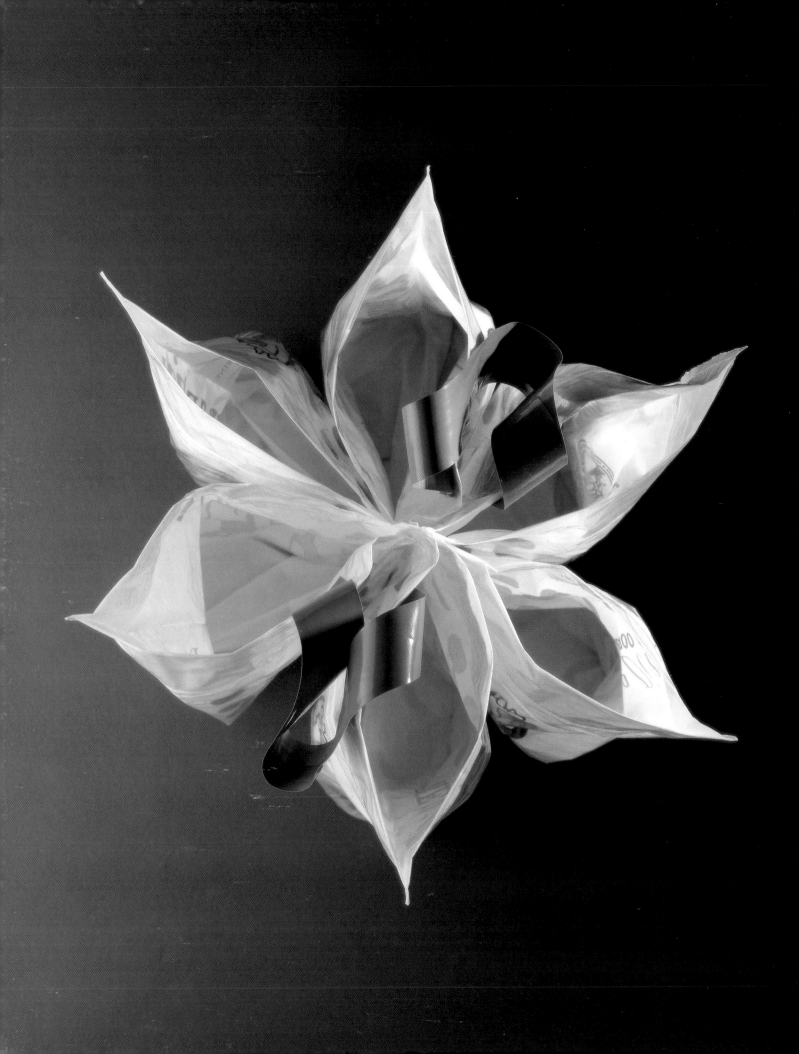

This reusable replacement wine carrier bag is designed to carry up to 6 bottles. It is more robust, flexible and resistant to rain damage than traditional cardboard equivalents provided by other supermarkets. It was designed to accompany Waitrose's reusable carrier bag, which was the first reusable bag offered by a large chain of stores. The products are robust and designed to last approximately 20 trips. The reusable carrier bag saves up to 40 normal bags. In the first 3 years, 8 million reusable bags had been sold, saving an estimated 160 million free bags from being manufactured, which in turn prevented approximately 1,250 tonnes of plastic going into landfill. Both bags are made from 15% recycled plastic waste and manufactured in the UK as opposed to the Middle East where the free bags were produced, thereby eliminating considerable transportation costs. They can be replaced for free and recycled to manufacture new plastic items such as trolley corrals for the stores, local charities and schools. • LDPE

Waitrose

REUSABLE SHOPPING BAG 105

The traditional packaging of individual ice creams in complex aluminium or plastic laminates is a common source of litter and waste material. This paper cone for ice-creams in the Czech Republic is topped with a round cartonboard lid making it fully recyclable and biodegradable. In this instance it replaces the use of aluminium foil, thereby preventing non-renewable resources from entering the waste stream. • PA, CtB

STYBA Packaging Association

PAPER CONFECTIONERY WRAPPER 107

Many different international companies are becoming conscious of the ecological footprint that they and their operations stamp on the environment. The Body Shop is one chain that has, from its very inception, sought to minimise this footprint. The most renowned solution, that was to become one of their leading trademarks, was the use of a company-wide refilling system for many of their hair and body products that utilised the same bottle design. This system required the customer to return their empty bottles to the store to be refilled. The system was supported by minimalist product identification that served to emphasise the product itself over the design of its graphic identification. The shop also accepts bottles from the customer for recycling. • LDPE

108 **REFILLABLE PLASTIC BOTTLE**

The Body Shop

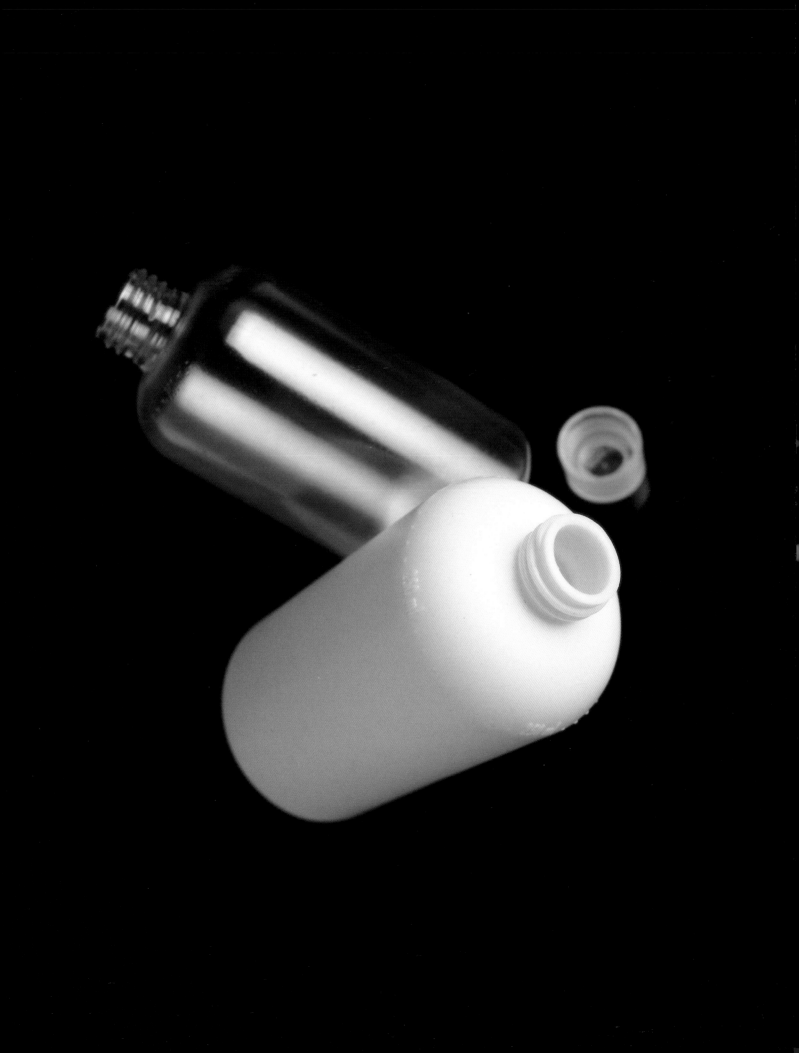

The coloured and clear plastic bottles used throughout Aveda's cosmetics range contain 40% post-consumer HDPE. Often perceived to be of a lesser quality and therefore particularly problematic in high-end products, post-consumer waste is seldom used in this type of market. In providing a use for recycled material, these products encourage the recycling process by proving that quality is not compromised. • HDPE

110 **RECYCLED PLASTIC BOTTLE**

Aveda

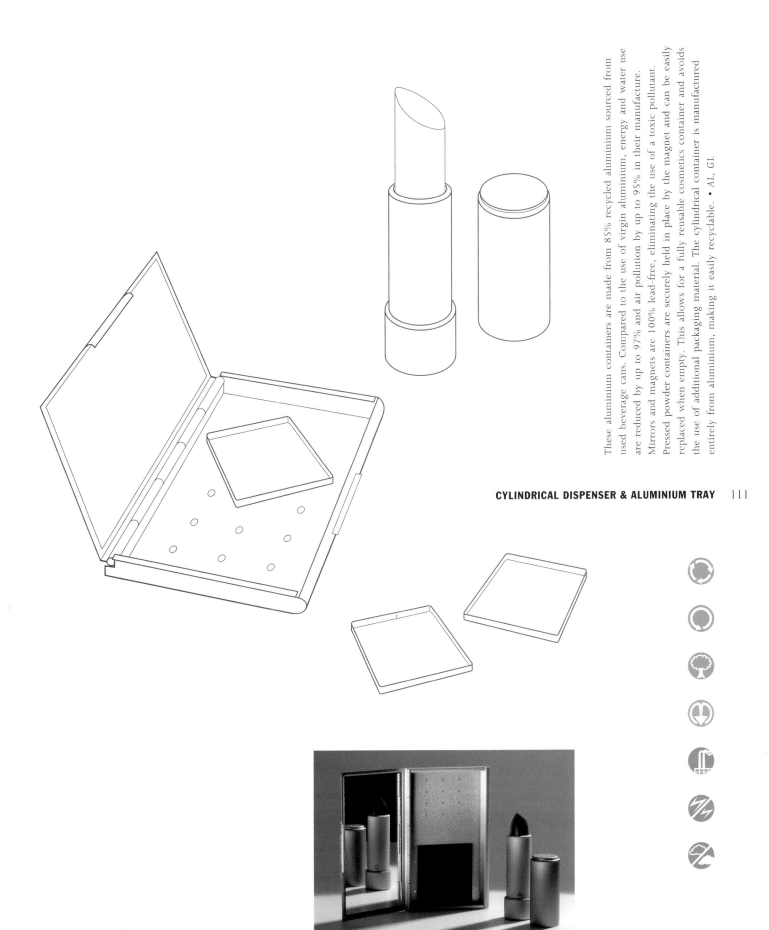

These aluminium containers are made from 85% recycled aluminium sourced from used beverage cans. Compared to the use of virgin aluminium, energy and water use are reduced by up to 97% and air pollution by up to 95% in their manufacture. Mirrors and magnets are 100% lead-free, eliminating the use of a toxic pollutant. Pressed powder containers are securely held in place by the magnet and can be easily replaced when empty. This allows for a fully reusable cosmetics container and avoids the use of additional packaging material. The cylindrical container is manufactured entirely from aluminium, making it easily recyclable. • AL, GL

CYLINDRICAL DISPENSER & ALUMINIUM TRAY 111

Aveda

This new software package designed for Microsoft Office 2001 for Mac software for Macintosh computers was required to be innovative, streamlined and stylish. This resulted in a slim, reusable plastic pack that has the space to store nine additional CDs and replaces a cumbersome cardboard box pack that was ten times heavier. The base is made from 100% post-consumer plastic, while the top is virgin material to maintain a clean appearance. With on-line instructions available which save paper, the only other materials now used are for the license agreement, front and back promotional sleeves, a small installation manual and plastic shrink-wrap. Transport costs have been reduced by 50%. • PP, PO

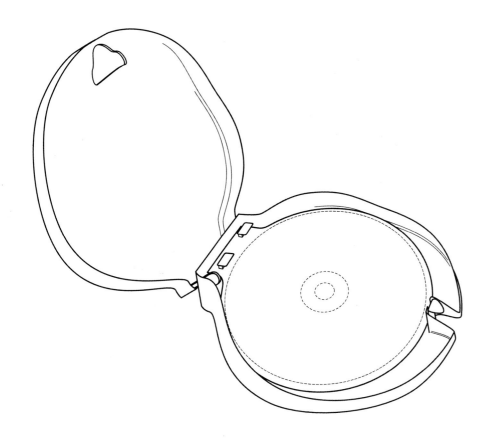

112 **SOFTWARE PACKAGING**

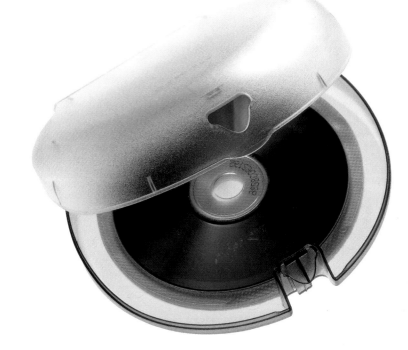

Microsoft

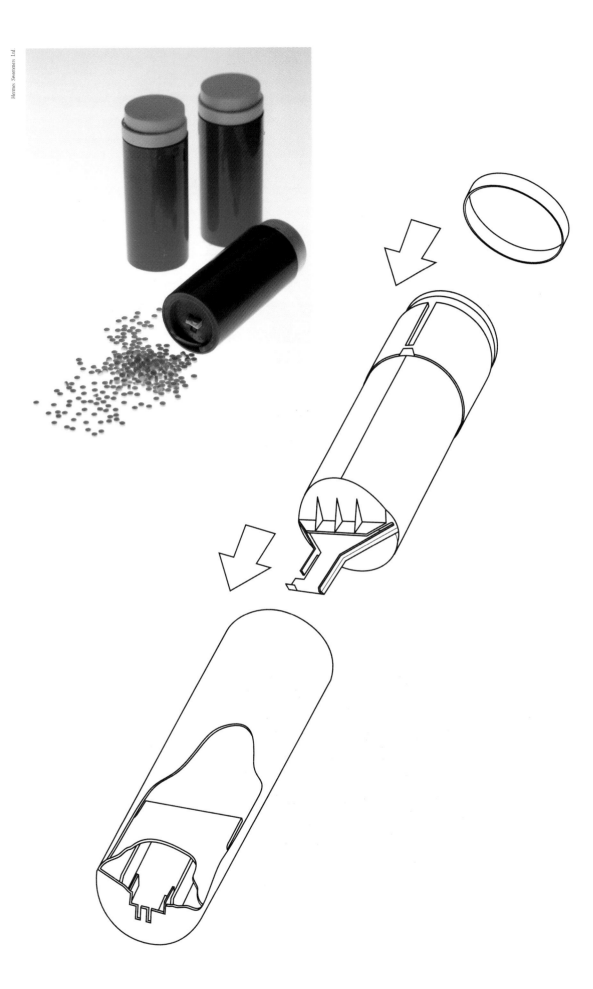

Earlier versions of this tablet dispenser utilised a number of different components and materials. This redesigned dispenser has improved function and maintained capacity by reducing the number of components and materials, whilst now also being refillable. The components in this redesigned dispenser have been reduced from six to three. The number of materials has been reduced from four to two, eliminating the need for a steel feather and reducing costs by 30%. Now lighter weight, easily dismantled and recycled and also refillable, this new dispenser has been significantly improved economically, functionally and environmentally. • PP

TABLET DISPENSER 113

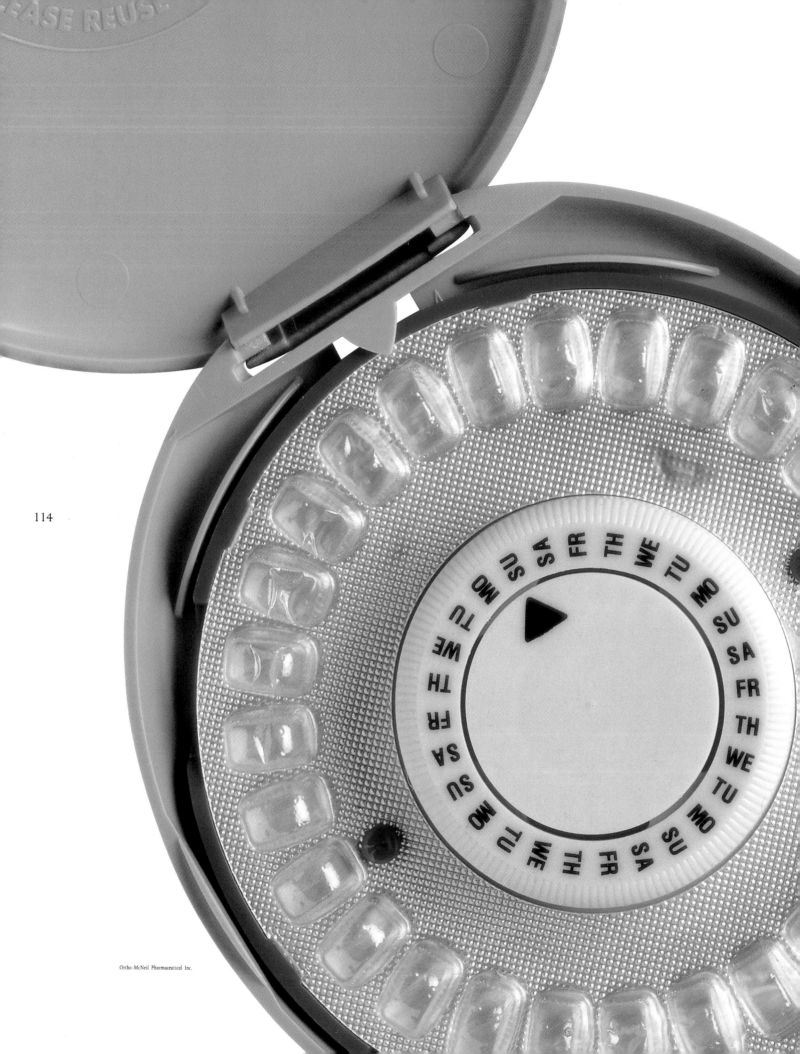

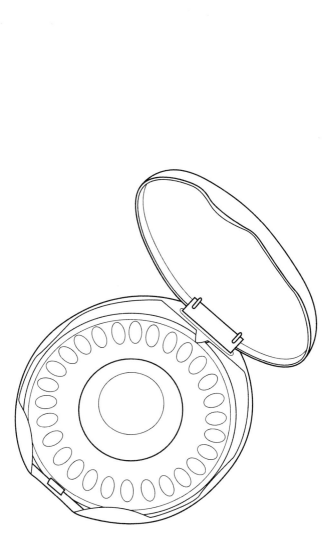

The design of this refillable, reusable and recyclable dispenser was conceived to provide a discreet and stylish container for the contraceptive pill. Each disc of pills can be replaced at the end of each cycle, generating less waste. Ortho-McNeil estimates that if all those currently taking this medication were to switch to this type of reusable packaging then 657 tonnes of plastic would be saved each year compared with traditional packaging. • PS

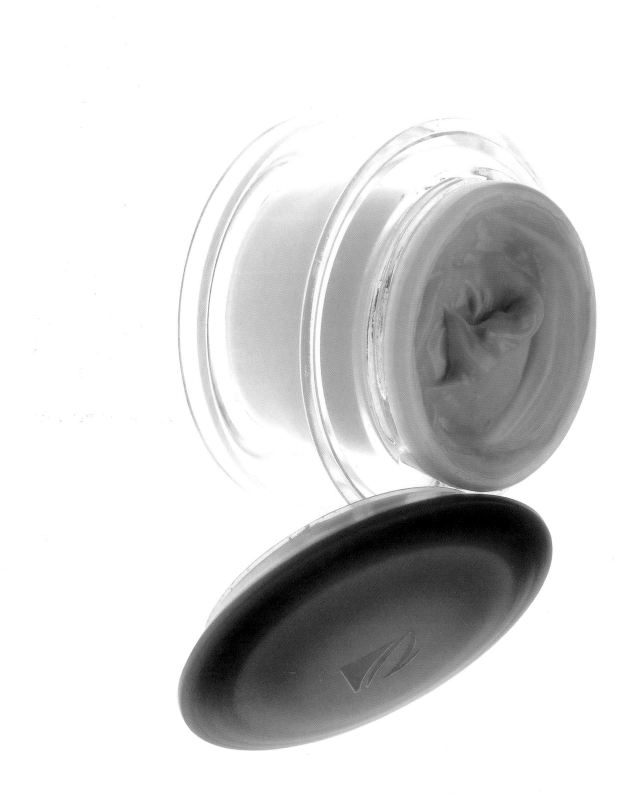

Although there is increasing popularity in the use of refillable packages for liquids, these packs seldom infiltrate the higher-end markets such as cosmetics and beauty products. This design challenges both these perceptions. By using a replaceable inner pot for containing moisturising cream, the outer package and lid act as the aesthetic container and provide protection to the contents. When the inner refill pot is empty a new one can be inserted without any mess or need for cleaning out old moisturiser. This system reduces material content by 82%, use of natural resources by 85% and energy use by 91%. It also reduces the cost of transportation and saves space. • HDPE

REFILLABLE COSMETICS POT 117

Designed to prevent the wastage of valuable materials after use, these bottles can be reused in many different ways as containers for other products or can be used to build a wide variety of recreational or functional structures. As individual modules these bottles can be attached securely to one another lengthways or sideways by pressing the knobs of one into the cavities of another. They are ideal containers for both liquids and solids and aim to prevent waste by adding value to a package through innovative design. • PET, PP, PVC, PS, PO

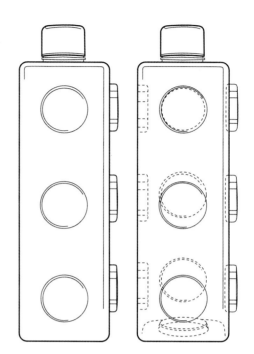

118 **MULTIPLE-USE BOTTLE**

EMIUM

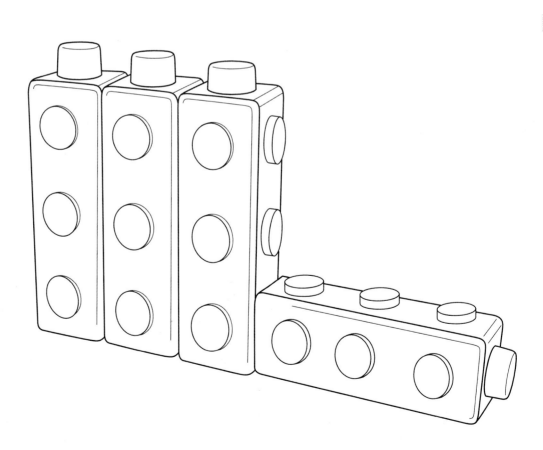

Manufactured by Karhulan Lasi
Supplied by the Association of Packaging Technology and Research

The range of glass bottles illustrated here is a selection used in the Finnish bottling industry. Each is designed to precisely the same specifications so that they can be returned for refilling regardless of the supplier. Suppliers of drink in Finland, whether alcoholic or not, conform to this system so as to ensure a closed-loop economy. Each bottle carries a deposit when purchased which is refundable on return. This ensures that all the bottles are safely returned for reuse, thereby minimising material and manufacturing wastage. This nationwide refilling system has ensured that Finland produces less packaging waste per capita than any other European country. • GL

REUSABLE GLASS BOTTLE 121

These plastic bottles are heavier duty than most plastic bottles manufactured today as they are designed for reuse in Finland's refilling system. Each is designed to precisely the same specifications so that they can be returned for refilling regardless of the supplier. Suppliers of soft drinks in Finland conform to this system for refilling plastic bottles so as to ensure a closed-loop economy. Each bottle carries a refundable deposit, which ensures that all the bottles are safely returned for reuse. This has significantly minimised material and manufacturing wastage. This nationwide refilling system has ensured that Finland produces less packaging waste per capita than any other European country. • PET

122 **REUSABLE PLASTIC BOTTLE**

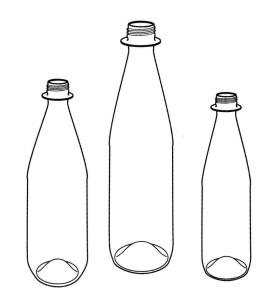

Manufactured by Ryttylän Muovi Oy
Supplied by the Association of Packaging Technology and Research

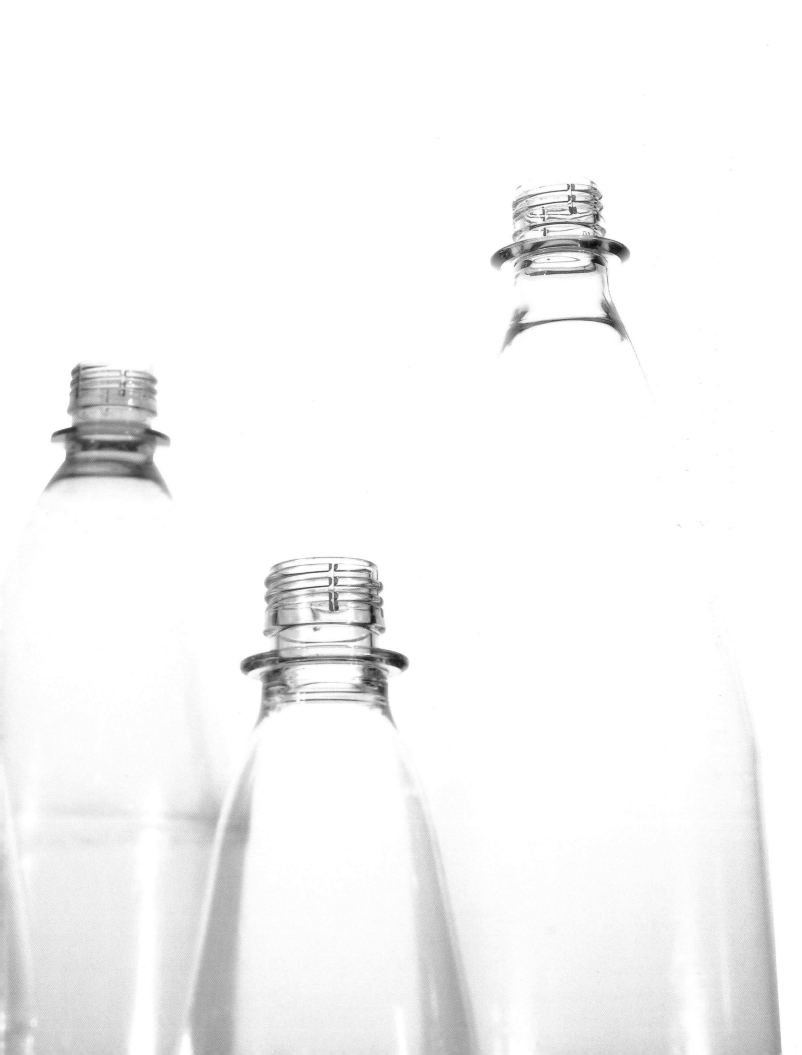

As one of the biggest recyclers in the world, Sonoco recycles more than 1 million tonnes of paper annually to produce paper products. This resealable paper-bottom canister comprises 70% recycled material. The paperboard used is 100% recycled, and includes 90% board from post-consumer sources and 10% from processes such as die-cutting. The remaining material could be made up of paper, plastics or metals depending on the customer's choice of closure. It is lighter than metal alternatives and increases shelf space. Unlike spiral-wound or convolute round containers, the shape does not restrict the manufacturing process and therefore provides many options for different shapes and sizes. A wider material sheet provides higher barrier protection and performance than spiral-wound containers. • PA, CtB, AL, HDPE, LDPE

RECTANGULAR COMPOSITE TUBE 125

This range of products has been designed to use as little plastic as possible. The rectangular shape has replaced circular containers, thereby providing a space saving of 26% on each item. Through clever stacking patterns, 30% less space is needed throughout its transportation, storage and distribution channels. The label is applied during the moulding process, thereby ensuring that only one material is used in the package, allowing for efficient recycling. The lid provides a tamper-evident seal and allows for reuse of the product. • HDPE

126 **OPTIMAL RECTANGULAR PLASTIC CONTAINER**

Stadium Design BV

Manufactured from some of the million tonnes of paper annually recycled by Sonoco, these containers are made from 100% recycled paperboard and wound together with other laminated materials such as aluminium foil and plastic films. Different options of materials for the lining, coating and closure provide the customer with a wide range of options to suit specific needs. This provides an effective barrier against moisture and oxygen permeation. These different options affect the overall recycled content by up to 50% or up to 90% with the use of a paper bottom. • PA, CtB, AL, ST, HDPE, LDPE

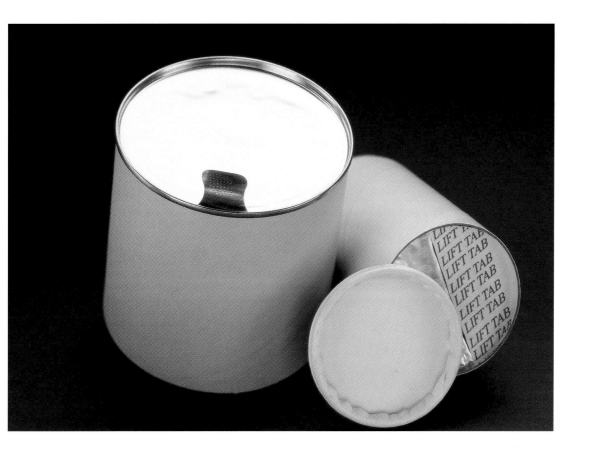

This aluminium or tin-plate ring can be seamed onto metal containers. The aluminium membrane with pull strip is sealed onto the ring. These processes take less time than existing sealing processes and use existing closing machines. This method of manufacturing provides efficiencies in energy use during production and a 10% reduction in weight. The open seal is also safe, with no sharp edges or product contamination created by the opening process. • AL

128　**SEAM-SEALED METAL CONTAINER**

Alcan Deutschland GmbH

Corus Packaging Plus

Most cans act as pressure vessels resisting pressure differences and have traditionally been manufactured from heavy, tin-plate materials. This lightweight product is able to flex with the pressure and give room to the expansion of its contents. Reduced environmental impact is achieved by using lighter gauge material and reduced scrap loss during manufacture. Overall savings equate to 15% less metal therefore a 15% weight reduction. The use of purified tin provides a low lead content with no additional heavy metals. The product is easily crushed to save space during collection and is fully recyclable. The larger surface area also provides a more effective sales platform. • AL

This 100% recyclable and reusable paper pallet is made of 100% corrugated fibreboard, thereby eliminating the use of wood. It significantly reduces cost and pollution in its production, and does not require the fumigation which wooden pallets must undergo to kill any insects. It is one-third of the weight of wooden pallets and could be mass-produced to any specified shape or size. Compared to a wooden pallet, it is safe and hygienic as it does not splinter or use nails or screws for construction. • CtB

Nippon Hi-Pack

Nippon Hi Pack

This package demonstrates the size and scale that can be obtained by using pulp moulding techniques. Manufactured from 100% post-consumer material these mouldings are designed to protect large fragile electronic goods during transportation. They replace expanded polystyrene mouldings, which cause considerable environmental damage. In contrast, these pulp mouldings are 100% recyclable and biodegradable. They are also lightweight, strong and static-free, which is very important when packing most electronic goods. They can be designed to protect products as large as full-size computer monitors or television sets. • PU

MOULDED PULP SUPPORT FOR ELECTRONIC GOODS 135

Manufactured using 100% post-consumer newspaper, this 100% recyclable and bio-degradable moulded casing provides a strong and lightweight cushioning to a wide range of products. Being static-free this type of moulded packaging is ideal for protecting electronic products. In this instance, this moulding has replaced a packaging piece that was made of expanded polystyrene, thereby achieving considerable environmental benefits over the use of a non-renewable material. • PU

136 **MOULDED BOTTLE SHIPPER**

EnviroPAK Corporation

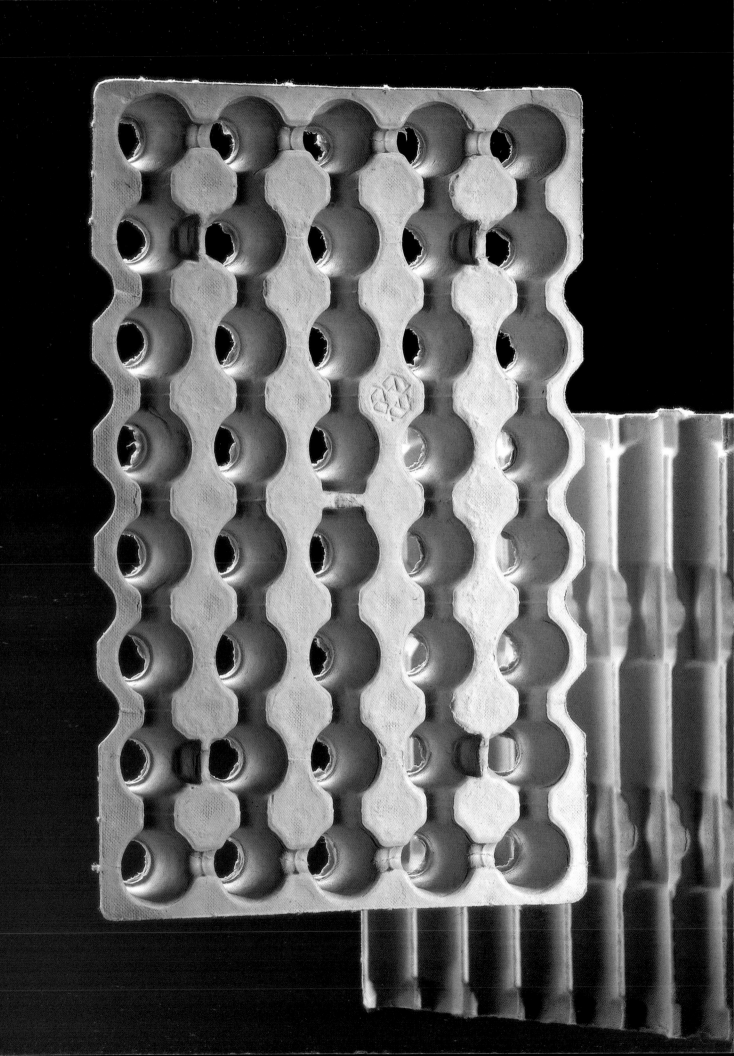

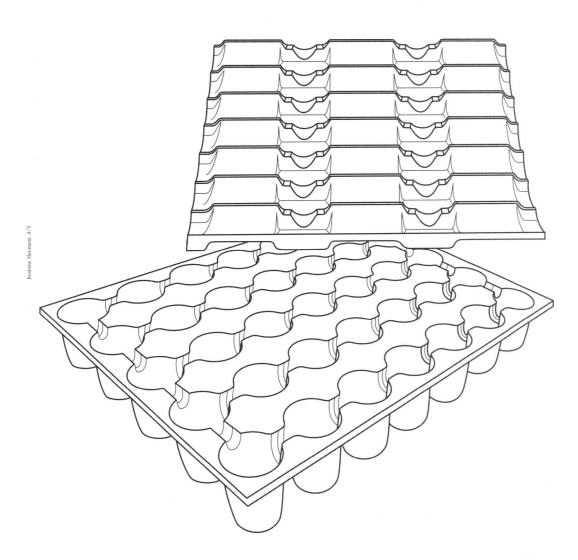

Brødrene Hartmann A/S

Manufactured using 100% recycled paper, this tray is designed for the transportation of highly fragile medical vials. The intricate detail obtained in this moulding demonstrates the diversity of this material and illustrates the fine degree of accuracy and definition that can be obtained in this type of moulding. This moulding is also 100% recyclable and biodegradable, lightweight, strong, cushioning, static-free, flexible and economical. By using this material instead of expanded polystyrene casings, it not only prevents the wastage of non-renewable materials but also provides a valuable use for different grades of recycled paper fibres. • PU

MOULDED TRAY 139

Much research has gone into whether certain crops could be used instead of paper to create pulp products. Early results from flax and hemp crops in Finland proved financially unviable, as their moisture content was so high that drying the crop was very costly, while their high level of lignin also posed a significant threat to the environment if mass-produced. However, with the introduction of a spring harvest, these crops dry out during the winter, preventing the need for drying later. The lignin is also removed by the perpetual frosts during winter. A special drying process achieves a second harvest in autumn increasing yield. Without this severe cold weather, the yields would be too costly. This method of production uses 10% of the energy used by wood-based pulp, making it an efficient, effective, renewable packaging material. • FH

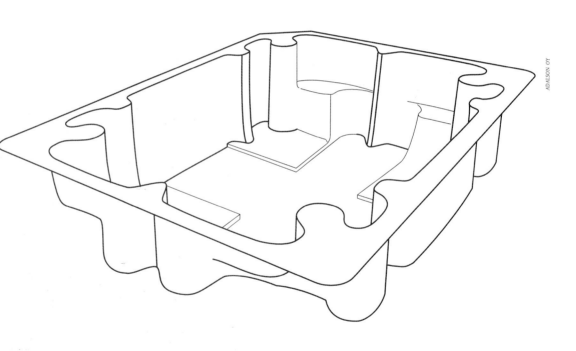

Potatopak and Apak have pioneered the use of potato starch for trays and inner containers for boxed goods. They overcame the problems of cross-contamination or leakage of materials, and an overly brittle structure to provide a light and completely biodegradable packaging material – a safe and compostable alternative to many other packaging materials. If discarded as litter, this material completely and harmlessly degrades in a matter of days. While research continues into providing renewable water-resistant barriers for this material, a specially formulated co-polyester film is sometimes currently used to seal the container against contact with the product. Developments in this technology could revolutionise this field of packaging. • StP, PO

**POTATO STARCH PACKAGING & WATERPROOF
BIODEGRADABLE TRAY**

Apak
PotatoPak Ltd

143

The increasing variety of materials for moulded void filling has opened this field of packaging up to stiff competition from the environmental sector. PaperFoam is one of the more recent materials to have entered this market to challenge older products such as expanded polystyrene. The ingredients for this material are renewable resources such as starch, natural fibres and water. With a foamed inner structure and smooth, dust-free outer surface, this package provides effective anti-static product protection and insulation. Its single-step production provides a cost-effective and energy-efficient manufacturing process. It is recyclable, biodegradable and can be composted or burnt without causing environmental harm. • PA, StP

144 **PAPERFOAM**

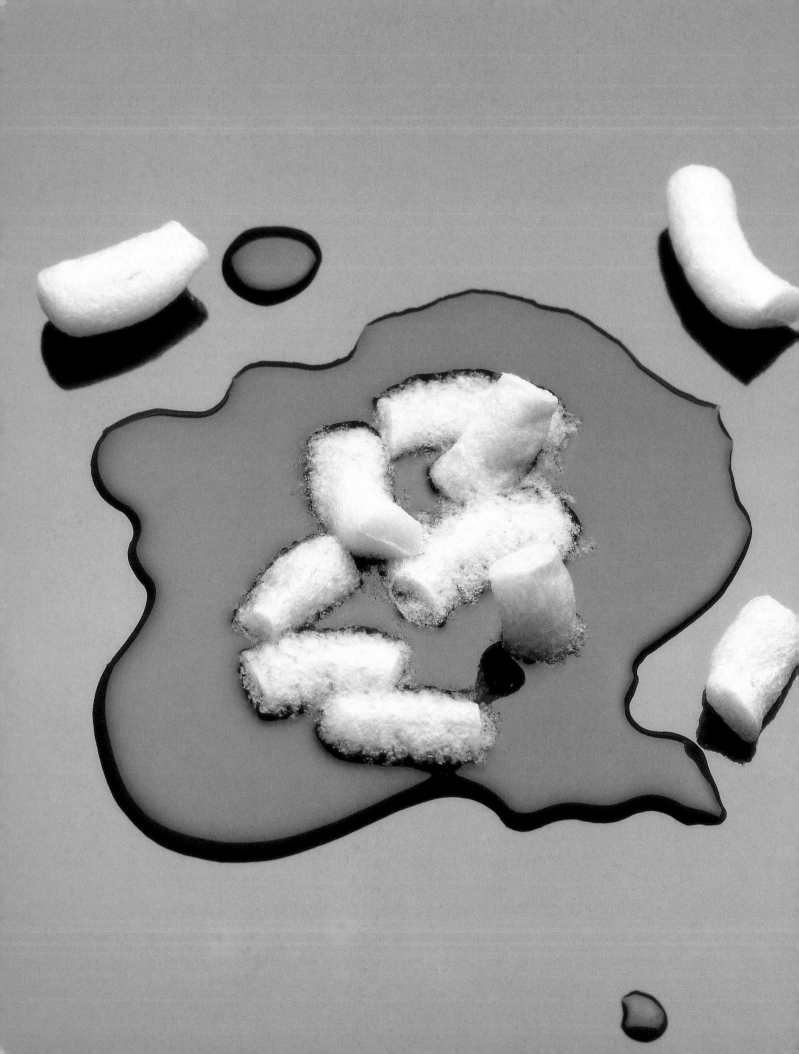

PRO-PAC Packaging (Aust) Pty Ltd.

This flowable void-fill cushioning material completely biodegrades in 13 minutes when mixed with water. It also composts without residues and does not pollute groundwater. These loose-fill pellets are derived from natural, annually renewable resources at a cost comparable to expanded polystyrene, and consist of a starch mixture made from potato, corn or wheat using a process of extrusion. The extremely high temperatures used in the extrusion process burn off any edible elements, and so the pellets do not provide a source of food for pests or vermin. These pellets are light, clean, free-flowing, static-free, reusable and versatile. • StC, StW, StP

BIODEGRADABLE LOOSE-FILL PELLETS 147

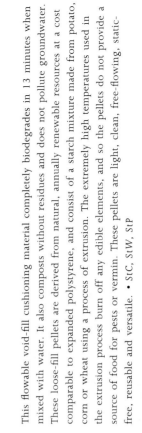

GREEN CHECKLIST

For the packaging designer, it is worth reflecting on a few practical points that might serve as a checklist for designing for the environment:

Always use the minimum amount of material to perform the task safely.

Use as few material types as possible.

Consider where the materials are to be sourced.

Use recycled materials wherever possible.

Make the package as light as possible without compromising safety.

149

➤ Consider how the pack is to be used and disposed of.

➤ Consider all packaging options e.g. reuse, refill, compost.

➤ If possible, utilise the product strengths in the package to reduce material use.

➤ Consider the product's use and design appropriately e.g. biodegradable pots and labels for bedding plants.

➤ Consider the need and use of inks e.g. use non-toxic inks, or let the product sell itself.

➤ Design for easy disassembly.

➤ Assist in the identification of different materials e.g. by using colours or textures.

➤ Promote responsible use, reuse and disposal on your pack.

➤ Consider local legislation.

➤ Consider local waste management strengths and weaknesses e.g. collection, recycling, reuse, and design appropriately.

➤ Consider the transportation of the product to and from use.

➤ Consider how manufacturing value can be retained by subsequent uses e.g. bottles as bricks.

➤ Consider the manufacturing process and how material and cost savings can be achieved e.g. by looking at the shape of a die cut.

➤ Always consider the simple solution.

➤ Small is beautiful.

➤ Ask yourself what the world would be like if everyone used this package.

Bibliography for Introduction

Bruce, M. E., *Common-Sense Compost Making*. Faber and Faber Ltd., London, 1946

Durrell, G., Forward to Myers, N., *The Gaia Atlas of Planet Management*. Gaia Books Ltd., London, 1994

Green Games Watch 2000
http://www.nccnsw.org.au/member/ggw

Hart, S. L., 'A Natural-Resource-Based View of the Firm', *Academy of Management Review*, 20 (4), 1995: pp966–1014

Institute of Packaging Professionals, Japan, *Packaging Trend in Japan*. http://www.jpi.or.jp

Kinnock, G., *Eritrea – Images of War and Peace*. Chatto and Windus Ltd., London, 1988

Mackenzie, D., *Green Design*. Laurence King Ltd., 1991

Palmer, J. A., *Fifty Key Thinkers on the Environment*. Routledge, London, 2001

Papanek, V., *The Green Imperative*. Thames & Hudson, London, 1995

Papanek, V., *Design for the Real World* (2nd Ed.). Thames & Hudson, London, 1971

Rees, W. E., 'Reducing our Ecological Footprints', *Siemens Review*, 62 (2), 1995: pp 30–35

Verband Kunstsofferzeugende Industrie, *Economic Data and Graphics Regarding Plastics*, 2000: http://vke.de

Vitousek, P. M., Ehrlich, P. R., Ehrlich, A. H. and Mason, P. A., 'Human Appropriation of the Products of Photosynthesis', *BioScience*, 36, 1986: pp368–373

Wines, J., *Green Architecture*. Taschen, Koln, 2000

150

General Bibliography

Anderson, W. T., 'Communities in a World of Open Systems', *Futures*, 31, 1999: pp457–463

Artigiani, R., 'Chaos and Constitutionalism: Toward a Post-modern Theory of Social Evolution', *World Futures*, 34, 1992: pp131–156

Bach, J. I., 'Evolutionary Guidance System in Organisational Design', *World Futures*, 36, 1993: pp107–127

Banathy, B. H., 'The Characteristics and Acquisitions of Evolutionary Competence', *World Futures*, 23, 1987: pp134–135

– 'The Design of Evolutionary Guidance Systems', *Systems Research*, 6, 1989: pp289–295

– 'A User–designed Mediation Approach, Fostering Evolutionary Consciousness and Competence', *World Futures*, 36, 1993: pp155–164

– *Designing Social Systems in a Changing World*. Plenum, New York, 1996

Barkow, J. H., Cosmides, L. and Tooby, J. (Eds), 'The Updated Mind: Evolutionary Psychology and the Generation of Culture', 1992, in Broadbent, J., and Denison, E., 'Design and Theories of Social Evolution', *Proceedings of the 44th Annual Meeting*. International Society for the Systems Sciences, Toronto, Canada, 16–22nd July, 2000

Borgman, A. 'The Depth of Design', in Buchanan, R. and Margolin, V., *Discovering Design – An Exploration in Design Studies*. University of Chicago Press, Chicago and London, 1995

Boulding, K. E., 'Evolutionary Visions and Human Life', 1981, in Bach, J. I., 'Evolutionary Guidance System in Organisational Design', *World Futures* 36, 1993: pp107–127

– 'Punctuationalism in Societal Evolution', *Journal of Social and Biological Structures*, 12, 1989: pp213–223

Broadbent, J., 'Rationale for a System Approach to Industrial Design Education'. International Society for the Systems Sciences 1998 Conference, Atlanta, 19–24th July, 1998

– 'Redesigning Socioculture: The Convergence of Design, Systems and Social Evolution', *Proceedings of the 44th Annual Meeting*. International Society for the Systems Sciences, Toronto, Canada, 16–22nd July, 2000

Broadbent, J. and Denison, E., 'Design and Theories of Social Evolution', *Proceedings of the 44th Annual Meeting*. International Society for the Systems Sciences, Toronto, Canada, 16–22nd July, 2000

Brown, H. 'The Challenge of Man's Future', in Granovetter, M., 'The Idea of "Advancement" in Theories of Social Evolution and Development', *American Journal of Sociology*, 85 (3): pp489–515

Bruce, M. E., *Common-Sense Compost Making*. Faber and Faber Ltd., London, 1946

Buchanan, R. and Margolin, V., *Discovering Design – An Exploration in Design Studies*. University of Chicago Press, Chicago and London, 1995

Carneiro, R. L., 'A Theory of the Origin of the State', *Science*, 169, 1970: pp733–8

Chase-Dunn. C. and Hall, T. D., 'The Historical Evolution of World Systems', *Sociological Inquiry*, 64 (3), 1994: pp257–280

Churchman, C. W., *The Systems Approach and its Enemies*. Basic Books, New York, 1979

Collen, A., 'Design of a Life: Sustainability and the Inquirer/Researcher alias Designer in an Evolving World System', *World Futures*, 51, 1998: pp223–238

Crosby, R. W., 'The Future of Human Evolution: Towards an Understanding of Possibilities', *World Futures*, 27, 1989: pp33–51

Csanyi, V., *General Theory of Evolution*. Academiai Kiado, Budapest, 1982

– *Evolutionary Systems and Society*. Duke University Press, Durham, NC and London, 1989

– Csikszentmihalyi, M., 'Consciousness for the Twenty-first Century', *Zygon*, 26 (1), 1991: pp7–25

Dilnot, C., 'Transcending Science and "Anti-science" in the Philosophy of Design Method', 1981, in Broadbent, J., 'Redesigning Socioculture: The Convergence of Design, Systems and Social Evolution', *Proceedings of the 44th Annual Meeting*. International Society for the Systems

Sciences, Toronto, Canada, 16–22nd July, 2000

Dobb, M., *Studies in the Development of Capitalism* (Rev. Ed.), (1st Ed. 1947). International Publishers, New York, 1963

Durrell, G., Forward to Myers, N., *The Gaia Atlas of Planet Management* (2nd Ed.). Gaia Books Ltd., London, 1994

Evans, B., Powell, J. A., and Talbot, R. J., *Changing Design*. John Wiley and Sons Ltd., Chicester, 1982

Frank, A. G., *Dependent Accumulation and Underdevelopment*. Monthly Review Press, New York, 1979

Fry, T., *A New Design Philosophy – An Introduction to Defuturing*. UNSW Press, Australia, 1999

Fukuyama, F., *The End of History and the Last Man*. The Free Press, New York, 1992

Galtung, J. and Inayatullah, S., *Macrohistory and Macrohistorians*. Praeger Publishers, Westport, CT, 1997

Gilman, R., 'Sustainability: The State of the Movement', 1990, in *Context*, Spring 1990: pp10 at Context Institute: http://www.context.org

Granovetter, M., 'The Idea of "Advancement" in Theories of Social Evolution and Development', *American Journal of Sociology*, 85 (3): pp489–515

Green Games Watch 2000
http://www.nccnsw.org.au/member/ggw

Harman, W., 'The Coming Transformation, Parts 1&2', *The Futurist*, 11, 1977: pp4–12 and 106–112

Ho, M., 'Evolutionary Theory and World Future', *World Futures*, 38, 1992 : pp97–106

Inayatullah, S., 'Future Generations Thinking', *Futures*, 29 (8), 1997: pp701–706

Institute of Packaging Professionals, Japan, *Packaging Trend in Japan*. http://www.jpi.or.jp

Kahn, P. H., *The Human Relationship with Nature*. The MIT Press, Massachusetts and London, 1999

Kahn, H. and Briggs, B., *Things to Come*. Dover, New York, 1950, in Loye, D., *The Knowable Future*. John Wiley and Sons Ltd., New York

Kinnock, G., *Eritrea – Images of War and Peace*. Chatto and Windus Ltd., London, 1988

Korten, D. C., *The Post Corporate World – Life after Capitalism*. Berret-Koehler and Kumarian Press, 1998

Laszlo, E., *Introduction to Systems Philosophy*. Harper and Row, New York, 1972

– 'The Choice: Evolution or Extinction', *A Thinking Person's Guide to Global Issues*. G.P.Putnam's Sons, New York, 1994

– Evolution: *The General Theory*. Hampton, Cresskill, New Jersey, 1996

Loye, D., 'Scientific Foundations for a Global Ethic at a time of Evolutionary Crisis', *World Futures*, 49, 1997: pp3–17

McDonough, W., 'Redesigning Design Itself', *Whole Earth*, Winter 1998: pp30

Mackenzie, D., *Green Design*. Laurence King Ltd., 1991

Mesarovic, M. and Pestel, E., *Mankind at the Turning Point*. Dutton, New York, 1974

Mumford, L., *The Condition of Man*. Harcourt, Brace,

Jovanovich, 1973

Ornstein, R. and Ehrlich, P., *New World: New Mind*. Simon and Schuster, New York, 1989

Palmer, J. A., *Fifty Key Thinkers on the Environment*. Routledge, London, 2001

Papanek, V., *Design for the Real World* (2nd Ed.). Thames & Hudson, London, 1971

– The Green Imperative – *Ecology and Ethics in Design and Architecture*. Thames & Hudson, London, 1995

Paritsis, N. C., 'Societal Evolution: A Process without Random Variation', *World Futures*, 37, 1993: pp173–178

Rees, W. E., 'Reducing our Ecological Footprints', *Siemens Review*, 62 (2), 1995: pp30–35

Sanderson, S. K., *Social Transformations*. Rowman and Littlefield Publishers Inc., 1999

Smith, A., *The Wealth of Nations 1776*. Ed. by Skinner, A. Penguin Books, Middlesex, 1986

Tainter, J. A., *The Collapse of Complex Societies*. Cambridge University Press, New York, 1988

Wallerstein, I., 'The Rise and Future Demise of the World Capitalist System: Concepts for Comparative Analysis', *Comparative Studies in Society and History*, 16, 1974: pp387–415

– The Modern World System Vol 1. Academic, New York, 1974, in Chase-Dunn. C. and Grimes, P., 'World Systems Analysis', *Annual Review of Sociology*, 21, 1995: pp387–417

Wines, J., *Green Architecture*. Taschen, Koln, 2000

151

Legislation

Having now seen examples of how the packaging problem is being dealt with by various companies, it is necessary to close, however briefly, on the significant and important issue of legislation. Legislation undoubtedly shapes the nature of a design solution, for what appears environmentally sound in one country might be flawed in another, depending on the structure of waste management and the priorities placed on available methods of dealing with waste.

It is only relatively recently that serious political moves to implement waste management policies in legislation have been made. After the environmental agenda had been established on the world stage, it was inevitable and vital that politicians were given the appropriate guidance and information. This was necessary if they were to introduce the appropriate legislation required to meet the fresh demands commanded by an increasingly informed and aware public. This process is always slow, often ineffective and never simple. Round after round of political lobbying by often competing industrial sectors makes for a political minefield. The implementation of legislation remains, and is likely to continue to be, a very contentious issue. Such political and legislative wrangling at all levels of government and industry, all over the world, have led to a true kaleidoscope of methods to cope with the problem of waste. Some are clearly more successful than others, but what does need to be recognised are some clear goals established by unbiased well-reasoned discussion. Without this, packaging policy will be forever dogged by the types of heavy-handed pressure previously exerted by the likes of the motor and energy industries when they have the most to lose from a changing economic climate.

Unfortunately there is no space to illustrate the details and effectiveness of each of these legislative measures in such a limited context. It remains only to emphasise how critical it could be to understand the policies in place in a particular area before designing solutions to suit. The types of materials used, the systems of refilling, recycling or disposal all vary considerably and very few universal truths exist about dealing with packaging. Perhaps the one overriding truth that could be stated is that one should seek to use a minimum amount of packaging material without unreasonably compromising the safety or security of the product. Prevention should come before the recovery or reuse of materials.

In terms of design, legislation will likely affect the decision-making process and should therefore be factored into the design solution. As has been illustrated previously in many of the case studies, solutions are a product of their time and place and may transpose poorly into other situations, but that does not negate their success – it merely underlines the complexity of seeking solutions. Even with attempts to homogenise whole continents such as with the EU Directive on Packaging and Packaging Waste, there will remain countries that choose to opt for alternative methods to suit their own particular needs. For example, the UK and France have taken opposite sides on who to place responsibility with for packaging. In the UK it is the brand owner or importer, and in France it is the packaging manufacturer. Australia's Packaging Covenant chooses a route that would be incongruous in a country such as Eritrea. Equally, the Swedish system of deposits on goods would not be favoured in the US, nor would Denmark's prohibition of non-returnable packaging suit China.

If a refilling infrastructure is in place then it would seem right to design packaging to utilise this effective system, whereas if recycling was well established, then the design solution might be very different. The same can be said for materials selection and what types of materials are most easily collected, recycled or even sourced. If one type of material needs to be sourced from across the globe, it would seem appropriate to try and source an alternative that was manufactured nearer to its point of use. The same can also be said for manufacturing processes. Perhaps a design solution might be determined by the manufacturing process that is available close to home, rather than having the packs manufactured and shipped from overseas. This is also the case with waste disposal, where most countries are beginning to realise the importance of managing this as close to source as possible rather than shipping it across countries or even continents, though this still continues. The US waste-paper export figures rose by 924% between 1970 and 1986 and is reported to be still rising.

Another important consideration for packaging designers when dealing with legislative requirements is not to do just enough to pass certain standards, but seek to lead by example, thereby pressuring legislation to move forwards as new standards are met. This is where designers might regard themselves as having considerable influence for instigating positive change through innovative and inspirational design. The examples seen in this book have all exceeded the regulations imposed on them by their respective country's legislation and by further pushing the boundaries of design, legislation will be forced to follow suit, raising the legislative standards as improvements are realised by design.

Acknowledgements

This book was conceived, researched and executed over a period of time in which many transformations were – and still are – taking place, both on a macro and micro level. Above all else, this period of time would have been impossible to contend with without the support of our family, friends and colleagues. Our deepest dept is to our parents for their support and patience without whom this book would have been impossible.

The complexities underlying the issues only mildly touched upon in this book could not have been tackled without the indefatigable and profound guidance of Dr John Broadbent. His teaching cannot be done justice in this text, but his comprehension of the sciences of complexity and inevitable social transformations are an inspiration. The complete reformation of one's own paradigm by insightful challenges to cognitive frameworks and perceived norms is a rare and privileged experience that he has provided. To both he and his wife Margaret for their kindness, friendship and guidance our gratitude could not be greater.

The undertaking of this book would not have been possible without the time and efforts of a great many people. The sheer scale and depth of their help makes it impossible for us to mention them all by name, but to all these people go our sincere gratitude and thanks, not least to every company or organisation that was kind enough to offer samples for inclusion in the book. These include: Alicia Rudick, Angela Lowe, Anne Jensen, Annie Carey, Annukka Leppänen-Turkula, Barry Bennett, Beata Bär, Bruno Ruf, Colleen Brady, Dace Strode, David Tebworth, Dennis Spiers, Donna Bisset, Doreen Kruger, Drew De Grado, Gail McClelland, Gerhard Bär, Graham Casey, Gregg Otto, Hartmut Knell, Hatim Akbarally, Heidi Bucher, Helen Slifkas, Hiroshi Uemura, Jan Amrein, Jerry Gibson, Jim Barker, Jim Lovinsky, Jimmy Tam, John Leach, John Oakley, Jonathan Kahn, Jurjen Rolf, Karen Shillinglaw, Karl-Heinz Bolwien, Katherine Woodhouse, Kay Walsh, Keathea Henderson, Kim Knies, Larry Nielsen, Larry Whitney, Lee Holden, Linda Chappell, Lorena de Vizio, Luciana Pellegrino, Lucie Dion, Luis Pittau, Malcolm Wilson, Margaret Gregory, Marietta Julio, Martin Gradman, Mary Murphy, Masatsugu Shiota, Matti Salste, Mike Moorhead, Mirta Fasci, Myra Richey, Nicholas Apostol, Nick Jones, Nicole Marie Malek, Olli Aaltonen, Patti Sullivan, Paul Eilbracht, Ravi Philar, Robert Pascoe, Sally Sprunec, Sander Havik, Siem Haffmans, Stefan Slembrouck, Steve Mohr, Steve Schultz, Susan van der Steenhoven, Susanna Partanen, Susanne Jagenburg, Suzanne Borsinger, Terhen Järvi-Kääriäinen, Terry Robins, Till Isensee, Toby Matthews, Updesh Thakur, Vlado Volek, Walter Staub, Wolfgang Lattner and Zenya Tanabe. The authors also wish to thank those that provided valuable information, support and critically challenged our research: David Perchard, Brian Natruss, Ed Bauer, Diana Conley, Elizabeth Johnson, Elkie Jordans, Elli Sarri, Guenter Schaufler, Jason Shugar, Joe Grygny, John Davis, John Gertsakis, Laurel Bloch, Mark Higgins, Mary Murphy, Michael Coe, Monica Winn, Richard Mahoney, Risto Laiho, Rob Krebs, Tony Kingsbury, Victor Bell, Wendy Jedlicka, and all those at SHOUT and The Northcott Society for providing the support of an extended family.

Special thanks also goes to the editorial and production team at RotoVision. In particular our gratitude goes to Erica Ffrench for her support, efficiency and the professionalism with which she guided this project to its final ends. Thanks also go to James Campus for his outstanding design, and to John Suett for his superb photography. Finally, thank you to Kate Noël-Paton, without whose support from the outset this book would not have transpired.

Useful Addresses

ADALSON OY, Finland
Suviojantie 9
45610 Koria
Finland
Tel: +358 5 886 5526
Fax: +358 5 375 5743
Email: info@adalson.fi
Web: www.adalson.fi

Air Packaging Technologies (APTI),
USA
25620 Rye Canyon Road
Valencia
CA 91355
USA
Tel: +1 800 424 7269
Fax: +1 661 294 0947
Email: info@airbox.com
Web: www.airbox.com

Air-Ride Packaging, USA
StowBrook Office Centre
636 Great Road
Stow
MA 01755
USA
Email: info@airridepackaging.com

Akbar Brothers Ltd., Sri Lanka
PO Box 1726 No. 334
T. B. Jayah Mawatha
Colombo 10
Sri Lanka
Tel: +94 1 697 151
Fax: +94 1 699 029
Email: akbar@akbar.com
Web: www.akbar.com

Alcan Deutschland Gmbh, Germany
Am Eisenwerk 30
Plettenberg
D-58840 Ohle
Germany
Tel: +49 2 391 610
Fax: +49 2 391 612 201

Altstoff Recycling, Austria
Web: www.ara.at

Aluminium Federation, UK
Broadway House
Calthorpe Road
Five Ways
Birmingham BI5 1TN
UK

American Center for Design, USA
Web: www.ac4d.org

American Packaging Corporation, USA
Email: lbloch@ampkcorp.com

Amway
6450 Jimmy Carter Blvd.
Norcross
GA 30071-1799
USA
Tel: +1 770 449 5466
Fax: +1 770 368 4619

Apak, UK
Oaklands
Butler Road
Bagshot
Surrey GU19 5QF
UK

APEAL, UK
Steel Packaging
Web: www.apeal.org

Associação Brasiliera de Embalagem
(ABRE), Brazil
Web: www.abre.org.br

Association of Packaging Technology
and Research, Finland
Email: ptr.ry@pakkausteknologia-ptr.fi
Web: www.pyr.fi

Aveda, Australia
Level 1
100 Dorcas Street
Melbourne
Victoria 3205
Australia
Tel: +61 3 9690 8537
Fax: +61 3 9690 8587
Email: info@aromascience.com
Web: www.aveda.com

Bär & Knell, Germany
Untere Turmgasse 7
D-74206 Bad Wimpfen
Germany
Tel: +49 7 063 6891
Fax: +49 7 063 6980
Email: baerknell@aol.com

Ben & Jerry, USA
30 Community Drive
South Burlington
VT 05403-6828
USA
Tel: +1 802 846 1500
Web: www.benjerry.com

Berkley Industries, USA
14450 Industry Circle
La Mirada
CA 90638-5811
USA
Tel: +1 714 522 5400

Fax: +1 714 522 5544
Web: www.berkleyindustries.com

The Body Shop, UK
Watersmead
Littlehampton
West Sussex BN17 6LS
UK
Tel: +44 (0)1903 73 15 00
Fax: +44 (0)1903 72 62 50
Email: info@bodyshop.com
Web: www.the-body-shop.com

British Glass, UK
Northumberland Road
Sheffield S10 2UA
UK

British Plastics Federation, UK
5 Belgrave Square
London SW1X 8PH
UK

Corporations Supporting Recycling
(CSR), Canada
Email: info@csr.org

Corus Packaging Plus, the Netherlands
PO Box 10.000
1970 CA IJmuiden
the Netherlands
Tel: +31 25 149 3186
Web: www.corusgroup.com

Danisco Pack (UK) Ltd., UK
Old Whieldon Road
Stoke-on-Trent ST4 4HW
UK

Delta Paper, USA
Email: jshugar@deltapaper.com

Design4u BV, the Netherlands
PO Box 3051
Nl-2601DB Delft
Netherlands
Tel: +31 15 214 8903
Fax: +31 15 214 3323
Email: info@eilbracht.nl

The Design Council, UK
28 Haymarket
London SW1Y 4SU
UK

Deutsche Gesellschaft für Kunstsoff-
Recycling (DKR) GmbH, Germany
Frankfurter Straße 720–726
D-51145 Köln
Germany
Tel: +49 2 203 931 7724
Fax: +49 2 203 931 7774

Email: dkr-comm.de@t-online.de
Web: www.dkr.de

Duales System Deutschland (DSD),
Germany
Email: pressestelle@gruener-punkt.de

Dumfries Plastics Recycling Ltd., UK
College Road
Dumfries DG2 0BU
UK

Dumfries Recycled, UK
Web: www.dumfriesrecycling.co.uk

Duralam Inc., USA
Tel: +1 920 734 6698
Fax: +1 920 734 5241
Web: www.duralam.com

EcoDesign, Canada
Email: penner@infoserve.net
Web: www.ecodesign.bc.ca

EMIUM, Argentina
Email: emium@emium.com.ar
Web: www.emium.com.ar

Enak Ltd., UK
Tel: +44 (0)1403 26 55 44
Web: www.enak.co.uk

Environmental Packaging International,
USA
Web: www.environ-pac.com

Environmental Plastics of Puerto Rico
(EPPR), Puerto Rico
Road No. 1
Km. 49.3
Cidra
P.P. 00739
Puerto Rico

The Environment Register of Packaging
PYR Ltd., Finland
Email: pyr@pyr.fi

EnviroPAK Corporation, USA
4135 Galley Court
St Louis
MO 63045
USA
Tel: +1 314 739 1202
Fax: +1 314 739 2422
Email: sales@enviropak.com
Web: www.enviropak.com

The European Organisation for
Packaging and the Environment
(EUROPEN), Belgium
Le Royal Tervuren
Avenue de l'Armée 6 Legerlaan

B-1040 Brussels
Belgium
Tel: +32 2 736 3600
Fax: +32 2 736 3521
Email: packaging@europen.be
Web: www.europen.be

FASTTrack Systems, USA
Two Village Road
Suite 10
Horsham
PA 19044
USA
Tel: +1 215 830 9330
Fax: +1 215 830 9332
Email: mail@fasttracksystems.com

Finnish Packaging Association, Finland
Email: risto.laiho@pakkausyhdistys.fi

The Flexible Packaging Association, UK
4 The Street
Shipton Moyne
Tetbury
Glos. GL8 8PN
UK

The Green Dot of Latvia, Latvia
Web: www.packaging.lv

Greenpeace International, the
Netherlands
Keizersgracht 176
1016 DW Amsterdam
the Netherlands
Tel: +31 20 523 6275
Fax: +31 20 523 6200
Web: www.greenpeaceimages.org

Brodrene Hartmann A/S, Denmark
Klampenborgvej 203
DK-2800 Lyngby
Denmark
Tel: +45 4587 5030
Fax: +45 4587 1503
Email: mgr@hartmann.dk
Web: www.hartmann.dk

Heineken, the Netherlands
Web: www.heineken.com

Hermes Sweeteners Ltd., Switzerland
Ankerstrasse 53
PO Box
CH-8026 Zurich
Switzerland
Tel: +41 1 242 6777
Fax: +41 1 242 1489
Email: mail@hermasetas.com
Web: www.hermasetas.com

International Moulded Pulp
Environmental Packaging Association
(IMPEPA), USA
Web: www.impepa.org

INCPEN, UK
Email: info@incpen.org

Institute of Packaging, India
Email: enquiry@iip-in.com

Institute of Packaging, Argentina
Email: iaenvase@infovia.com.ar

Institute of Packaging, UK
Sysonby Lodge
Nottingham Road
Melton Mowbray
Leics. LE13 0NU
UK
Email: info@iop.co.uk

Interseroh, Germany
Web: www.interseroh.de

Kent Paper, Australia
Tel: +61 2 9949 6666

Keystone Business Service Inc., USA
PO Box 12.460
Ogden
UT 84412
USA
Tel: +1 801 782 6917
Fax: +1 801 782 9375
Email: slikpak1@aol.com

Kiem, the Netherlands
Rapenburgerstraat 109
1011 VL
Amsterdam
the Netherlands
Tel: +31 20 638 5678
Fax: +31 20 638 4905
Email: info@kiem.nl
Web: www.kiem.nl

LOMBARD Pty Ltd., Australia
Tel: +61 3 9376 2500
Web: www.lombard.com.au

Liquid Food Carton Manufacturers
Association, UK
30B Wimpole Street
London W1M 8AA
UK

Macfarlane Packaging Ltd., UK
Tel: +44 (0)1563 52 51 51

McDonald's, Sweden
127 85 Skärholmen
Besöksadress:
Lindvretsvägen 9
Sweden
Tel: +46 8 740 8500
Fax: +46 8 740 8600
Web: www.mcdonalds.se

Menasha Corporation, USA
Outback Packaging
Buncher Industrial Park
Building 104, Avenue A
Youngwood
PA 15697
USA
Tel: +1 724 925 7225
Fax: +1 724 925 7067
Email: info@outbackpackaging.com
Web: www.outbackpackaging.com

Other Menasha packaging products:
Menasha Corporation, USA
PO Box 367
Neenah
WI 54957
USA
Tel: +1 920 751 1000
Fax: +1 920 751 1236
Web: www.menasha.com

Metal Packaging Manufacturing
Association (MPMA), UK
Elm House
19 Elmshot Lane
Chippenham
Slough
Berks SL1 5QS
UK

Metsä-Serla Oyj, Finland
Tako Carton Plant
PO Box 207
33101 Tampere
Finland
Tel: +358 1 463 5399
Fax: +358 1 463 5374
Metsä-Serla web:
www.metsaserla.com
Tako Carton Plant web:
www.tradepoint.fi/takocpl

Microsoft, USA
Web: www.microsoft.com

Migros, Switzerland
PO Box 8031
Zurich
Switzerland
Tel: +41 1 277 2068
Fax: +41 1 277 2333
Web: www.migros.ch

156

Moulded Fibre Technology, USA
1235 Guerrero Street
San Francisco
CA 94110
USA
Tel: +1 415 474 0429
Fax: +1 415 474 0430

Nalgene, UK
Tel: +44 (0)1432 26 39 33
Web: www.nalgenunc.com

The Netherlands Design Institute
Email: conny@design-inst.nl

Nippon Hi-Pack, Japan
5-7-1, Nyoisaru-Cho
Kasugai City
Aichi
486-8902
Japan
Tel: +81 56 834 8171

Nippon Hi-Pack, Hong Kong
Tel: +852 2730 1108
Fax: +852 314 2752

Norway Packaging Association,
Email: pco@dne.no

Ortho-McNeil Pharmaceutical Inc., USA
Tel: +1 908 218 6637
Web: www.ortho-mcneil.com

Packaging and Industrial Films
Association, UK
The Fountain Precinct
1 Balm Green
Sheffield S1 3AF
UK

The Packaging Council of Australia
Email: packcoun@packcoun.com.au

The Packaging Council of Canada
Email: info@pac.ca

Packaging Institute of the Philippines
Room 216
2nd Floor, Comfoods Building
Sen. Gil Puyat Avenue
Makati City
Philippines
Tel: +63 2 817 2936
Fax: +63 2 817 2936
Email: pipmlax@info.com.ph

Packaging Machinery Manufacturing
Institution, USA
Email: info@packexpo.com
Web: www.packexpo.com

Packaging Magazine, UK
Email:
mmurphy@unitedbusinessmedia.com

Pactech Engineering Inc., USA
4444 Carver Woods Drive
Cincinnati
OH 45242-5545
USA
Tel: +1 513 792 1090
Fax: +1 513 891 4232

PaperFoam BV, the Netherlands
Bellstraat 33
3771 AH Barneveld
the Netherlands
Tel: +31 34 240 1667
Fax: +31 34 240 1588
Email: info@paperfoam.com
Web: www.paperfoam.com

Patagonia, Europe
59–63 Avenue Jean-Baptisete Clément
92100 Boulogne
Paris
France
Tel: +33 14 110 1818
Fax: +33 14 605 5722

Pira, UK
Packaging Division
Randalls Road
Leatherhead
Surrey KT22 7RU
UK

PostSafe Ltd., UK
3 The Parade
Trumps Green Road
Virginia Water GU25 4EH
UK
Tel: +44 (0)1483 48 66 18
Fax: +44 (0)1483 48 92 67

Potatopak Ltd., UK
55b Alexandra Street
Blandford Forum
Dorset DT11 7EY
UK
Tel: +44 (0)1258 45 30 55
Fax: +44 (0)1258 45 30 55
Web: www.potatoplates.com

PRO-PAC Packaging (Aust) Pty Ltd.,
Australia
6 Rich Street
Marrickville
NSW 2204
Australia
Tel: +61 2 9560 7799
Fax: +61 2 9560 4447

RAP, UK
73 Sheen Road
Richmond
Surrey TW9 1YJ
UK
Tel: +44 (0)20 8334 6005
Fax: +44 (0)20 8334 6006
Email: info@rapuk.com

Royal Melbourne Institute of
Technology (RMIT), Australia
Centre for Design at RMIT University
GPO Box 2476V
Melbourne 3001
Australia
Tel: +61 3 9925 3485
Fax: +61 3 9639 3412
Web: www.cfd.rmit.edu.au

Russia Packaging Industry, Russia
Email: info@unipack.ru
Web: www.unipack.ru

Sealed Air Corporation, USA
10 Old Sherman Turnpike
Danbury
CT 06810
USA
Tel: +1 203 791 3559
Fax: +1 203 791 3765

Sonoco Products Company, USA
PO Box 160
North Second Street
Hartsville
SC 29551
USA
Tel: +1 803 383 7000
Web: www.sonoco.com

Sony Corporation, Japan
Sony Fukushima Corporation
GB Engineering Division
Japan
Tel: +81 24 958 5039
Fax: +81 24 958 5897
Web: www.sony.com.jp

Stadium Design BV, the Netherlands
Oude Weerlaan 27
2181 HX Hillegon
the Netherlands
Tel: +31 25 252 2144
Fax: +31 25 252 3571
Email: info@stadiumdesign.nl

Stora Enso Oyj, Finland
55800 Imatra
Finland
Tel: +358 2 046 121
Fax: +358 2 046 247 20
Web: www.storaenso.com

Sweetheart Cup Company Inc., USA
Owings Mills
MD 21117
USA
Tel: +1 800 800 0300
Web: www.sweetheart.com

Swiss Packaging Institute, Switzerland
Email:
svi_verpackung@compuserve.com

SYBA Packaging Association, Czech
Republic
Obalová Asociace SYBA
Czech Republic
Tel: +42 2 2491 9591
Fax: +42 2 2491 9591
Email: syba@syba.cz
Web: www.syba.cz

Sylvacurl, USA
Eastview Enterprises Inc.
PO Box 56
East Hardwick
VT 05836-0056
USA
Tel: +1 800 472 2032
Web: www.sylvacurl.com

Tri-Wall Europe, UK
Tel: +44 (0)1600 77 22 22

United Nations Environment
Programme (UNEP), the Netherlands
Email: unep@unep.frw.uva.nl
Web: www.unep.org

Updesh Thakur, India
Email: eternal@bom7.vsnl.net.in

Verpackung, Germany
Web: www.verpackung.org

Visy Recycling, Australia
30–32 Plummer Road
Laverton
Victoria 3026
Australia
Tel: +61 3 9248 2166

Yves Rocher, Australia
Tel: +61 3 9821 4508

Waitrose, UK
Southern Industrial Area
Bracknell
Berks RG12 8YA
UK
Tel: +44 (0)1344 42 46 80
Web: www.waitrose.com

Women in Packaging, USA
Email: packwm@aol.com

World Packaging Association, USA
Email: wpo@pkgmatters.com

Worthington Steelpac Systems, USA
Tel: +1 717 851 0328
Web: www.worthingtonindustries.com

INDEX

Aborigines, Australian 12
ABRE 69
Accelerated development 12
ADALSON OY 140–1
Air box, protective 94–5
Airtight packaging 94–5
Akbar Brothers Ltd. 52–3
Alcan Deutschland Gmbh 128–9
Aluminium packaging 111, 128–9
Aluminium recycling 18–19
Amway 40–1
Anti-static coatings 94–5
Anti-static packaging 134–9
Apak 142–3
APTI 94–5
Artistic recycling 32–3
Automatic package filling 73
Automotive Door-Pillar pack 37
Aveda 96–7, 110–11

Bär & Knell 32–3
Battery Packaging 80–1
Bauxite 18
Ben & Jerry 50–1
Berkley Industries 82–3
Biodegradable
 bags 100–1
 battery packaging 80–1
 cups 62–3
 film 92–3
 food packaging 70–1, 106–7
 jewel packaging 76–7
 moulded pulp 134–9
 PaperFoam 144–5
 pellets 146–7
 plates 48–9
 shavings 58–9
 trays 142–3
Biodegradable Loose-Fill Pellets 146–7
Biodegradable Rubbish Bag 100–1
Blister packs 114–15
Body Shop, The 26, 108–9
Bottles
 bags 104–5
 banks 19–20
 connecting 29–30
 deposit 122–3
 flexible 88–9
 glass 19–20, 120–1
 module 118–19
 multiple-use 118–19
 plastic 122–3

recycled 110
refillable 86–7, 108–9, 120–3
refills 86–7
reuseable 42–3
secondary purposes 28–31
WOBO 28–9
Boxes
 fibreboard 74–5
 hat 75
 medical 72–3
 protective air 94–5
British Polythene Industries Plc 31
Brodrene Hartmann A/S 138–9
Bulk purchases 25

Cans 18, 130–1
Card packaging 80–1
Cardboard
 engineering 35
 packaging 64–8
 recycling 22–3
Cartonboard Packaging for Cold Fast-Food 68
Cartonboard packaging 64–8, 70–3, 78–9, 106–7
Cartonboard Packaging for Hot Fast-Food 64
Cartons
 dry food 78–9
 gable-top 84
 ice-cream 50–1
 medical 72–3
 paperboard 50–1
 pre-glued 72–3
 recyclable 69
 unbleached 50–1
Catastrophes, environmental 10
CD packaging 112
Cellulose film 92–3
Cellulose packaging 69
CFCs see Chlorofluorocarbons
Change
 evolutionary 14–15
 packaging requirements 9
 society 7–8
Chlorofluorocarbons (CFCs) 11
Clam-Shell Container 82–3
Clothing 31
Co-polyester film 142–3
Coated paperboard 78–9
Cold Takeaway Food Packaging 70–1
Colours, glass 20

Component reduction 113
Composite tubes 124–5, 127
Compostable
 bags 100–1
 jewel packaging 76–7
 packaging 41
 pellets 146–7
 plates 48–9
 starch products 142–5
Composting 26–7
Compressive strength 37
Confectionery wrappers 106–7
Connecting bottles 29–30
Construction materials 31
Consumerism, ecological 9–12
Containers
 cosmetics 111
 plastic 126
 seam-sealed 128–9
 shipping 40–1
 spiral-wound 125, 127
 stackable 126
 standardised 23
Contraceptive pill 114–15
Corn packaging 76–7
Corrugated
 card frames 102–3
 card packaging 74–5
 fibreboard 36–7
Corus Packaging Plus 130–1
Cosmetics packaging 86–7, 96–7, 108–9, 111, 116–17
Crude oil 31
Cups 62–3
Cushioned envelopes 54–5
Cushioned packaging 94–5
Cylindrical Composite Tube 127
Cylindrical Dispenser & Aluminium Tray 111
Czech Republic 107

Danisco Pack (UK) Ltd. 74–5
David S Smith Packaging 36
De-inking 23
Deposit bottles 122–3
Design4u BV 76–7
Design
 environmental 8
 practices 16
 role of 15–17
Design Council, The 16–17
Designers 16–17

Deutsche Gesellschaft für Kunststoff-
 Recycling Gmbh (DKR) 32–3, 44
Devolution 12
Dispensers
 cylindrical 111
 pill 114–15
 spray 96–7
 tablet 113
Disposable
 cups 62–3
 plates 48–9
Distribution 25
DKR see Deutsche Gesellschaft für
 Kunststoff-Recycling Gmbh
Doorstep collections 20, 44
Drinking cups 62–3
Dry-food packaging 78–9
Drying flax crops 140–1
Duales System 43–4
Duralam Inc. 85

Ecobase program 39
Ecological consumerism 9–12
Economic
 outcomes 12
 rationalism 13
 systems 10
Edible Plastic Film 92–3
Elasticised low-slip plastic 102–3
Electronic goods packaging 134–5
Elongated Fast-Food Packaging 98–9
EMIUM 29–30, 118–19
Enak Ltd. 92–3
Envelopes 54–7
Environmental
 degradation 9
 footprints 12
 perceptions 8
 policy of:
 Migros 39–40;
 Sydney 2000 41
 responsibility 47
Environmental Plastics of Puerto Rico
 (EPPR) 31–2
EnviroPAK Corporation 136–7
EPPR see Environmental Plastics of
 Puerto Rico
European Union, waste management
 28
Evolutionary choices 12
Evolutionary systems perspective
 12–15

Fast-food packaging 34–6, 41, 64–8,
 98–9
FASTTrack Systems 40–1
Feedstock 22
FFW see Flexible Food Wrap
Fibreboard
 boxes 74–5
 corrugated 36–7
 pallet 132–3
Films
 cellulose 92–3
 co-polyester 142–3
 food-grade 90–1
 plastic 84
 water-soluble/edible 92–3
Financial deposit incentives 23, 42
Finland, Reusable System 24, 42–3,

120–3
Flat-pack packaging 36–7
 fast-food 64–8, 70–1, 98–9
 medical 72–3
 suspension 102–3
Flax & Hemp Fibre Pulp 140–1
Fleeces 31
Flexible Food Wrap (FFW) 34–5, 64
Flexible Liquid Vessel 88–9
Flexible Packaging Pouch 85
Flexible Refill 86–7
Folded card packaging 80–1
Food
 cans 130–1
 packaging 34–6, 41, 64–8, 70–1,
 78–9, 98–9
 waste 14
Food-grade film 90–1
Fragile Goods Packaging 74–5
Fumigation 132

Gas by-products 26
Germany, systems approach 43–4
Glass
 bottles 120–1
 Kor-Kap system 37–8
 recycling 19–21
 transit packaging 37–8
Globalisation 7, 13
Grease pouch 90–1
Green Checklist 149
Green Dot symbol 43

Handmade Paper Packaging 52–3
Harley Davidson 38–9
Hatbox 75
HDPE see High-density polyethylene
Heat-sealing paper 35
Heineken Breweries 28–9
Hemp Fibre Pulp 140–1
Hermes Sweeteners Ltd. 113
High-density polyethylene (HDPE)
 30–1
Hot Fast-Food Container 65
Hot Fast-Food Container with Lid
 66–7
Hot fast-food packaging 64–7, 98–9
Hygiene 25

Ice-Cream Carton 50–1
Icons 45, 47
Incineration 21
Ink cartridge packaging 82–3
Internal refillable pots 116–17

Jewel Packaging 76–7

Karhulan Lasi 120–1
Kent Paper 62–3
Keystone Business Service Inc. 90–1
Kor-Kap Flat-Glass Packaging System
 37–8

Labels 60–1
Laminated plastic 94–5
Landfill sites 8, 12, 32
LDPE see Low-density polyethylene
Lead-free packaging 111
Leaf Plate 48–9
Legislation 64, 69, 152

Lids, cardboard 66–7
Life Cycle Analysis 14
Lifestyles 7
Light-weighting 17, 39
Lipstick containers 111
Liquids packaging 88–9
Litter 9
Living standards 14
Locally-made packaging 52–3
LOMBARD Pty Ltd. 100–1
Loose-Fill Pellets 146–7
Low-density polyethylene (LDPE)
 96–7

McDonald's 35–6
Macfarlane Packaging Ltd. 60–1
Macintosh computers 112
Magnets 111
Material Roll Unitiser 37
Materials 45, 47
Medical Ampoule Carton 72–3
Medical packaging 72–3, 138–9
Metal container, seam-sealed 128–9
Metal recycling 18–19
Metsä-Serla Oyj 72–3
Microsoft 112
Migros 39–40
Milk bottles 24
Module bottles 118–19
Moulded Bottle Shipper 136–7
Moulded packaging 82–3
Moulded Pulp Support for Electronic
 Goods 134–5
Moulded Tray 138–9
Moulded void filling 144–5
Multiple-Use Bottle 118–19

Nalgene 88–9
Natural fibres 144–5
Natural Step, The 36
Natural Wood Void-Fill 58–9
Newspaper pulp 136–7
Newspapers, recycled 55
Nippon Hi-Pack 54–5, 132–5

Olympic Games Sydney 2000 41
On-line instruction manuals 112
Optimal Rectangular Plastic Container
 126
Organochlorines 51
Ortho-McNeil Pharmaceutical Inc.
 114–15

Packaging industry 13–14
Packaging Ordinance (Germany) 43–4
Packaging systems 18–28
Pactech Engineering Inc. 88–9
Pallets, fibreboard 132–3
Papanek, Victor 15, 16
Paper
 cartons 50–1, 62–3, 69, 84
 composite tube 124–5, 127
 confectionery wrapper 106–7
 cups 62–3
 envelopes 54–5
 fibreboard pallet 132–3
 food packaging 64–7, 69, 98–9
 gable-top carton 84
 locally-made packaging 52–3
 packing systems 34–6

recycling 22–3
suspension packaging 102–3
void filling 40–1
Paper Confectionery Wrapper 106–7
Paper Gable-Top Carton 84
Paperboard cartons 50–1
PaperFoam 144–5
PaperFoam BV 144–5
Patagonia 31
Pellets, loose-fill 146–7
Perceived costs 24
Perfume packaging 96–7
PET see Polyethyleneterephthalate
Physical attributes, plastics 30
Pill Dispenser 114–15
Plant nutrients 26–7
Plastic
 bags 104–5
 bottles 108–10, 122–3
 CD packaging 112
 consumption 14
 containers 126
 elasticised low-slip 102–3
 films 84, 92–3
 flexible pouch 85
 laminated 94–5
 recycling 21–2, 30–3
 wood 30–1
Plates 48–9
Pleated Paper Portion Container 62–3
Political intervention 11
Pollution 10
Polyethyleneterephthalate (PET) 31
Polypropylene packaging 68
Polystyrene packaging 82–3
Polystyrene pellets 40
Polythene envelopes 56–7
PostSafe Ltd. 56–7
Potato Starch Packaging & Waterproof
 Biodegradable Tray 142–3
PotatoPak Ltd. 142–3
Pouches 78–9, 85–7, 90–1, 96–7
Pouchless Dry Food Carton 78–9
Powder containers 111
Pre-glued cartons 72–3
Pre-measured containers 90–1
PRO-PAC Packaging (Aust) Pty Ltd.
 146–7
Product testing 16
Protective Air Box 94–5
Protective packaging 54–9, 72–5,
 94–5
Public opinion 11
Public participation, waste
 management 20, 41, 108–9
Puerto Rico 30–1
Pull strips 128–9
Pulp moulding 134–41
Pulping 22
Purposes, packaging 28
Pyrolysis 18

RAP see Rapid Action Packaging
Rapid Action Packaging (RAP) 34–5,
 64–8, 70–1, 98–9
Reconstitution 27–8
Rectangular Composite Tube 124–5
Rectangular Plastic Container 126
Recyclable
 bags 104–5

bottles 108–9
card packaging 80–1
cartons 69–79, 106–7
cups 62–3
dispenser 113–15
envelope 56–7
fast-food packaging 64–8, 98–9
Recyclable Paper Carton with Window
 69
Recycled
 aluminium containers 111
 bottles 110
 materials 11
 paper 52–5, 124–7, 132–9
 polystyrene 83
Recycled Plastic Bottle 110
Recycling systems 18–28
Redesigning bottles 28–30
Refillable
 bottles 86–7, 108–9, 120–3
 cosmetics pot 116–17
 dispenser 114–15
 tablet dispenser 113
Refillable Cosmetics Pot 116–17
Refillable Plastic Bottle 108–9
Refilling 25–6
Renewable materials 140–7
Resealable labels 60–1
Resealable pouch 85
Resin packaging 76–7
Resins, plastic 22
Responsibility 13
Retention Packaging 102–3
Returnable packaging 23–4
Reusable
 bags 104–5
 boxes 74–5, 102–3
 CD packaging 112
 dispenser 114–15
 drinks containers 88–9
 envelope 56–7
 pallet 132–3
 pouch 96–8
 shavings 58–9
Reusable Glass Bottle 120–1
Reusable Plastic Bottle 122–3
Reusable Shopping Bag 104–5
Reusable System, Finland 24, 42–3,
 120–3
Rio Earth Summit (1992) 11
Robotic Arm Pack 36–7
Rubbish bags 100–1
Ryttylän Muovi Oy 122–3

Sealed Air Corporation 102–3
Seam-Sealed Metal Container 128–9
Self-Sealing Envelope 56–7
Sexed-up designs 15
Shavings 59
Shipping containers 36–7, 40–1,
 136–7
Shopping bags 104–5
Single-Use Grease Pouch 90–1
Skin-care product packaging 86–7,
 110
Software Packaging 112
Sonoco Products Company 124–5,
 127
Sony Corporation 80–1
Sorting, glass recycling 20

Sorting, plastics recycling 22
Spiral-wound containers 125, 127
Spray Dispenser Pouch 96–7
Square Food Can 130–1
Stackable plastic containers 126
Stadium Design BV 126
Stand-up pouches 78–9
Standardised containers 23
Starch-based packaging 17, 36,
 100–1, 142–5
Steel packing systems 37–9
Steel recycling 18–19
Stora Enso Oyj 78–9, 84
Suspension & Retention Packaging
 102–3
Sustainable living 12
Sweetheart Cup Company Ltd. 62–3
SYBA Packaging Association 106–7
Sydney 2000 41
Sylvacurl 58–9

Tablet Dispenser 113
Takeaway Food Packaging 70–1
Tamper-evident lids 126
Tamper-Evident Resealable Label 60–1
Teams, design 17
Temperature-affected film 92–3
Temperature resistance 88–9
Tetley UK 60–1
Tin-plate packaging 128–31
Trays
 aluminium 111
 biodegradable 142–3
 moulded 138–9
Tri-Wall 36–7
Tubes, composite 124–5, 127

Unbleached cartons 50–1
Unsustainable lifestyles 7–8
Updesh Thakur 48–9

Vacuum-formed packaging 82–3
Vase packaging 75
Vegetables, excess packaging 26
Vegetables, reuseable crates 42
Virgin material 27
Visy 41
Void-filling 40–1, 58–9, 144–7

Waitrose 104–5
Waste, minimising 14, 34, 36, 41
Waste bags 100–1
Water-resistant packaging 76–7
Water-Soluble & Edible Plastic Film
 92–3
Waterproof Cushioned Paper Envelope
 54–5
Waterproof packaging 54–7, 142–3
Weather-resistant packaging 85
Wheel grease pouch 90–1
Wine carrier bags 104–5
WOBO bottles 28–9
Wood
 jewel packaging 76–7
 plastic 30–1
 void-fill 58–9
Worthington Steelpac Systems 38–9

Yves Rocher 86–7, 116–17

THIS WALKER BOOK
BELONGS TO:

First published in *Fairy Tales* 2000 by Walker Books Ltd
87 Vauxhall Walk, London SE11 5HJ

This edition published 2010

2 4 6 8 10 9 7 5 3 1

Text © 2000 Berlie Doherty
Illustrations © 2000 Jane Ray

The right of Berlie Doherty and Jane Ray to be identified respectively
as the author and illustrator of this work has been asserted by them
in accordance with the Copyright, Designs and Patents Act 1988

This book has been typeset in Palatino

Printed in China

British Library Cataloguing in Publication Data:
a catalogue record for this book is available from the British Library

ISBN 978-1-4063-2980-3

www.walker.co.uk

Rumpelstiltskin

BERLIE DOHERTY

Illustrated by

JANE RAY

WALKER BOOKS
AND SUBSIDIARIES
LONDON · BOSTON · SYDNEY

Once upon a time there was a poor weaver who had a beautiful daughter. When she worked beside him spinning her thread, her hair shone like strands of gold, and her father would look at her and sigh.

"Daughter, you're much too beautiful to marry a poor man. You deserve to be married to the King of the Realm and to live in great happiness."

His daughter looked at him and smiled and carried on with her spinning. "I'm happy with you, Father. And no one has asked me to marry him yet. And anyway, I'm never likely even to meet the King of the Realm!"

Now, one day the weaver and his daughter were sitting outside in the sunshine at work, because their cottage was cold and damp and gloomy inside, with walls that were five feet thick and a low thatched roof that sank over the tops of the tiny windows. They were enjoying the birdsong when they heard the clattering of hooves and some men on horseback drew up. They were dressed

very grand indeed in silks and fine cloth, which the weaver admired. And it was obvious that the grandest of them all was admiring the weaver's daughter, and the way the sunlight gleamed in her long golden hair.

"You think she is beautiful?" the weaver asked, thinking to himself how wonderful it would be if this man wanted to marry his daughter.

"I do," said the fine young man. "I think she's more beautiful than any girl I have ever seen."

"More than that," the cunning weaver said. "She is the cleverest. She can spin straw into gold."

"Well," laughed the young man, "I would like to believe that. Perhaps your daughter would come with me and show me. If what you say is true, old man, I will ask your daughter to be my wife. May I take her to my castle?"

It was only then that the weaver realized that he was talking to the king himself. He fluttered round his daughter. "Go on," he whispered, tripping over bales of cloth in his excitement. "Go with His Majesty before he changes his mind."

"But Father," she whispered back, "how can I? You know I can't spin straw into gold!"

"Ssh!" her father whispered back.

"Never mind. He's half in love with you already. Off you go!"

And because she loved her father, she went. He stood at his cottage door and waved goodbye to her, and tears of hope streamed down into his beard. "My daughter will marry the king," he said.

And maybe his words were heard by the creatures of the wood, and maybe they weren't.

As soon as they arrived at the castle the young king put the girl into a room, and all that was in it was a spinning wheel and a mound of straw.

"Let's see what you can do, because I would like to marry you," the king said.

"But how can I marry a poor weaver's daughter?" And he closed the door on her.

The girl stared gloomily at the straw. "His Majesty will be putting me on a horse and sending me home again tomorrow," she said. And a bit later she was still staring at the straw. "He won't be sending me home on a horse. He will be making me walk barefoot and ashamed." And a bit later she was still staring at the straw, and she said, "He won't be sending me home at all. He will be putting me in the dungeon for lying to him, and I'll never see my father again. Oh, my poor father!"

"Now stop that crying!" She heard a strange, croaky voice, and looked around to see a little hump-backed man with skin that was crumpled like an old dry apple. "What will you give me if I spin this straw into gold for you?"

"Can you really do that?"

"I said I could," the little man snapped, holding out his hand.

The girl took off her necklace and gave it to him, and he told her to close her eyes, and she fell asleep to the sound of the hum of the spinning wheel. And when she woke up, the little man had gone and in the corner of the room where the straw had been there was now a heap of gold.

"This is wonderful," the king said when he saw it. "But can you do it again?"

He ordered more straw and left her in her room, and the girl was more downhearted than ever. She thought of her father in his lonely cottage waiting for news of her.

"How can I possibly spin this straw into gold?" she said. "Oh, my poor father. Will I ever see him again?"

"Stop that!" she heard the little man say, and there he was, standing next to her and holding out his hand. "We did it once, we'll do it twice."

So the girl pulled off her ring and gave it to him, and closed her eyes and fell

asleep to the sound of the spinning wheel humming. And when she woke up, the little man had gone and so had the pile of straw. And in its place there was a heap of gold.

When he saw it the king was even more delighted with her. "Your father was right," he said. "You are as clever as you are beautiful. But before I ask you to marry me, I must be sure that you can do it a third time." He ordered more straw to be brought to her room, and he closed the door and left it there.

And this time the girl was in deep despair. Night came down, and no sign of the little man. The moon came up, no

sign of the little man. Dawn began to creep across the sky, no sign of the little man. "Oh, my poor father," she sobbed.

"Stop that!" There was the little man, standing by her side and holding out his hand. "We did it once, we did it twice, we'll do it thrice."

"But I haven't anything else to give you," the girl said. "You've had my necklace, you've had my ring, and I haven't anything else."

"I'll spin your straw into gold," the little man said. "And you will marry the king. And when your first child is born, you will give him to me. That is my bargain. Do you agree?"

Outside the cockerel crowed. Day was coming. "Yes, yes," said the girl, and she closed her eyes.

And it was just as the little man with the crumpled apple skin had said. The king was so pleased to see that the straw had been turned into gold that he asked the girl to marry him, and she said *yes*.

There was a wonderful wedding, and the weaver came to live in the castle grounds and to make fine cloths for his son-in-law the king, and a year later the girl gave birth to a baby boy. On the night of his christening the girl sat in her room singing her baby to sleep.

"Stop that!" said a voice, and there at

her side was the little man, holding out his hands. "I've come for my child," he said.

"Please, please don't take him away from me," she begged.

"You will have three chances," he said. "If you haven't guessed my name by the end of the third day, then the baby will be mine." And the next moment, he was gone.

The girl thought all night and all next day; she asked everyone she met what their names were, she sent out the king's servants to collect names, and nothing seemed right. That night, the little man appeared just as he said he would.

"Know my name?" he croaked.

She thought she might as well try the most obvious ones first.

"Humpty-back?" she suggested.

"No!" he snapped.

"Shrivel-skin?"

"No, no!" He stamped his foot on the ground.

"Stampy-foot?"

"No, no, no!" and he stamped and hopped round the room. And next thing, he had gone.

The girl sent the servants even further, and they all came back with names that didn't seem right. And at midnight, the little man came again.

"Know my name?"

This time she thought she would try the least likely names. She began with, "Harry Handsome?"

"No!" he smiled.

"Gilbert Golden-heart?"

"No, no!" he chuckled.

"Michael the Mighty?"

"No, no, no!" And he laughed and danced round the room. "One last chance!" he croaked, and the next moment, he was gone.

Again, the girl sent out all the servants, and again they came back with names that just didn't seem right. Night came, and the last servant came home to the castle. He was the groom's lad, and

he ran up the stairs to her room three at a time and pounded on her door.

"I've got a story to tell you!" he panted.

"This is no time for stories!" said the girl. "Look at the time! It's nearly midnight."

"But listen!" the lad said. "I rode over the mountain and through the wood and across the river, and I came to a place I'd never seen before. I stopped to rest my horse, and there where the fox has his lair and the old owl roosts I found a little hut, and inside it I heard a croaky voice singing. I peeped through the door and there was a strange little

man leaping round his fire and singing."

"And he'll be here any minute," the girl said. "Go away and let me think! The clock is beginning to strike!"

"No," said the lad. "Listen! This is the song the little man sang:

Oh, I can dance and Oh, I can sing!
Tonight I'll have the son of the king!
Servants look high, servants look low,
They won't have my secret, wherever they go;
Servants go back the way they came,
Rumpelstiltskin is my name."

The clock finished striking and the lad ran back to the stable. The girl picked up her baby, and there was the little man, standing next to her and holding out his hands.

"Know my name?" he asked.

"Could it be Lee, or Tom, or Liam?" the girl said.

"Oh no," said the little man. "Nothing like."

"Could it be Francis? Matthew? Or Geoffrey?"

"Oh no. No good. You give up, don't you? The baby's mine!"

But instead of giving him the baby, the girl began to sing:

"Oh, I can dance and Oh, I can sing!
You'll never have the son of the king!
Servants looked high, servants looked low,
They found out your secret,
I'll have you know;
Servants came back home again,
RUMPELSTILTSKIN is your name!"

and she laughed with delight and hugged her baby boy to her.

The little man stamped so hard that his foot went right through the floor, and he went with it, and was never seen again. And the stable-lad was given a horse that was the colour of gold, and everybody lived happily to the end of their days.

TITLES IN THE FAIRY TALE SERIES

Available from all good bookstores

www.walker.co.uk

FOR THE BEST CHILDREN'S BOOKS, LOOK FOR THE BEAR.